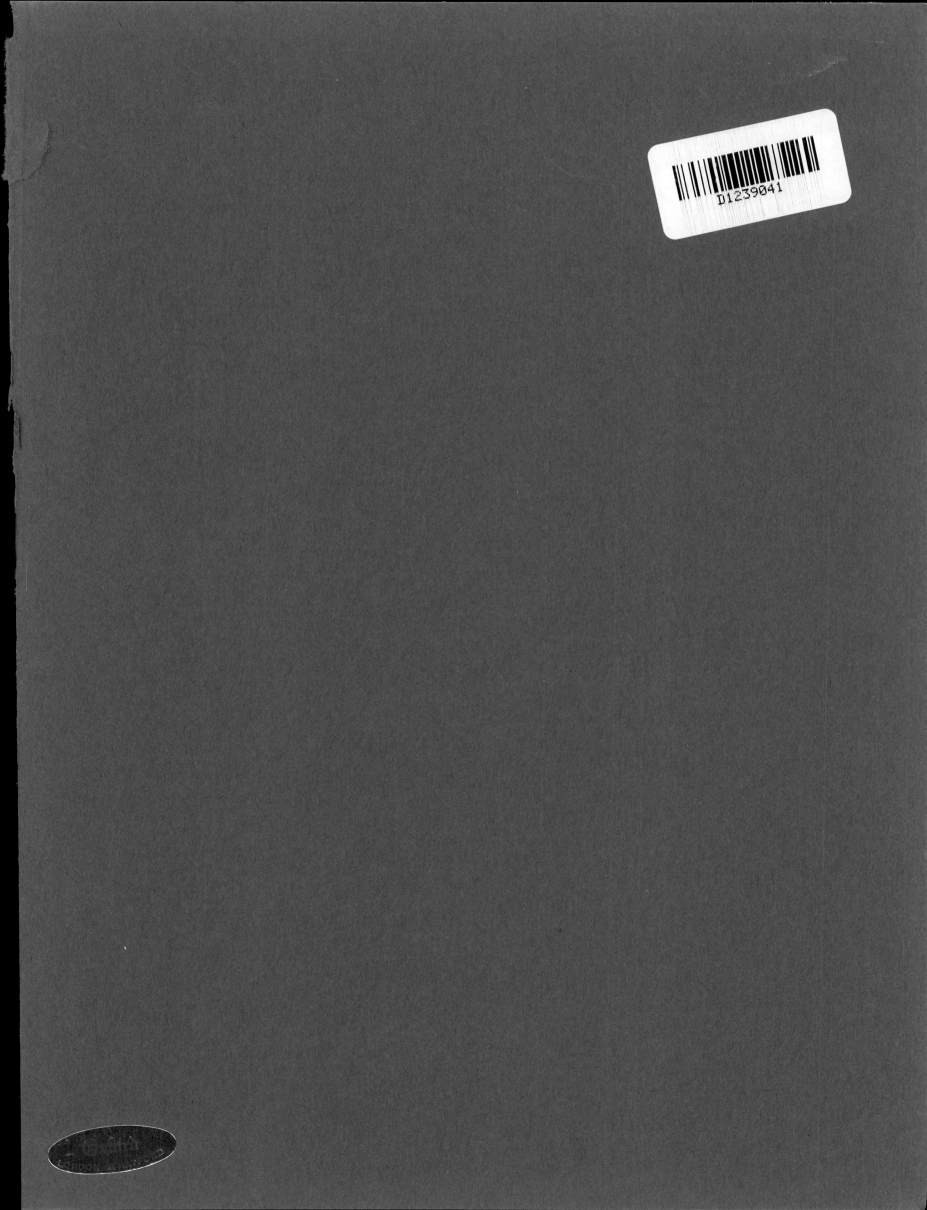

Pellan

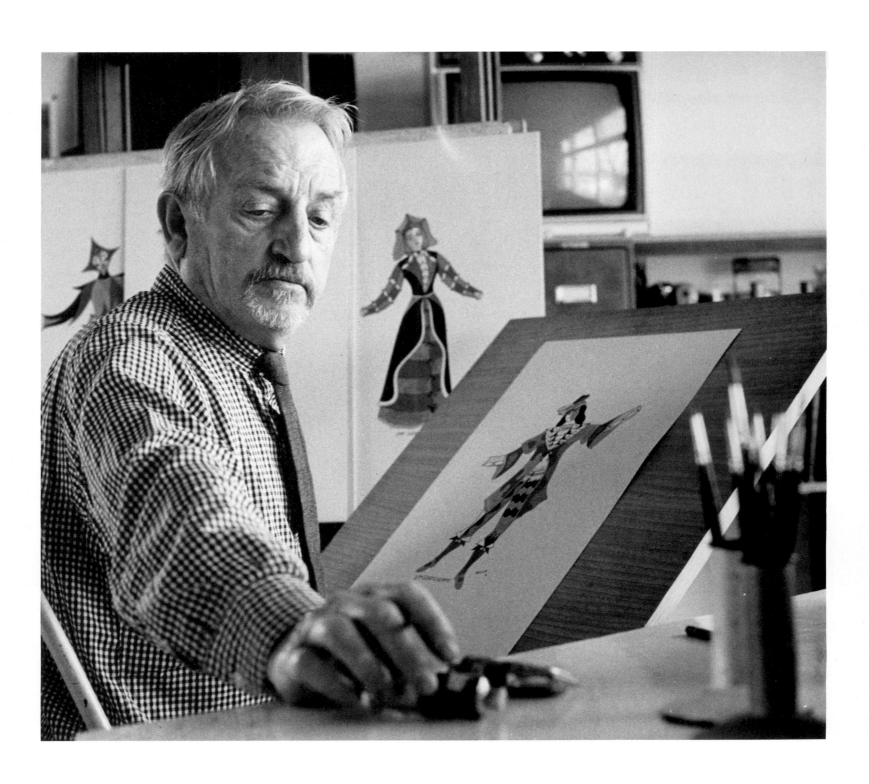

Germain Lefebvre

Pellan

McClelland and Stewart Limited

The Canadian Publishers
McClelland and Stewart Limited
Illustrated Books Division
25 Hollinger Road, Toronto

0-7710-5240-5

Special thanks are due to the Canada
Council for a grant-in-aid for publication
of this book.

Contents

Foreword

On a sunny afternoon last summer, Pellan, his wife Madeleine and I sat on the patio of their home. We chatted as friends do about nothing in particular while admiring the calm landscape which gently slopes towards the meandering river nearby. To see the bottom of the slope, you have to sit up erect in your chair because the thick hedge of young maples obstructs the view. "Soon, we won't be able to see anything," Pellan said. "It wasn't long ago that I planted these shrubs. I cared for them, trimmed them and now they're growing incredibly. I can't keep them at a reasonable height any longer. They're spreading madly."

Shortly before, we had examined the artist's photographic records. In his studio, we had spread out everywhere – on long tables, chests, couches and even on window ledges – several hundred photos of paintings, drawings, costumes and theatre sets, jewels, masks and murals. Looking at the green invasion which Pellan had drawn to my attention, I could not help but think of the other invasion, the one he had reconstructed in facsimile form in his *atelier* but which, in reality, spills over into hundreds of public and private collections the world over.

For more than fifty years, Pellan has pursued his creative activity. He has completed more than five hundred paintings; this figure does not include his drawings and other artistic achievements. He still paints with the same ardour. Nothing can turn him away from his art. Once, he was confined to bed following a delicate operation on his spine; he devised an ingenious method to continue working even though he was bed-ridden.

The man is blessed with rare dynamism; he takes up any challenge. He is ready to try anything and his perseverance enables him to overcome the most serious obstacles. During his career, he has achieved a number of resounding successes. In the recent history of Quebec art, his place is predominant.

Pellan's pictorial universe is dizzying; it is fascinating in its diversity and complexity. Still, there is a unity, an unquestionable unity – that of life itself in perpetual regeneration and proliferation, as evidenced most of all undoubtedly in the organic world. Is it not revealing that flowers, plants and gardens are in the forefront of Pellan's thematic concerns?

Pellan's creative energy has the vigour, the formidable power of a plant bursting through concrete in order to grow in the sun.

Such were the lasting impressions I felt upon coming into contact with the man and entering into the heart of his universe of colour.

I have tried to express these feelings throughout the story of his career as well as in a commentary on the various facets of his work. Pellan's images have a great deal to say; they suggest many visual experiences. Words often are only a pale substitute to evoke the scope and density of his art. I also considered it essential that a substantial amount of space be devoted to the reproduction of his works.

The texts are largely based on the accumulation of information gathered from the artist and his wife during a series of stimulating conversations. In addition, all the artist's records were placed at my disposal, thus eliminating long and difficult research.

The Pellans always welcomed me with great cordiality; to work in their company struck me as being pleasant relaxation. It is my earnest wish that they will find here the expression of my deepest gratitude.

I also wish to warmly thank Madame Françoise Saint-Michel and Mr. Bill Bantey who edited the manuscript. I benefitted from their advice in the final formulation of the text. Mr. Bantey is also responsible for the excellent English translation. The judicious observations of Messrs. François Gagnon and Jean-René Ostiguy shed new light on the lesser known periods of Pellan's career. Their contribution was precious to me. The writing of this book was greatly facilitated by the understanding and encouragement of Mr. David Giles Carter, director of The Montreal Museum of Fine Arts. Madame Denise Denis enthusiastically assumed responsibility for the long work involved in preparing the manuscript. She carried out the task with exemplary efficiency and deserves all my thanks.

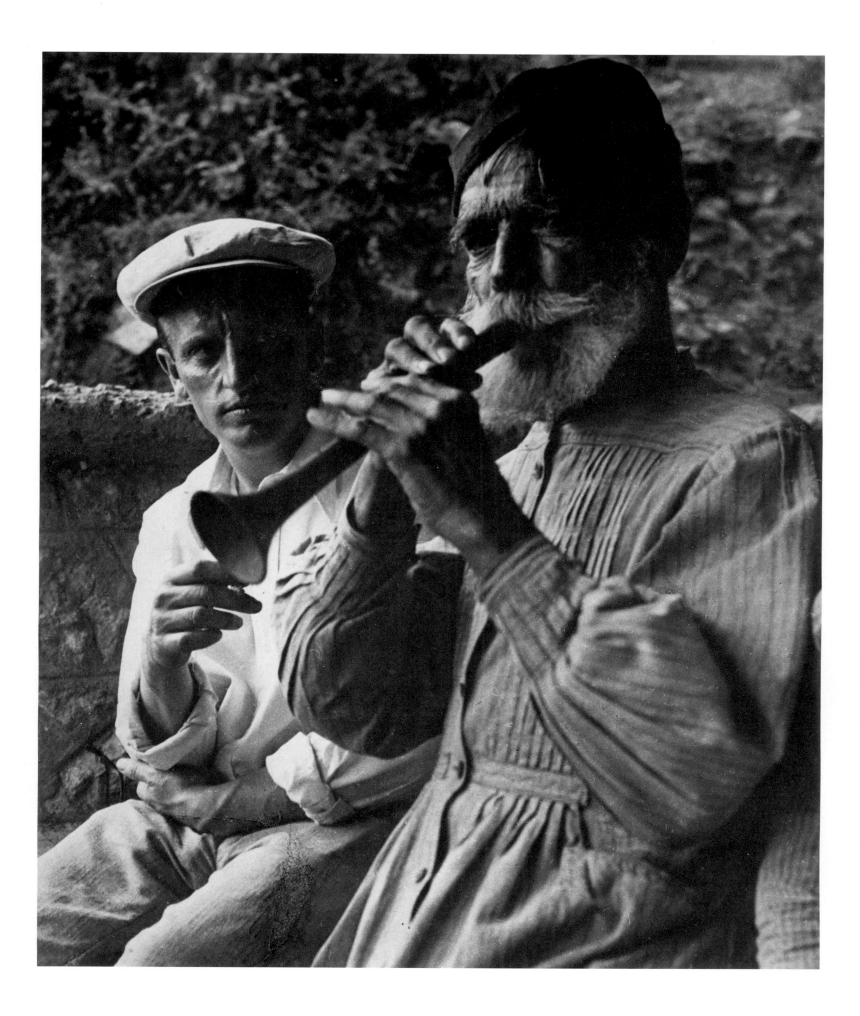

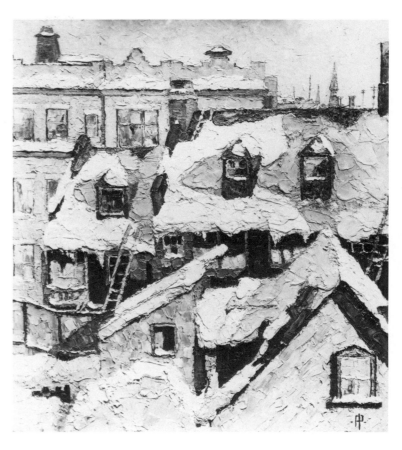

Coin du vieux Québec
1922
35 × 22 1/2
oil on canvas/ huile sur toile
National Gallery of Canada/
Galerie nationale du Canada, Ottawa

Part One: The Man

The history of great artists, it is well known, is unending since it merges one day with art history itself when works in museums and in private collections stamp the destiny of the elected with the halo of eternity. Yet, based on the common rule, it must have a beginning, humble and modest as it may be. Very often, it takes some time for the history of the man and that of the artist to blend. For many painters, musicians or poets, the road to a place in history is long indeed.

At times, however, early and sudden events change the usual order of things. Certain people of passionate temperament – true forces of nature – immediately recognize the signs of the future and clearly and unhesitatingly set the course of their careers. Such was the case with Pellan. Few artists can say, like Pellan, that they sold a painting to an institution as prestigious as the National Gallery of Canada at the age of sixteen.

Here, undoubtedly, is a self-evident indication of his rare creative ability. Little time separates the painting, *Un coin du Vieux Québec,* from the first pictorial attempts of the young student, yet the machinery already had been subtly broken in and soon would be ready to undertake vast exploration in the infinite fields of the plastic universe.

Truthfully speaking, Pellan had few other pastimes before painting. His favourite memories relate to the long moments he spent as a child carefully sketching everything within reach.

Alfred Pelland*, second son of Alfred Pelland and of Régina Damphousse, was born May 16th, 1906, in Saint-Roch ward of the Ancient Capital of Quebec. His brother, Réginald, was only a year older. A sister, Diane, completed the family circle two years later. Then came the awful bereavement which darkened the childhood of the little Pellands: only months after Diane's birth, the mother died following illness. Pellan does not remember; he was not yet three years old.

Nor does he remember the house on rue des Fossés since he lived there only a short time. Urban progress did away with it and there is no longer even a trace of the street. In fact, it was in suburban Limoilou, on the other side of the St. Charles River, that he spent his childhood years. Things were far from dull; the father, taking advantage of every free moment, made use of the time to look after his little

* Pelland is the correct spelling of the name. The artist eliminated the "d" around 1930 and began to sign Pellan because it seemed "more plastic" to him.

family. Pellan recalls this well – the walks, the games, and especially the locomotive.

Mr. Pelland was a Canadian Pacific employee, part of a crew assigned to one of the powerful engines which clothed themselves in clouds of steam and coal smoke before shuddering off to the sound of an infernal noise. The young Pellan could not have been more proud when he was invited aboard the extraordinary machine.

Indeed it was a terrible shock when he learned one day that the locomotive did not belong to his hero. However, his father was to make up for this disappointment with an unforgettable Christmas gift when Alfred Pellan turned ten: a fascinating, well-furbished miniature locomotive similar in every way to the real thing; it even operated on the same principle of steam compression. Still all spruced up today, it stands on the window ledge of the playroom in the Pellans' Auteuil home.

So vivid are the railroad memories in Pellan's mind that he cannot go aboard a train without being tempted to start a conversation with the ticket-taker or, preferably, with the mechanics. On his last trip, however, he was disappointed: the glorious *Frontenac Express* which transported his father between Montreal and Quebec had since been replaced by a few shabby wagons containing only a handful of passengers.

The fun-filled trips in his father's company were one thing, but there were also many hours of solitude for Alfred at home, and the maid could not always succeed in

Les poires vertes
1927
13 × 16
oil on canvas/ huile sur toile
Mme. Antoinette Capitant, Paris

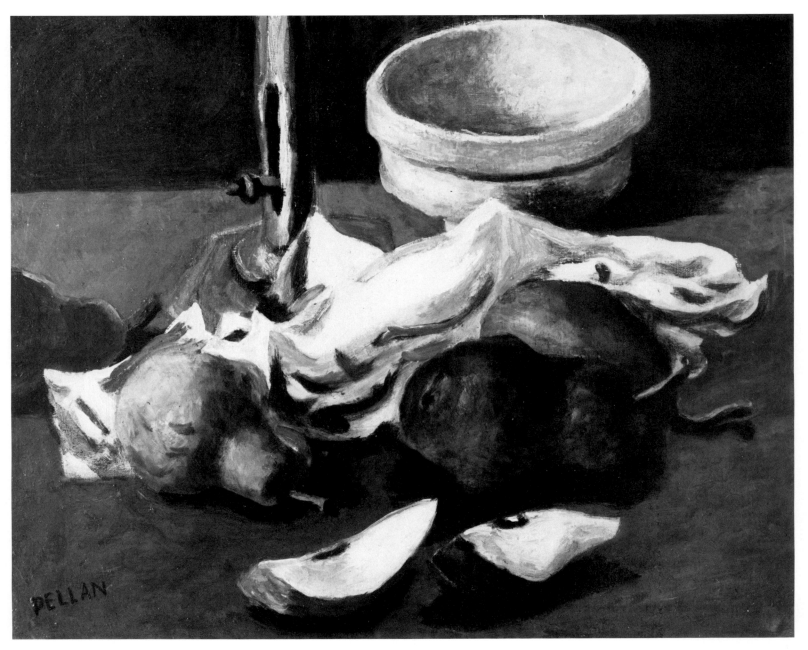

making the atmosphere gayer. And there were long days when, suffering from excruciating stomach pains, he had to stay at home and follow a strict diet of bread and milk. Happily, his health otherwise was excellent though he was to endure this pain for more than thirty years. Doctors were unable to diagnose the problem. To carry out an urgent commission on schedule, he at times painted with ice-bags strapped to his waist.

After years of suffering and after consulting with doctors at the hôpital de la Charité in Paris – even today, Pellan remembers standing completely naked in the amphitheatre in front of professors and students who were discussing his symptoms – it was Dr. Paul Dumas who succeeded in detecting the source of the persistent pain: chronic appendicitis. Only in 1943 was Pellan freed of his pain through surgery.

The youth's repeated attacks frequently interrupted his school work and did not add to any appreciation of academic subjects. Nor did he always resist the temptation to play hookey: the wind of freedom often altered the course of his activities. He did not really feel committed to the classroom, to desks, ink wells, and even less to grammar, geography and arithmetic. He kept his distance from these subjects. Already strongly individualistic, he resisted neat, two-by-two files or didactic approaches.

Even when he resigned himself to his classroom seat, he was constantly distracted by exercises which carried little weight in the official program of the Department of Public Education. Pellan enjoyed making pencil sketches in the margins of his copy book. He sketched illegally on Monday, Tuesday, Wednesday, and Thursday; finally, on Friday morning, in the drawing class, he no longer had to hide;

Nature morte à la lampe
1932
25 × 32
oil on canvas/ huile sur toile
Musée national d'Art moderne, Paris

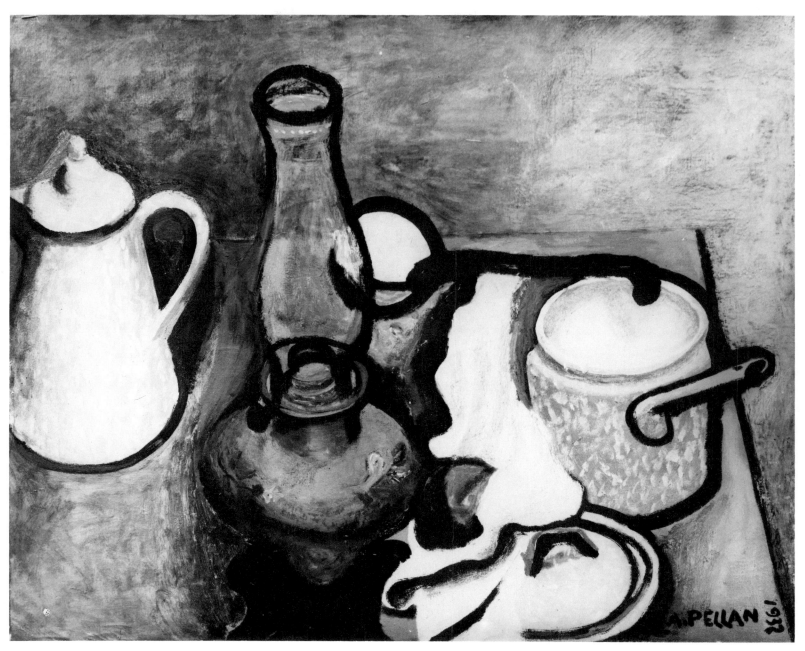

he did what everyone else was doing. His monthly report card obviously reflected his highly unorthodox concentration of interest. He was first in drawing – always at the top of the column of figures – but in other subjects, his rank was low. Still, he was a generally well-behaved student; neither difficult nor troublesome, he went almost unnoticed, except, of course, during the drawing period.

One day, one of his teachers told Pellan that he, too, painted and showed Pellan his work. The student felt some pride in being singled out in this way. It was as though he had been given a special status, a form of competence, as though the enthusiasm and passion he manifested as soon as he began to draw pictures had been justified. Pellan was not yet a painter but he was already a draughtsman.

He began to paint a little later, following in his father's footsteps. In reality, Pellan's father's career as a painter had

been short-lived. Confined to his home by illness, the father had obtained a few tubes of colour, brushes and some canvas and, to pass the time, had painted a number of pictures to decorate the walls of his house. Why painting? There was no special reason, except that he felt like it. Perhaps there had been some unknown master in the line of Norman or Scottish ancestors. Or perhaps one should look back into the branch of the earlier Catalans. Does it really matter? In any event, if an old legacy did indeed exist, it took another generation before it was revived since Mr. Pelland, as soon as he was well again, returned to his locomotives.

Then one day the adolescent son found the box of colours. He discovered his vocation, he likes to recall, in a cigar box! The first attempts were timid, bearing no resemblance to the later fairy tale marvels. Still, the beginner

11

Nature morte à la palette
1936
18 × 21
oil on canvas/ huile sur toile
Musée de Grenoble

Panier bouclé
1933
45 1/2 × 35
cil on canvas/ huile sur toile
National Gallery of Canada/
Galerie national du Canada, Ottawa

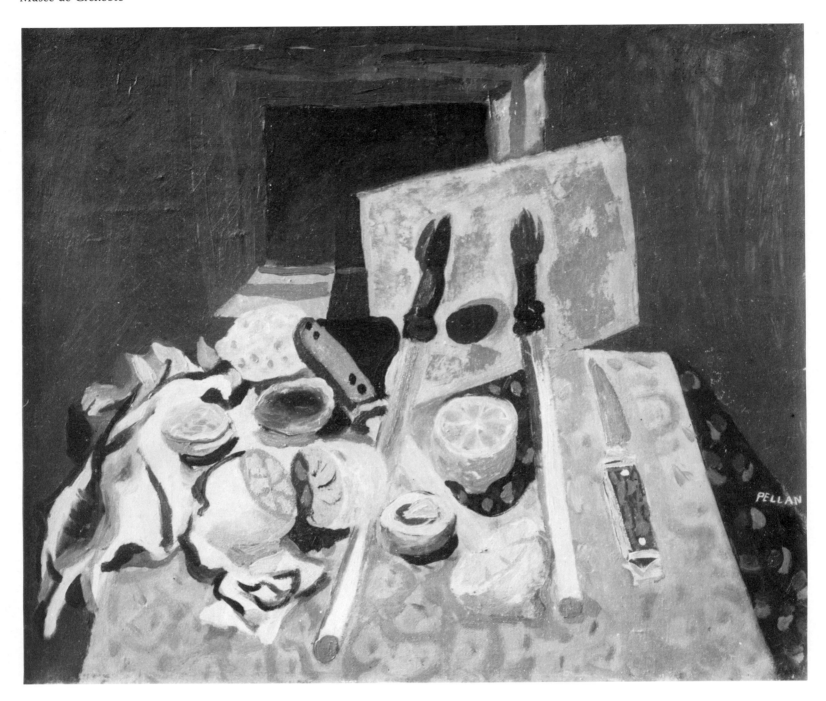

showed talent. He himself was especially thrilled. He was unaware, of course, that while he amused himself copying calendar pictures – a trout fisherman or a horse galloping in the plains – he was giving hold within himself to an obscure force which soon would become an irresistible, indisputable necessity – his *raison d'être* in this world, his way of life here. Little by little, he was freeing within himself an extraordinary force for plastic achievement.

For the time being, however, Pellan remained at the beginning stage, even though he did not lack in conviction. The cigar box no longer sufficed to contain the materials he acquired with his pocket money. The magazine and calendar models began to lose interest for him. Like a professional, Alfred Pellan loaded all his material in a handcart and went in search of nature.

It was on the bank of the river, near the old port, that he particularly enjoyed setting up his easel. He painted the water, boats, cargoes, the shore on the other side, the sky. Only one thing bothered him during these sessions – the presence of strollers, playmates looking over his shoulder, asking questions and making suggestions. In fact, he preferred working at home where he could practise composition by varying the elements of his still lifes.

Virtually nothing of his initial work remains. Among

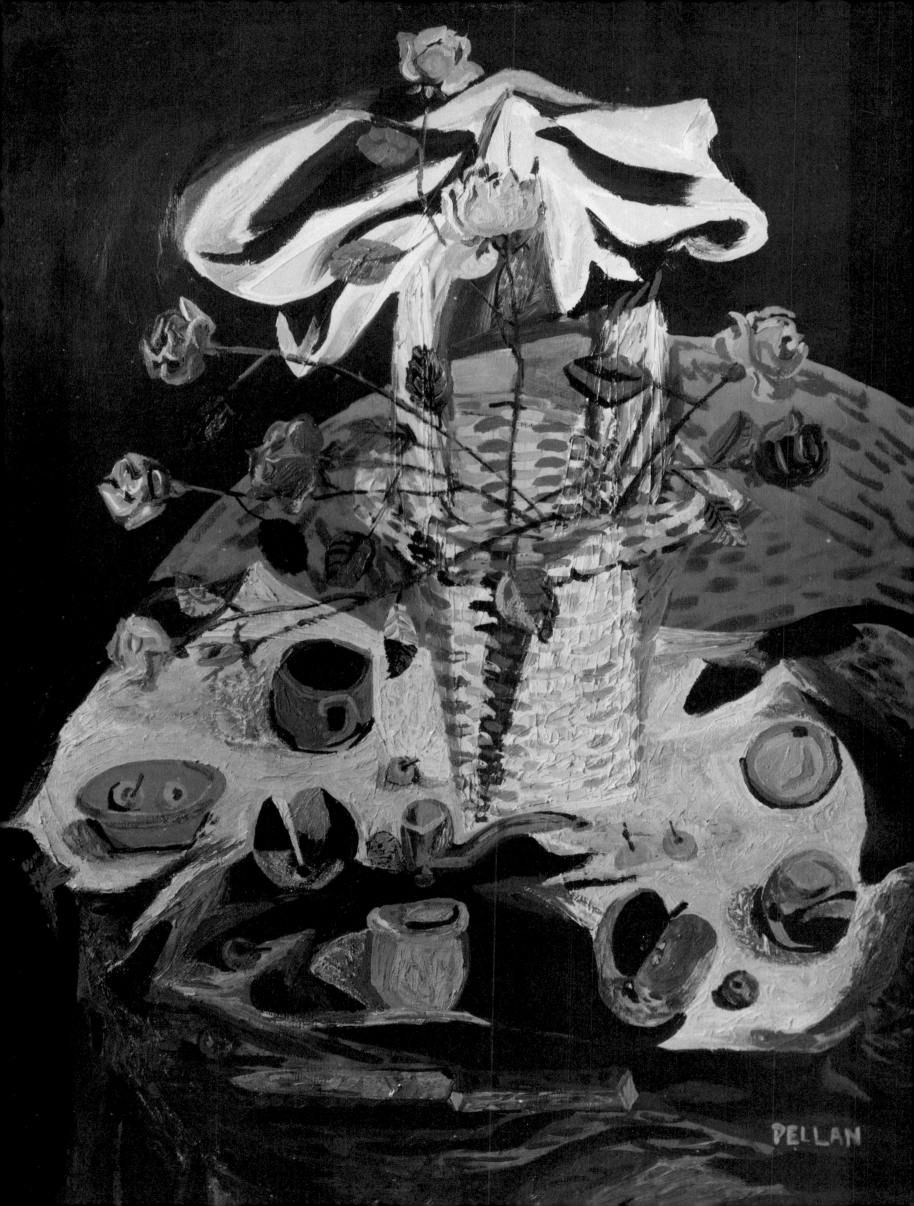

Femme au peignoir rose
1931
18 3/4 × 15
oil on canvas/ huile sur toile
Collection Maurice et Andrée Corbeil,
Montréal

Mlle. Geneviève Tirot
1932
16 × 13
oil on canvas/ huile sur toile
Dr. Gaétan Jarry, Montréal

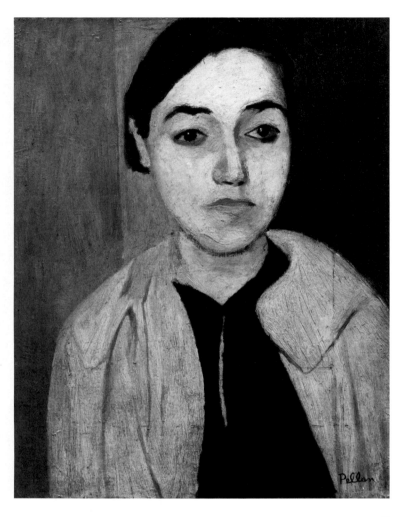

the few works he did not destroy was *Les fraises,* a small painting executed at the age of fourteen. It prompts one to regret the disappearance of all the other early works. For sure, this fresh image, rich in colour, celebrates nature and does not lack in pungency. Inspired originally by a pale and dull reproduction, Pellan quickly changed his focus of interest from the model to the autonomous organism taking shape on his cardboard. The transposition was bold.

Long before his stay in Paris, even before his first apprenticeship at the Ecole des Beaux-Arts in Quebec and still an adolescent ignorant of the great pictorial traditions of Western art and even more of its recent development, Pellan became part of a living art, the only true art which recreates itself with every moment and which even as it emerges forgets its name.

There was no talk of art in Pellan's entourage, nor was there any mystery or any mystifying rite in his pictorial activity. Alfred simply painted. It was as simple a matter as a carpenter cutting a piece of wood, fashioning it in such a way that others could use it. And it was as essential and as serious as the work of an electrician connecting wires or power transformers to set up a functional circuit.

And yet something truly wondrous happened when he intuitively spread a few spots of red among the blues and

the greens, when he joined the curves or developed his composition; there was something which kept him there, hours at a time, drawing, purifying his shades of colour and, finally, evaluating the finished work.

Decidedly, Alfred was not interested in science or mathematics, history or literature. His father quickly understood that. Nor did he object in any way to the adolescent's plan to follow the courses of the Ecole des Beaux-Arts in Quebec, then only starting. He was accepted without any difficulty and enthusiastically undertook the five-year cycle of studies.

The institution had structured its courses according to the rules of the academic educational system, based on the model of old European schools. But, as a result of the keen understanding of the director, Jean Bailleul, the students enjoyed great freedom in their studies. Pellan did not hesitate to adapt his schedules and to choose his teachers. His curiosity was insatiable, a curiosity matched only by his passion for work.

Arriving very early in the morning, he would break for lunch at home. He went on foot to save the cost of streetcar tickets. The money was used instead to purchase materials. He never had enough of them. His father's generosity was seriously threatened. After a busy afternoon, young Pellan often would go back to school to complete his work, returning home only late at night to sleep. Impressed by the young man's seriousness and his intense desire to learn, the heads of the school agreed to give him a key to the studios so that he could use them when he wanted without regard for the school's normal hours.

Pellan maintained this frantic pace throughout the years of his studies. When he concentrates on his work, nothing can divert him. He plunges into the heart of a plastic problem and disengages himself only when he has found the solution. The properties of colours, the dynamism of composition, the perfection of form are his only concerns; theoretical discussions on the ideological or moral implications of art do not interest him.

Pellan recalls the soul-searching which tormented his fellow students, then torn between the freedom of art and moral codes. Clandestinely, the director had established a life class for the sketching of models in the nude. He strongly urged his students to take the course but confessors secretly attempted to discourage the idea under threat of eternal damnation. The resulting tension was almost untenable, paralyzing the work of many students. Pellan, however, continued to draw and to paint. He pressed on with his plastic research, untroubled by the Casuistic concerns so foreign to his way of thinking.

At the school, students did not have to memorize untimely references. The institution had no theoretical course in art history; the library was open to all and anyone could thumb through the collections of reproductions or artists'

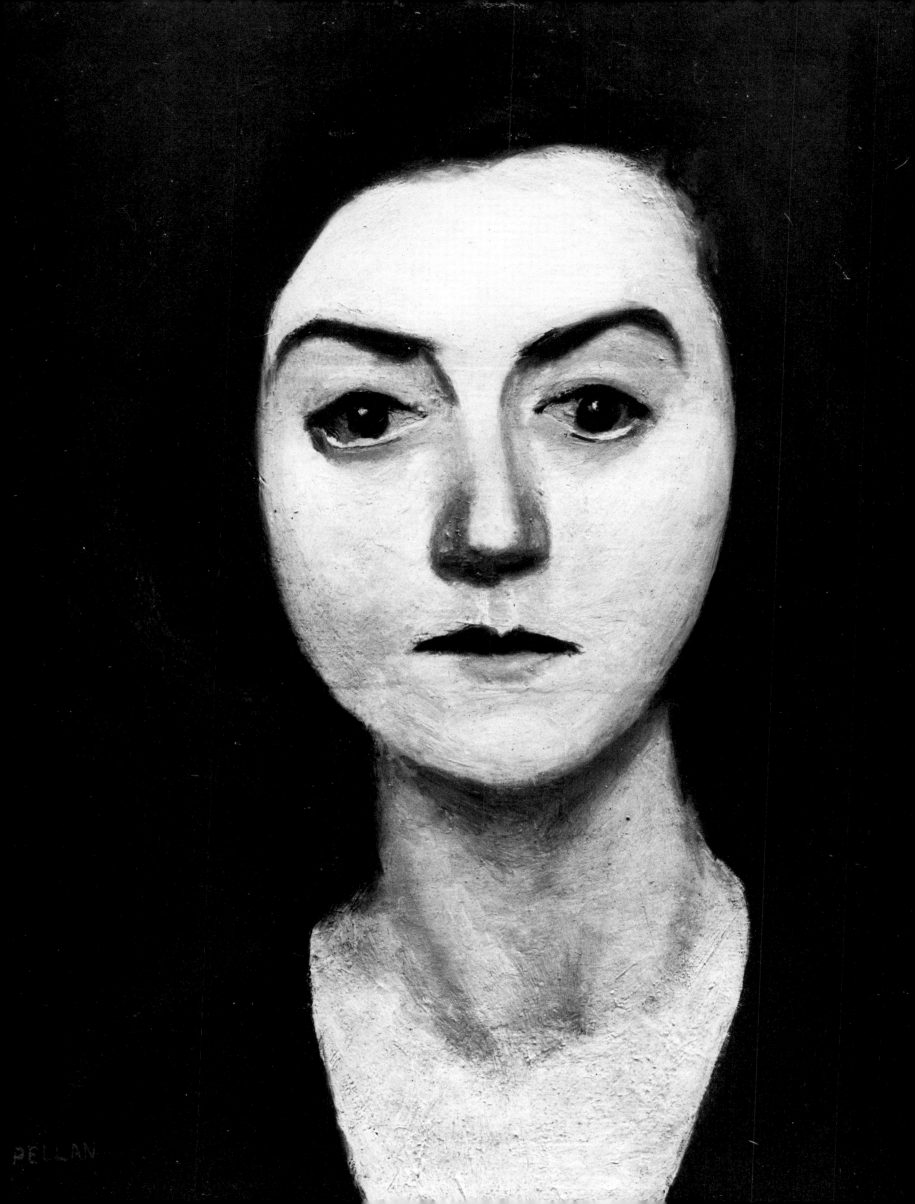

monographs. No one, however, was required to admire any given master and even less to imitate them. The bookshelves, it must be said, were far from complete; there was nothing, for example, on the new trends of the French school. Solely monochromatic plates were available to reveal to Pellan what he could admire of the works of Van Gogh, Cézanne and the Impressionist painters. He guessed, however, that they "must have been famous colourists."

Undoubtedly, the teachers referred at times to the great figures of Canadian art – the Clarence Gagnons, the Suzor Côtés, the Charles Huots who, in a limited art world, stood out as true stars – but contact with their work was infrequent. One day a teacher brought his class on a trip to l'Ile d'Orléans and the students were able to visit the studio of the celebrated Horatio Walker who was pursuing his production of pastoral compositions in the Barbizon tradition. At this stage, Quebec collectors had little contact with the art of the English provinces. The paintings of the Group of Seven – highly conservative at this point, it should be admitted – were not well known.

Pellan multiplied his experiments, inventoried all the subtleties of drawing and colour. He learned a great deal during the evenings he worked alone. His first achievements were convincing. At the conclusion of his first year of studies, he won first prize for painting in the elementary course. In the years that followed, he was to accumulate first prizes in an increasingly varied number of subjects. At the end of his courses, finally, he carried off all the first prizes – in drawing, painting, sculpture, pen drawing, anatomy and even a special first prize for sketching. To the honour accorded him by the National Gallery through the acquisition in 1922 of one of his paintings was added his first public success: in 1925, he won the grand prize of a poster competition organized in Quebec by the Kiwanis Frolics Program.

A spectacular reward crowned Alfred Pellan's efforts, confirming the success of his young career in the summer of 1926. A Quebec jury made up of Horatio Walker, Charles Huot, Jean Bailleul, Ivan Neilson, A. Panchelli, Gaston Hoffman and R. Lévesque, specially set up for the purpose, awarded him a bursary to study in Paris. He would leave early in August, accompanied by his classmate, Omer Parent. Both were the first winners of the Province of Quebec art bursaries, Pellan in the field of painting, Parent in the area of the decorative arts. There had been more or less official talk about these study periods abroad since the Ecole des Beaux-Arts had been founded by Athanase David and students had cast covetous eyes on the possibility of winning the bursaries.

As soon as the results became known, there was an explosion of joy at the Pellands'. It was absolutely extraordinary – here was a little guy from Limoilou going to study in the big schools in Paris, delegated by the official authorities of the province. Paris, France, the great museums, the cathedrals, the cradle of the language, of the culture! Feverishly, Pellan packed his bags, visited his relatives, friends, received, it goes without saying, congratulations and references, and left for Cherbourg.

In 1926, Paris was a world in itself. It was as though the whole of the universe had agreed to meet there. The movement had begun several decades earlier and was to end only with the world catastrophe of 1940. No new trends of thought since the beginning of the century, no *avant-garde* artistic or literary concepts or new forms of entertainment were without roots in Paris. Paris! A huge spider's web reaching out for everything the earth produced, anywhere and everywhere, to taunt the spirit. Paris! It was the spirit, the conscience of the world. It was a carnival, pleasure, love, *joie de vivre* bursting like fireworks at all hours. Everything was happening everywhere in Paris, day and night. Paris lived its public life at full speed. In Montparnasse, in Saint-Germain-des-Prés, in café after café, in theatres and in studios, in galleries and on crowded sidewalks, geniuses, painters, poets, writers, actors, philosophers, musicians, students, failures, and revellers were dismantling and re-creating the world as though by perpetual motion. A climate of intense creativity swept every corner of the city, appearing in every possible form.

Based on a new civilization introduced at the beginning of the century, minds turned to the search for new foundations, for new ways of dealing with reality. In painting, a long road had been covered since the controversy and excitement of Impressionism. An authentic art had been liberated: unceasingly, it raised new questions as it turned more and more resolutely to its own nature, its own means, line, colour, form, space, light. The liberation had been carried out and continued to evolve under the influence of the most varied ideas and the most original visions. Movements and "isms" succeeded one another at a frenzied pace without necessarily replacing one another. Fauvism (1905), Cubism (1907), Expressionism and abstraction (1910), Dadaism (1916), neo-realism (1918) and Surrealism (1923) provided the affluent mould in which the multiform flowers of living art meshed and developed. They appeared in countless studios in a city with forty thousand painters, in the flourishing galleries of dealers, in the major exhibitions which circulated beyond Paris. Paris was painting, celebrating, supplying itself with an orgy of images with the help of prodigious creators named Bonnard, Matisse, Braque, Picasso, Delaunay, Dufy, Derain, Miro, Ernst, Dali and many other famous and generous artists.

The imagination and love of art which marked the ebb and flow of the big cafés – from the Dôme to the Rotonde, from the Baty restaurant to the Coupole – at times brought together at the painters' tables the poets Paul Eluard, André Breton, Jean Cocteau and Louis Aragon; the musicians Al-

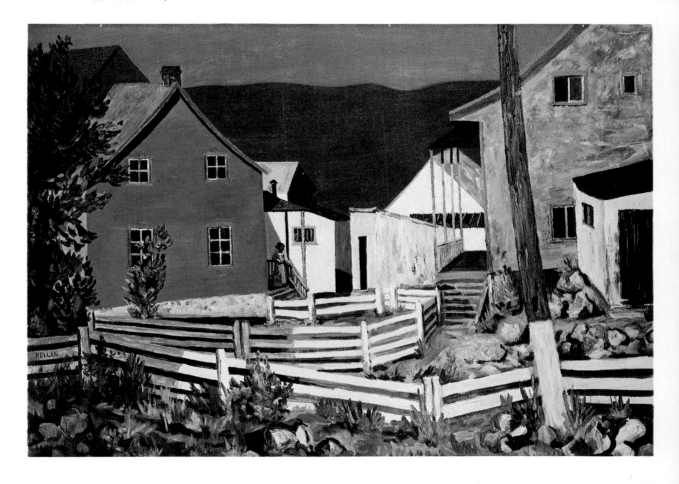

Maisons de Charlevoix
1941
oil on canvas/ huile sur toile
25 × 36
Dr. J. Gordon Petrie, Como,
Québec

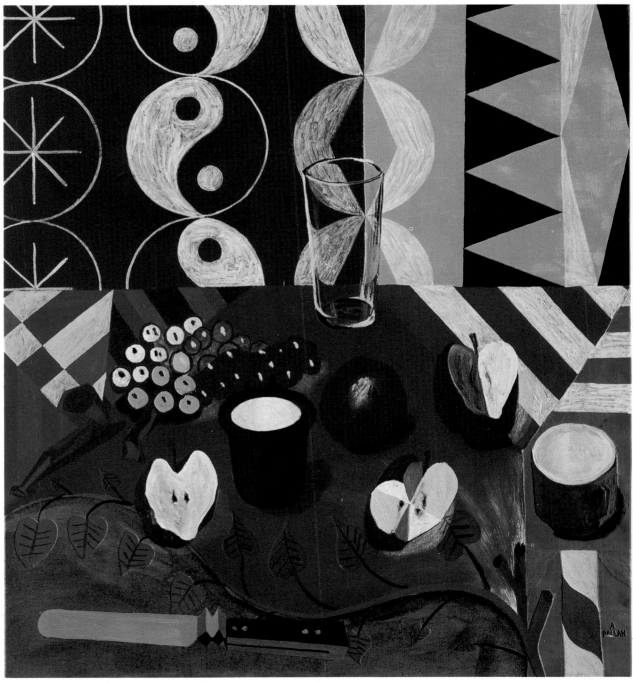

Nature morte au verre de cristal
circa/ vers 1943
oil on canvas/ huile sur toile
25 × 23 1/2
Mme. Camille Hébert, Montréal

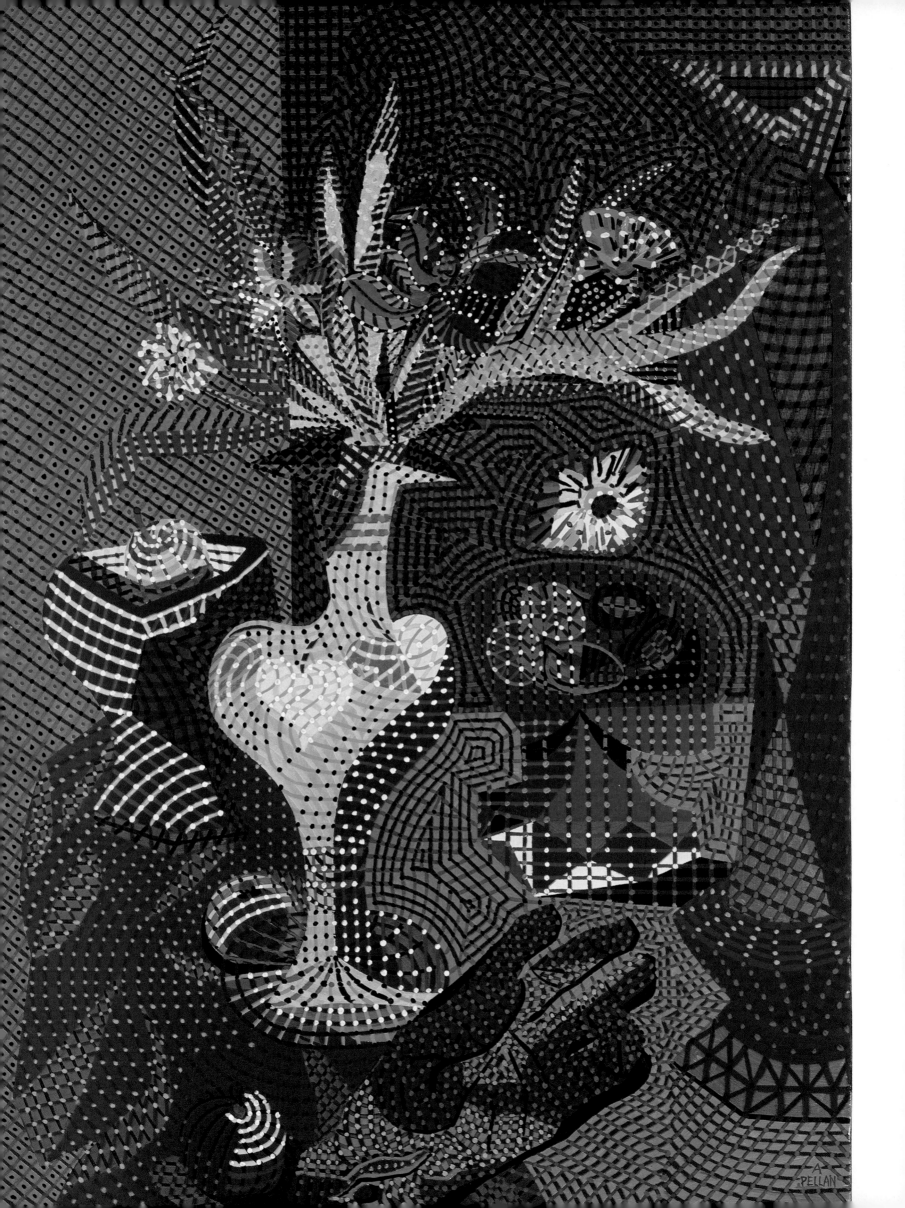

Nature morte au gant
1945
oil on canvas/ huile sur toile
36 × 25
Dr. J. Gordon Petrie, Como, Québec

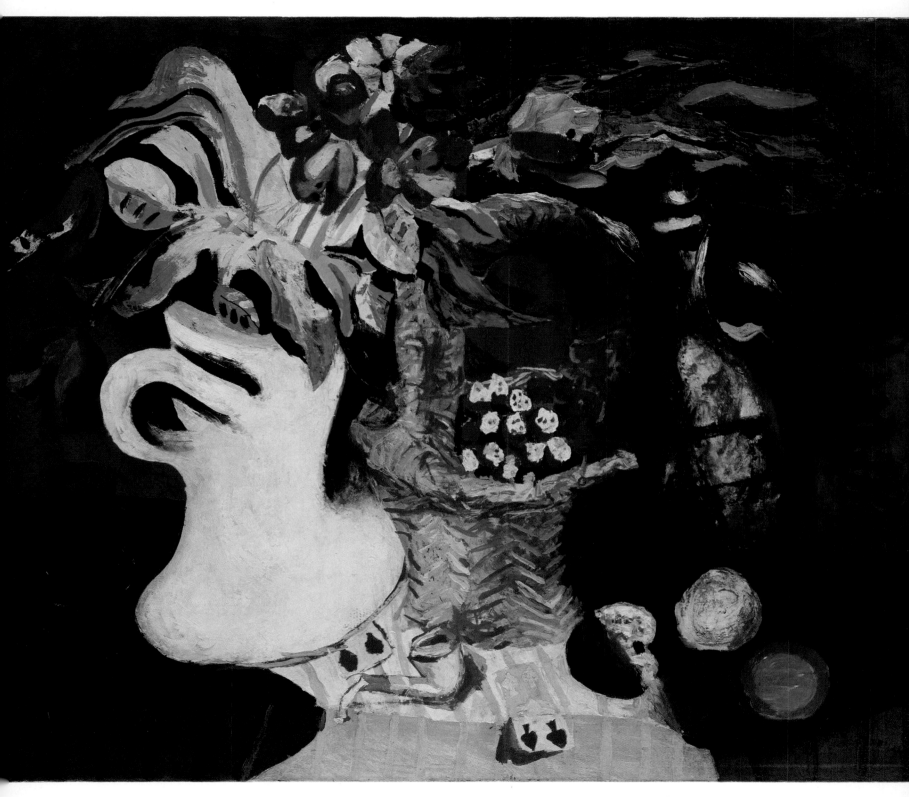

Le panier de fraises
1935
oil on canvas/ huile sur toile
32 × 39 3/4
Dr Paul Dumas, Montréal

Jeune fille aux anémones
circa/ vers 1935
oil on canvas/ huile sur toile
45 3/4 × 35
National Gallery of Canada/
Galerie nationale du Canada, Ottawa

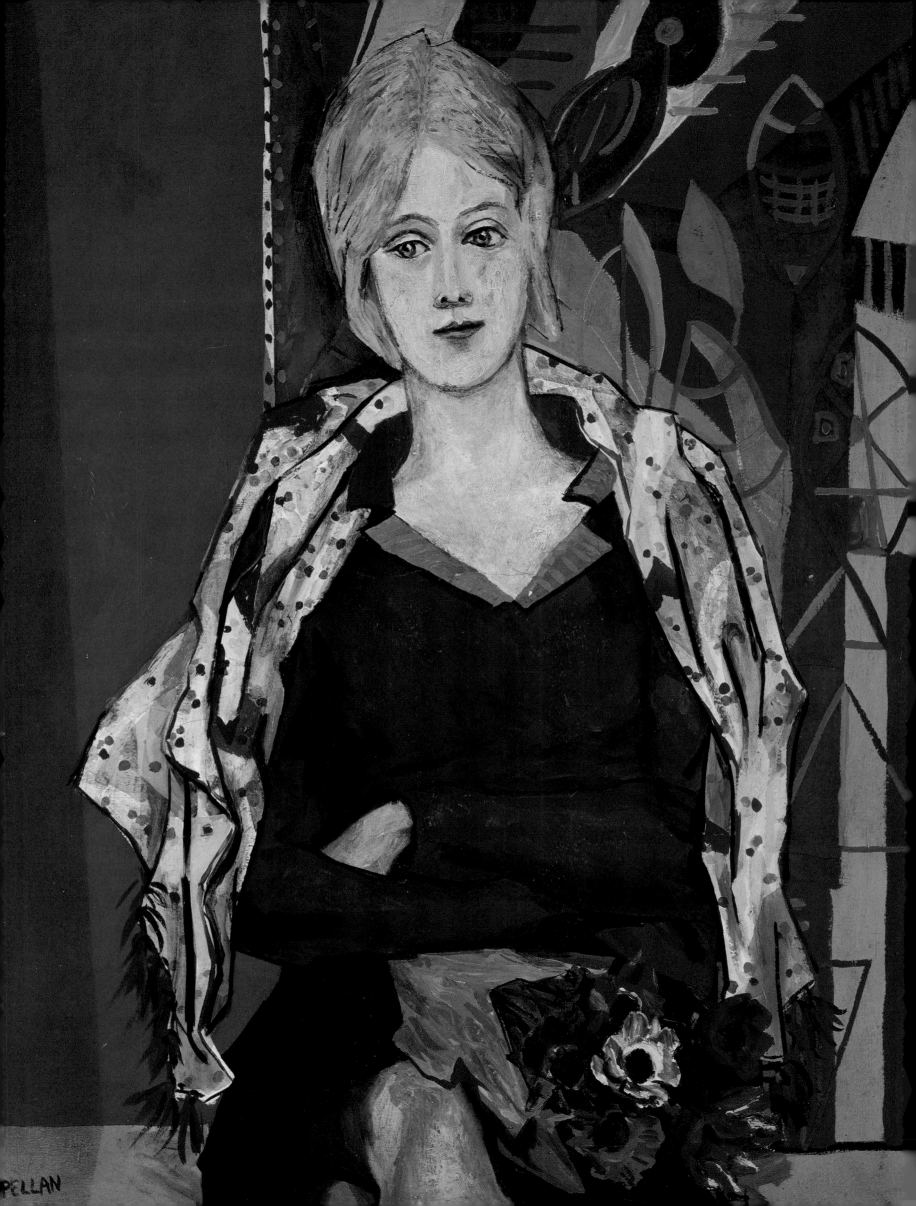

bert Roussel, Eric Satie, Georges Auric, Arthur Honneger or François Poulenc. In full blossom, the "cultural revolution" was being carried out on all fronts simultaneously, striking down all partitions. Since the smashing success of Serge Diaghilev's *Ballets russes* in 1909, the visual concept of major theatre or ballet productions was being entrusted more and more to modern artists. It was on the basis of a Jean Cocteau theme and with the music of Eric Satie that the ballet *Parade* was conceived in 1917, with Picasso creating the décor and costumes. Through the intermediary of the theatre, the public was being introduced to the new directions in French art and was becoming familiar with the work of the great painters.

It was in this Paris – a whirling and terrifying Paris, the mecca of art and thought – that Pellan arrived early in the autumn of 1926 to begin a lively adventure which was to continue for fourteen years. The result would prove much more than honourable as well as the determinant factor in the development of his career. The Quebec artist never rejected his early training in his native city and constantly manifested his appreciation to his old teachers who were the first to suggest to him, timidly perhaps, the illuminations of art. But the revelations of Paris were something else! Paris was a true introduction to the sacred fire, the dazzlement of a transfiguration.

Almost overnight, Pellan crossed the barrier at least a quarter of a century old separating Quebec art of that era from what was happening in every corner of the French capital. Indeed, it was pushing a point to use the word art in reference to both schools, so far removed was the reality of the Paris school from that of Quebec's.

Pellan enjoyed a few weeks of respite, making a few steps of the climb before being sucked into the whirlwind of modern art. To meet the requirements of the bursary he had been granted, he had to enroll in an official school. He chose the very respectable Ecole supérieure nationale des Beaux-Arts de Paris, attending classes as assiduously as his extra-curricular activities would allow. Carefully, he chose the best teacher available and went to the painting studio of Lucien Simon. "He was a good teacher, an intelligent man," Pellan recalls. "The boldness of the painters of the hour was largely beyond him but his work was honest and, from the plastic viewpoint, it was not lacking in quality. He was loyal and a man of absolute integrity. We regularly went to his studio to work but very often when he appeared, we would go out for coffee. It was rather insulting and yet he never sought revenge when it was time to judge our work. For example, he recommended me for the school's first prize for painting in 1928 and it was awarded to me."

Taking the most direct route and in order to benefit from the facilities for adjustment provided by the official agencies, Pellan rented a room in the Canadian pavilion of the *cité universitaire*. A student's room for a painter proved hardly appropriate, however, as time went on, especially since no space was provided for studio work. For a time, the artist used the studios in the United States pavilion but other problems arose there. Because of the moral concepts of the authorities, female models were banned. Initially, it was amusing to disguise the young girls as boys, but eventually that too became a bore.

Slowly, Pellan became part of the student milieu of the school. He made good friends who were more interesting to him than his neighbours of the *cité universitaire.* Soon, he decided to make the break completely and enter into the Parisian artistic movement directly. "At Canada House, the atmosphere was rather dull. It was really like a college. I already knew that everything was happening in Montparnasse. My friends were there. I spent my evenings there and I resolved to bring myself closer to my interests. So it became a celebration and it went on for years!"

Pellan's recollection of these years is somewhat confused. What persists above all in his memory is the sensation of timeless enchantment. So many things happened at once that it is difficult for him today to specify facts and pinpoint dates. It was a time when the present was perpetual; everything was born again each day. "Life was full of the unexpected. Events ran into one another without it being possible to anticipate them. It was like a whirlwind, a big whirlwind. The quality of life in all its facets reached great heights."

Pellan recalls the fabric of extraordinary camaraderie woven with acquaintances made the previous day. "We met everywhere in the cafés, at the Rotonde, at the Coupole, and then we got together again at the home of someone's friend late at night. The discussions, the celebrations, were unending." One simply had to go out in the afternoon and join with the throngs strolling the sidewalks for the evening's program to develop. A meeting, an invitation, a stop at the nearest *bistro* and the ball of the night before was on again. Still, applied and dedicated work in the studio punctuated the revelry.

Little money was needed to buy a great meal and no one deprived himself. Rents were so cheap that artists moved at will. If a friend suddenly was short of money, he was offered a corner of a room, of the studio, before he could even ask. Hand-carts travelled the streets of Montparnasse constantly, loaded with paintings, sculpture, boxes of drawings. Pellan himself moved about fifteen times during his fourteen years in Paris and opened his home many a night to a transient friend in his successive studios on the passage Dantzig, rue de Vanves, rue de Grenelle, or again that in the area of *La vache noire* in suburban Paris.

The source of most of the meetings and friendships was art – art which permeated the streets, which hit you like a whip as soon as you wandered into certain *arrondissements*,

Fruits au compotier
circa/ vers 1934
31 1/2 × 47
oil on canvas/ huile sur toile
M. et Mme. Paul LaRoque, Montréal

Jeune fille au col blanc
circa/ vers 1934
36 1/4 × 28 3/4
oil on canvas/ huile sur toile
Musée du Québec, Québec

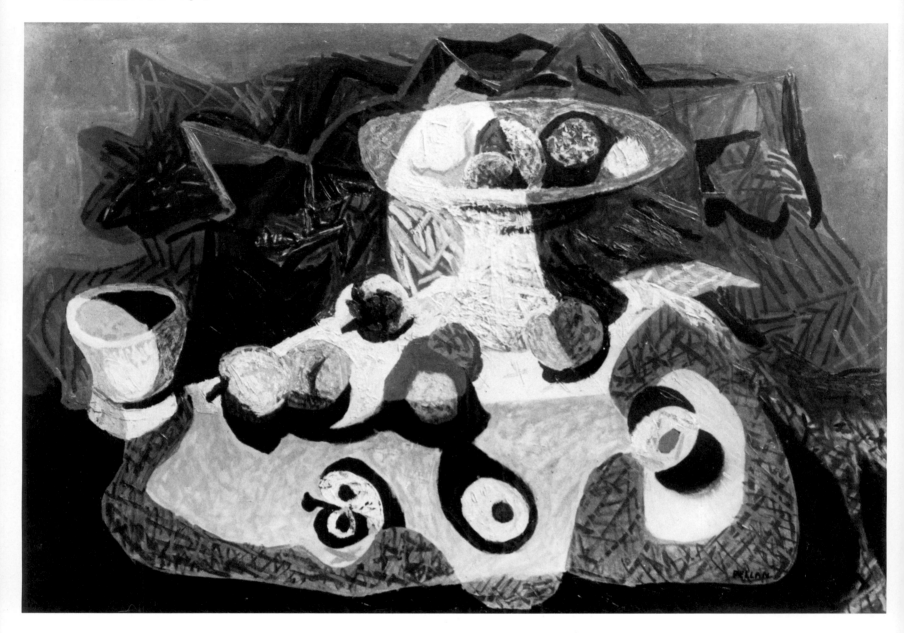

as you entered a gallery or simply admired a window display. Pellan surveyed the streets of Paris in every sense. Whenever he had a free moment, he would leave for the field, returning exhausted at the end of the day after having visually devoured Bonnards, Picassos, Braques, Utrillos, Dufys, Matisses until he was sick with envy. "It was absolutely marvellous. You could see everything in the galleries; the collectors hadn't come yet to carry things away. This was my real school. I wanted to see everything, to digest everything. There was nothing more beautiful or formidable. I moved from enchantment to enchantment!"

A number of great exhibitions marked a date in Pellan's stay in Paris. In 1932, he gorged on drawings and paintings by Picasso during an exhibition of the master's work at the Galerie Georges Petit. Then, in 1936, he had an opportunity to study the work of Bonnard and Vuillard at the gallery of Paul Rosenberg and to admire their dazzling power as

colourists. In 1937, finally, the incomparable Van Gogh retrospective was staged. "I went to the Van Gogh exhibition early in the morning on opening day. The choice of the works was remarkable. An incredible number of outstanding paintings had been assembled and I moved from one to the other as though in a trance. I couldn't stop and I finally found myself outside, dumbfounded. I had to go back in the afternoon to assimilate it all."

At the universal exhibition of Paris in 1937, Pellan was particularly impressed with the Spanish pavilion where Picasso had hung his celebrated and moving *Guernica.* Also on view was a large mural by the surrealist Juan Miro.

The stars of the School of Paris even at this stage were enjoying a solid reputation; the admiration of the young painters, it is clear, was accompanied by profound respect. The older artists were greeted from afar when they were spotted at the sidewalk cafés. A few words were exchanged

Instruments de musique
1933
52 × 77
oil on canvas/ huile sur toile
The Wellesley College Museum,
Wellesley, Mass.

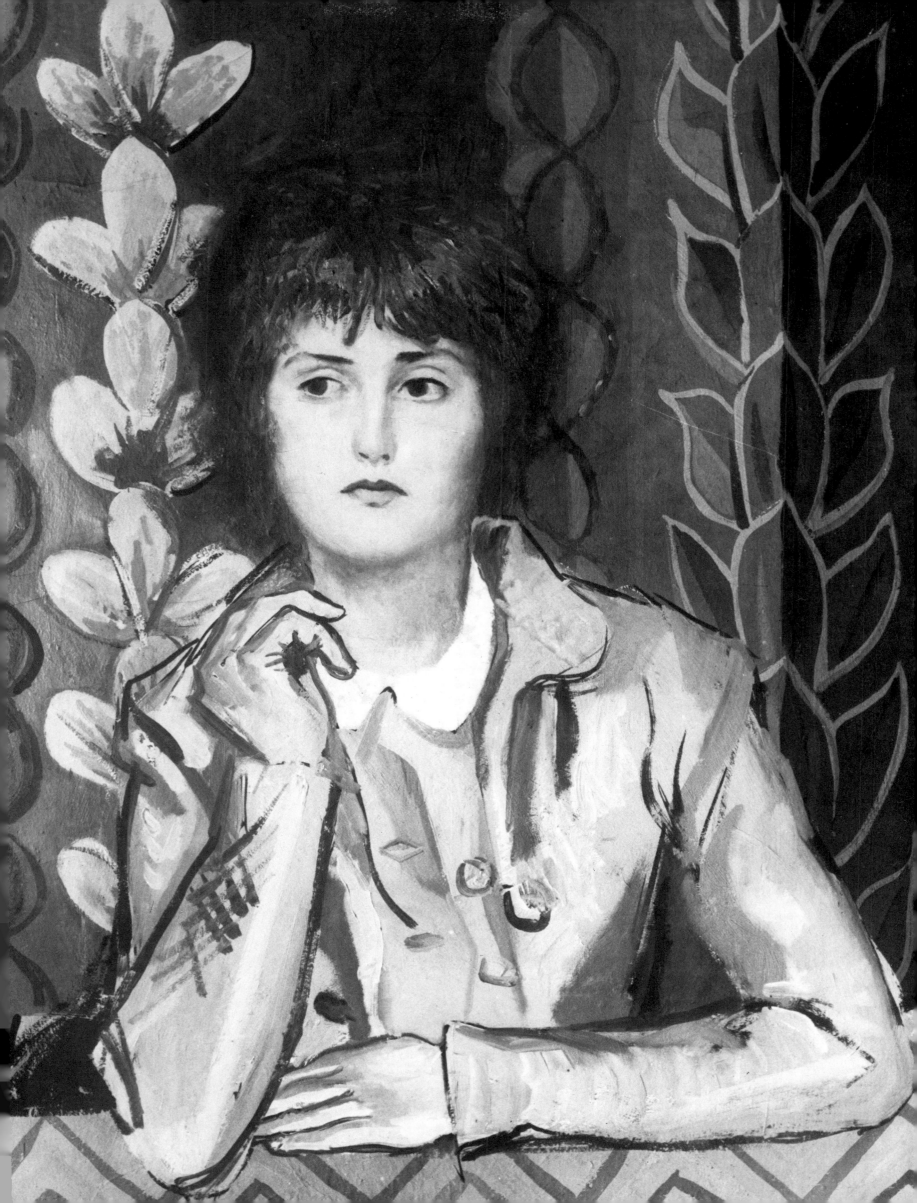

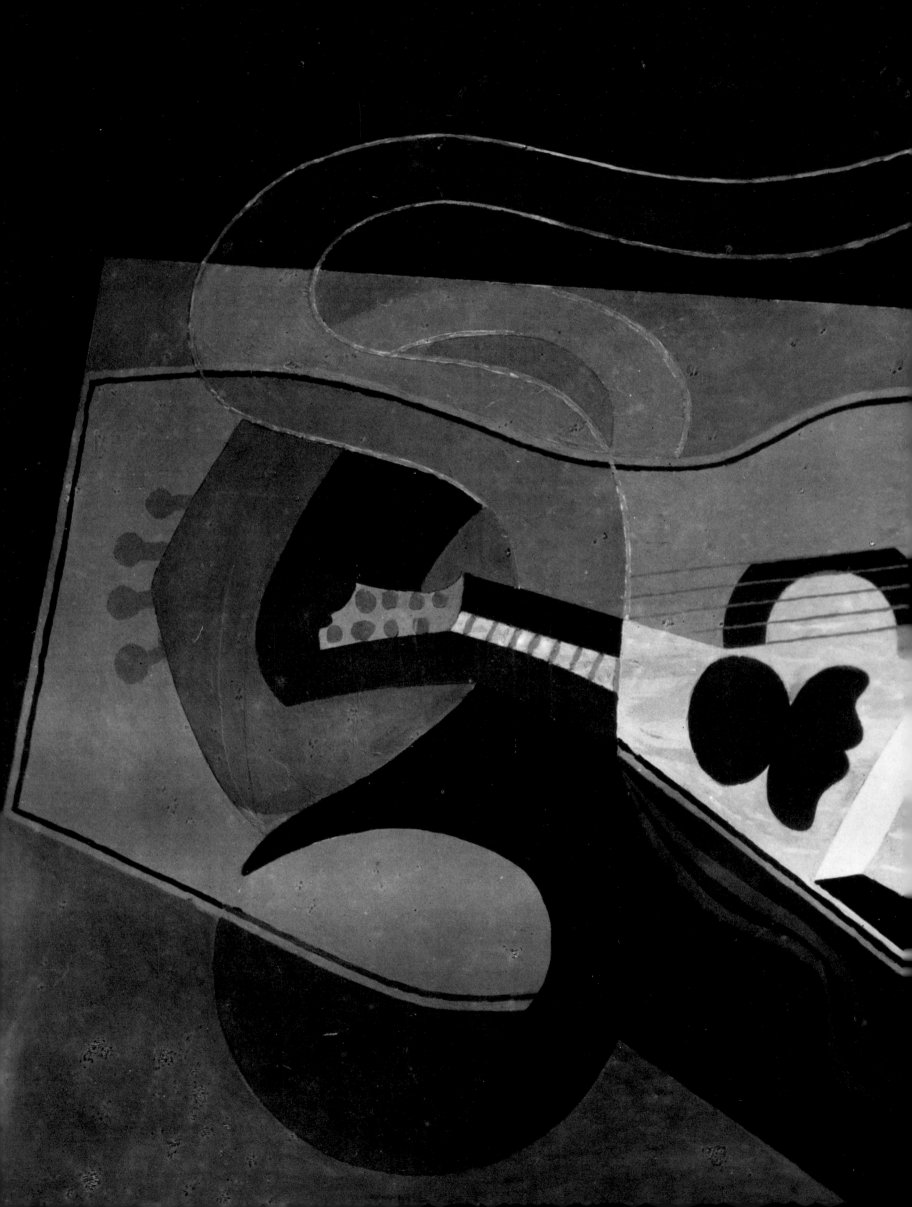

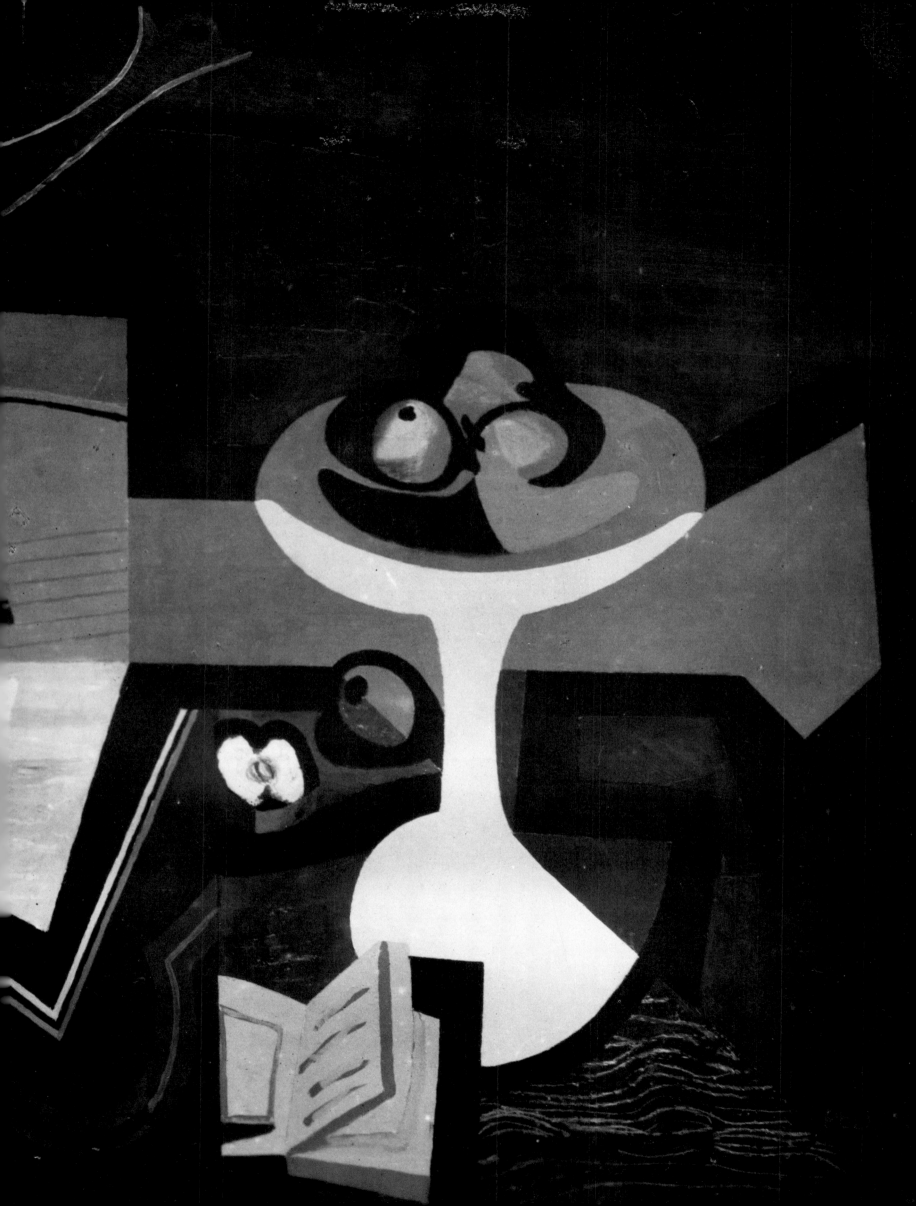

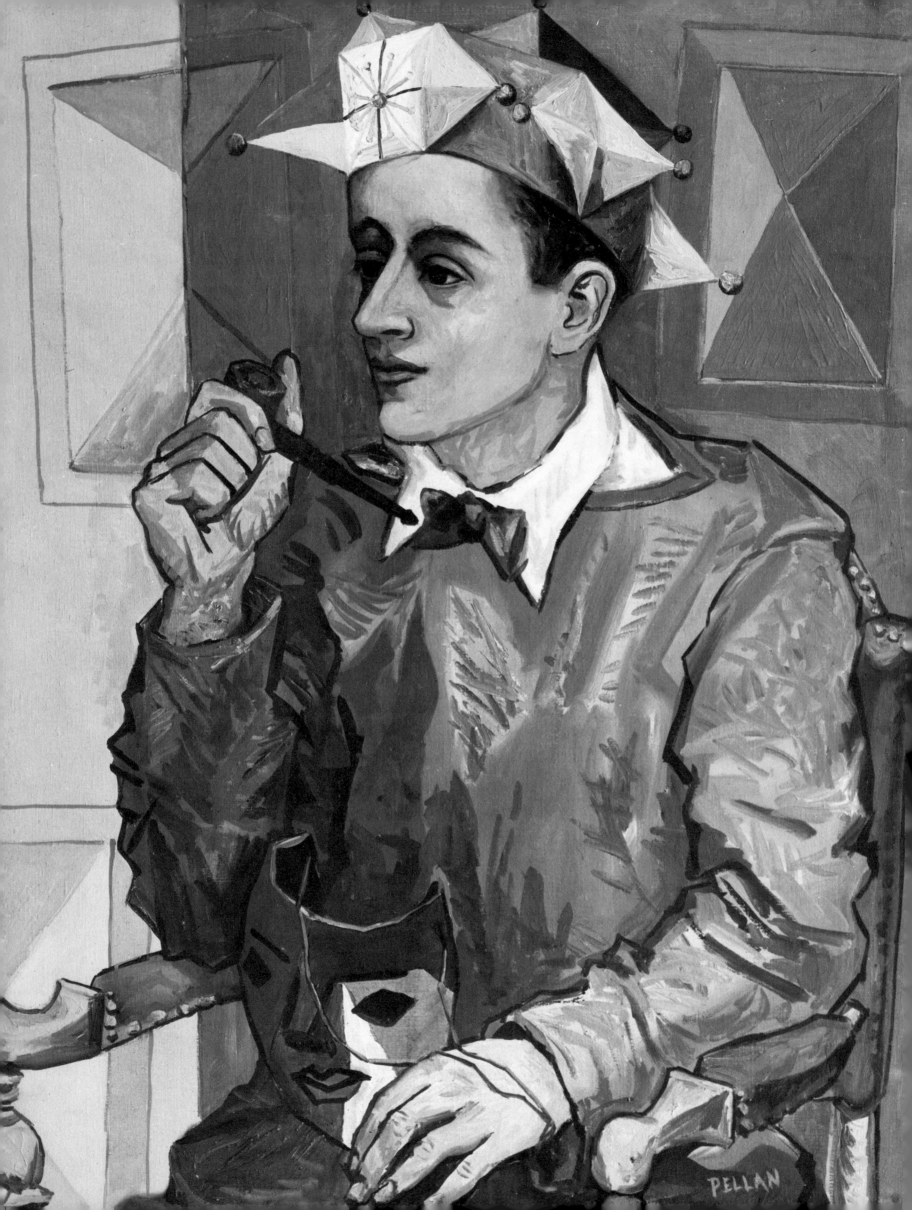

Jeune comédien
circa/ vers 1937
39 1/4 × 31 3/4
oil on canvas/ huile sur toile
National Gallery of Canada/
Galerie nationale du Canada, Ottawa

if one had the pleasure of being introduced to them. Rarely, however, was the relationship pushed any further, either because of timidity or discretion but particularly because of the artists' inaccessibility. The masters already were completely surrounded.

Nevertheless, Pellan had the opportunity to meet and rub shoulders with a good number of famous artists and to have useful conversations with them. The visit he made one day to Picasso at his home on rue la Boétie should be underlined. "Picasso had inspired great admiration on my part. I was so carried away by his ability to assimilate any plastic form that despite my fear of disturbing him, I decided to knock at his door without even an appointment. He received me very kindly and listened to me with the greatest attention. I had become – it is rather rare for me – a real word mill. I told him everything I could see in his works. I tried to express what I felt about the subtleties of his drawing, the fertility of his imagination. He continued to listen sympathetically." In his enthusiasm, however, Pellan forgot to request permission to see the works in Picasso's studio. It was only during a second visit to Picasso several years later at his home on the Quai des Grands Augustins that Pellan was to view the recent works of the master.

As a result of these meetings, Picasso expressed interest in seeing Pellan's paintings. Pellan, however, found his work was not good enough yet and preferred to wait until he had something more substantial, more solid, to show. His excessive modesty in delaying the visit meant it would never take place.

While enjoying these stimulating meetings and the pleasing visits to the galleries without, however, depriving himself of the long evening walks and the interesting discussions at the sidewalk cafés, Pellan continued to work hard. His lack of enthusiasm for the classes of the Ecole nationale supérieure des Beaux-Arts notwithstanding, he conscientiously attended until his bursary expired. But he did not unduly prolong this experience which, in his way of thinking, was dull and overly restrictive. Free as he was to maintain his usual conduct, he had the feeling he could not work at his own pace within the school's walls. He believed his potential was being somewhat suffocated.

One day, participating in a drawing class in the antique gallery, he was inspired by a monumental sculpture representing the Three Graces. He ran in search of an immense cardboard nearly five feet tall, set it up between two easels and went to work. The drawing progressed, the contours took shape under his steady hand. Pellan was satisfied with the result. Intrigued by his dedicated pace and the enthusiasm he displayed in the work, his classmates left their own easels, moved closer and expressed their admiration. Pellan was pleased. When the teacher appeared, he glanced at the work Pellan had done. His only comment was to

complain about its extravagant size.

When one realizes Pellan's thirst for freedom, his need to explore every possibility of art, it is easy to imagine his exasperation with such a sterile and narrow-minded attitude. From then on, he much preferred to work in the academies of the Grande Chaumière or Colarossi. These were free studios where, for a daily contribution, one could enjoy all the advantages and facilities of the institutions. Pellan went there on days when it was convenient to him, avoiding association with any teacher. "One could work for hours at will in complete silence." Sketches and drawings accumulated in his portfolio. Obviously, many pages disappeared or were lost as he moved from house to house. When a friend one day asked for an object or piece of wood to raise his bed-spring, Pellan gave him bundles of drawings which were placed at the four corners of the frame. They remained there for months and Pellan completely forgot about them. Eventually, they were lost forever.

Full of spirit and vitality, the young artist seldom stopped to admire the work he had accomplished. Constantly, he sought to improve, to render the many elements of his pictorial language more detailed. He readily did away with things which no longer pleased him.

Happily, however, an appreciable number of works successfully stood up to the severe test of self-criticism and, beginning in 1933, Pellan did not fear to submit his work to the public verdict. He participated that year in a group exhibition at the Galerie Beaux-Arts. The critic Claude Balleroy immediately noted the quality of his work. Following a visit to Pellan's studio, Balleroy's interest heightened and he predicted a brilliant future for Pellan in an article published in the *Revue du Vrai et du Beau:* " . . . even now a number of his paintings, both in terms of their execution and of their original colours, testify to a very real and definite talent in respect to his means, as well as to a manifest personality which, from one work to the next, affirms itself with increasing vigour. . . . Pellan, among the young of his generation, will be one of those referred to most frequently. I fully plan to lay claim at that time to the honour of having pointed this out."

Clearly, there was nothing better than such testimony to drive the young Quebecer on. He was making every effort to keep head above water in the roaring tide of the Paris sea where every talent, every culture and every ambition were colliding.

The following year, Pellan was delighted to have one of his works accepted for the *Salon d'Automne,* an event of national significance. All artists, whatever their discipline, could submit works to the exhibition but a jury of selection had to approve them.

The wheel had begun to turn and henceforth, works by Pellan would regularly appear in the circuit of Parisian exhibitions alongside the achievements of such established

artists as Derain, Dufy, Modigliani, Germaine Richier.

In 1935, he exhibited at the *Salon des Tuileries.* Shows in a variety of galleries followed: the Quatre chemins, Bernheim, the galeries de Paris, l'Equipe, Galerie Billiet Pierre Worms. For three consecutive years – from 1937 to 1939 – he participated in the *Exposition des Surindépendants.* He was enthusiastic about its form: any artist who wanted to participate could present his work. There was no segregation. The public alone judged the value of the works.

The year 1938 brought Pellan a rush of activity. He sent works to no less than seven group exhibitions, three of them abroad: the Galerie SV, Prague; 41 Grosvenor Square, London; and The Hague, in Holland.

In was in 1935, however, that Pellan attracted the attention of the Parisian critics. Though he had never attended the institution, the Académie Ranson opened its small gallery to him for his first solo exhibition. Visitors commented favourably. The opinion of Jacques Lassaigne was to stand out particularly. First published in *Sept* and *Magazine d'aujourd'hui,* it has since been quoted in most biographical sketches dealing with Pellan. The review said in part: " . . . Through his qualities of exuberance and of violence, Pellan, in our view, appears to be one of the most gifted painters of his generation. . . . " Further on, Lassaigne emphasized "the facility with which he assimilates the lessons of great painters as varied as Picasso or Bonnard." He went on: "The still lifes Pellan has just exhibited, abundant and knowledgeable in their order, frank and sober in colour, are the work of such a rich temperament that he can borrow from everyone and owe nothing to anyone." A more flattering tribute would be difficult to find.

The year 1935 also marked the first exhibition of the *Salon de l'Art mural de Paris.* A major competition was held under the honorary chairmanship of Eugénio d'Ors. A jury made up of Robert Delaunay and Ossip Zadkine, among others, awarded first prize to Alfred Pellan for his *Composition abstraite en rouge et noir,* know today as *Instruments de musique.* Pellan was more surprised than anyone when his success became public knowledge. "I was flabbergasted when I learned that I had won the prize because it was an international exhibition and even the great pontiffs of contemporary art, such as Léger and Picasso, *hors concours* naturally, were represented."

Pellan's spectacular triumph echoed as far as Quebec. On July 24th, 1935, the newspaper *l'Evénement* published an article of congratulations under the by-line of Gérard Morriset: "It is in order to warmly congratulate our friend Alfred Pellan. Young, passionate in his work, magnificently gifted, it is true, but also full of faith in his art, he has, through his persevering research, acquired solid ability. His pictorial language is enjoyable and he has been able to attract the attention of Parisian critics and collectors."

Quebec remembered the talented young man even though Pellan had made no special effort to foster his reputation. Only once, less than two years after his departure, had he sent any of his work to the Ecole des Beaux-Arts: a series of drawings which were to form an exhibition. He did nothing else. Regularly, he wrote to his father – he remained very attached to him – to report on his progress. Every two or three years, he returned home for a few weeks. But despite his filial affection, he began to miss Paris after only a few days at home. He was impatient to get back to his brushes and palette and his work. Nor could there be any question of undertaking long negotiations or the minute organizational details required for the preparation of a Quebec exhibition. He could not bring himself to be distracted from his creative work. Home was Paris now. It was in Paris that his career was taking shape. And yet, he nearly returned to Quebec prematurely in 1936, undoubtedly with great regrets.

Pellan's horizons at this stage were unlimited. He worked feverishly, constantly making new progress. He could exhibit his work when he wanted to, and the reviews were more than favourable. A single blemish marred the picture: Pellan found it difficult to support himself. The sale of a number of paintings to Parisian collectors did not suffice to make ends meet – to pay the rent and buy art materials. Pellan, however, refused to be beaten by material problems and managed to obtain a number of commissions for graphic design. For a time, he worked for a poster publisher. He also designed a perfume bottle for Revillon. He even painted, directly onto the fabric, dresses conceived for the celebrated couturier Schiaparelli. "I had a woman friend who designed exclusive dresses for the great houses. At times, she would bring me a dress and I would come up with decorative motifs which I then painted directly onto the dresses with special colours. It was very compelling work and it demanded great technique. One false move, one spatter, and a fine dress was ruined. But it took too much of my time and I had to give it up. Still, I was delighted to learn that Madame Miro had acquired some of my dresses while visiting the Côte d'Azur."

Such occasional income did not meet Pellan's needs and he often had to call upon his father's generosity even though he was reluctant to do so. In any event, that source was far from inexhaustible. Furthermore, Mr. Pelland would have liked to see his son return home. As his 1936 visit to Quebec came closer, the father persuaded him to apply for a teacher's post at the Ecole des Beaux-Arts de Québec. Pellan hesitated; he was not completely convinced. To be on the safe side, he consigned all his baggage and materials in Paris.

Pellan's father arranged an interview with Joseph Simard, then Secretary of the Province. Shortly after the artist's arrival in Quebec, he went to Mr. Simard's office. The authorities' greeting was far less enthusiastic than that of the artist's immediate circle. Proof of competence was

L'heure inhumaine
circa/ vers 1938
oil on canvas/ huile sur toile
51 1/4 × 64
Mr. and Mrs. Jules Loeb, Toronto

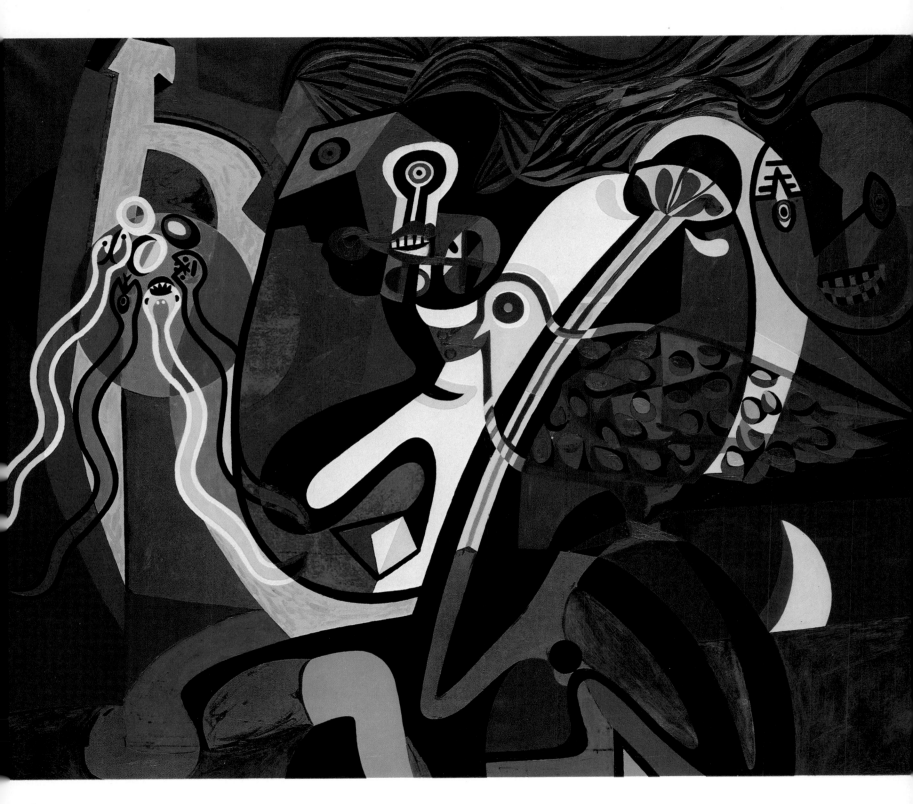

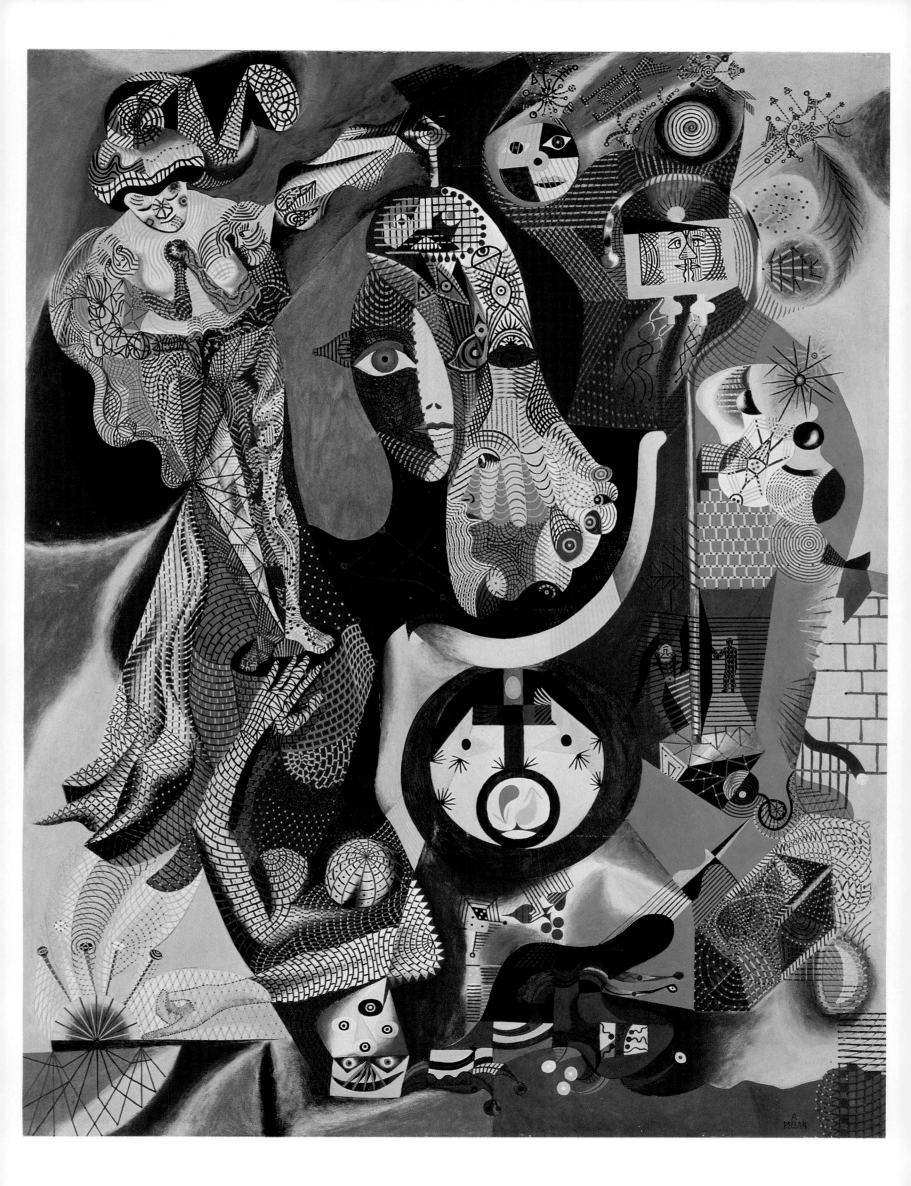

Femme d'une pomme
1946
oil on canvas/ huile sur toile
63 × 51
Art Gallery of Ontario, Toronto
donated by/ don de
Mr. and Mrs. Charles S. Band, 1956

Le sablier
1957
oil on paper/ huile sur papier
11 × 13
Dr. and Mrs. B. Schachter, Toronto

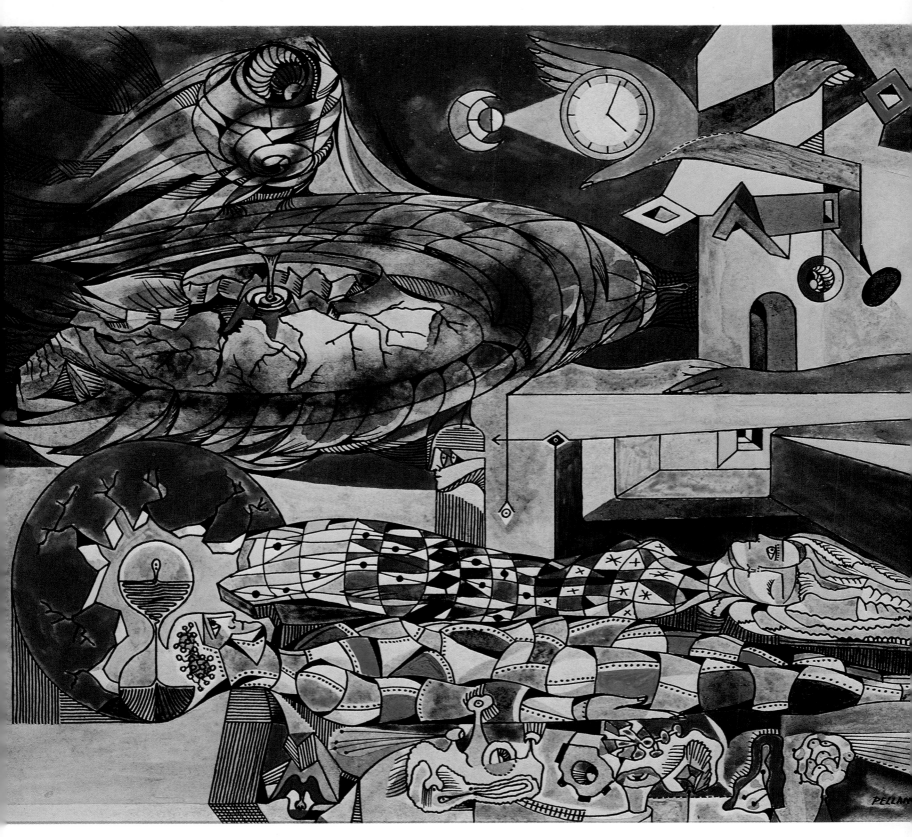

31

Symphonie
1944
oil on canvas/ huile sur toile
51 × 63
Collection Maurice et Andrée Corbeil,
Montréal

Sur la plage
1945
oil on canvas/ huile sur toile
82 × 66
National Gallery of Canada/
Galerie nationale du Canada, Ottawa

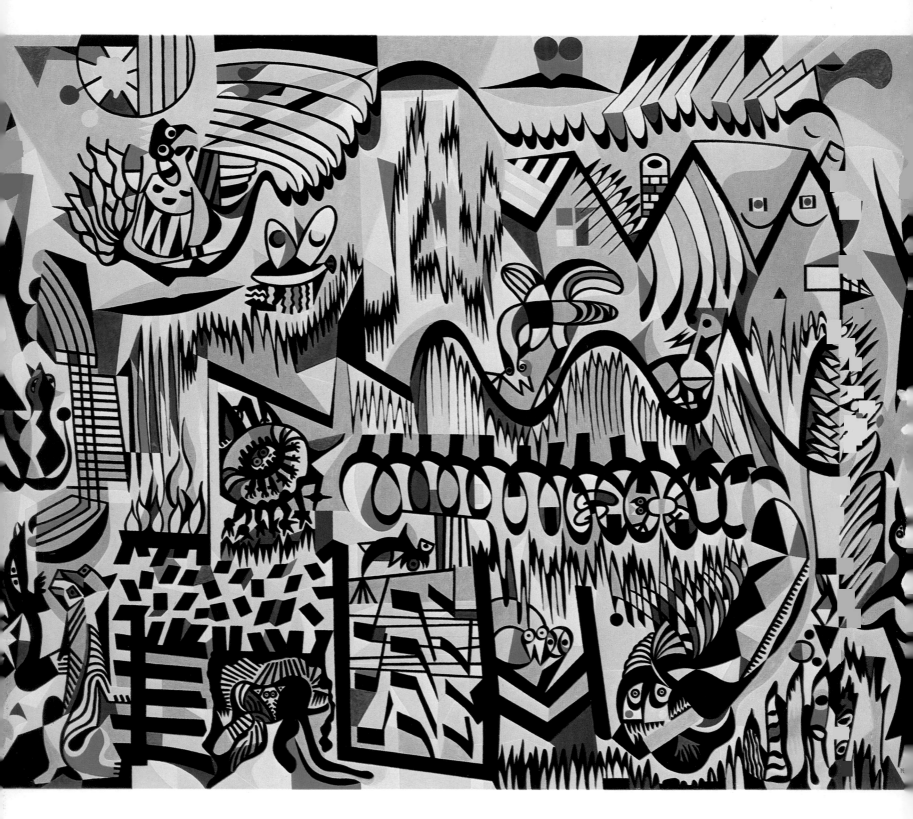

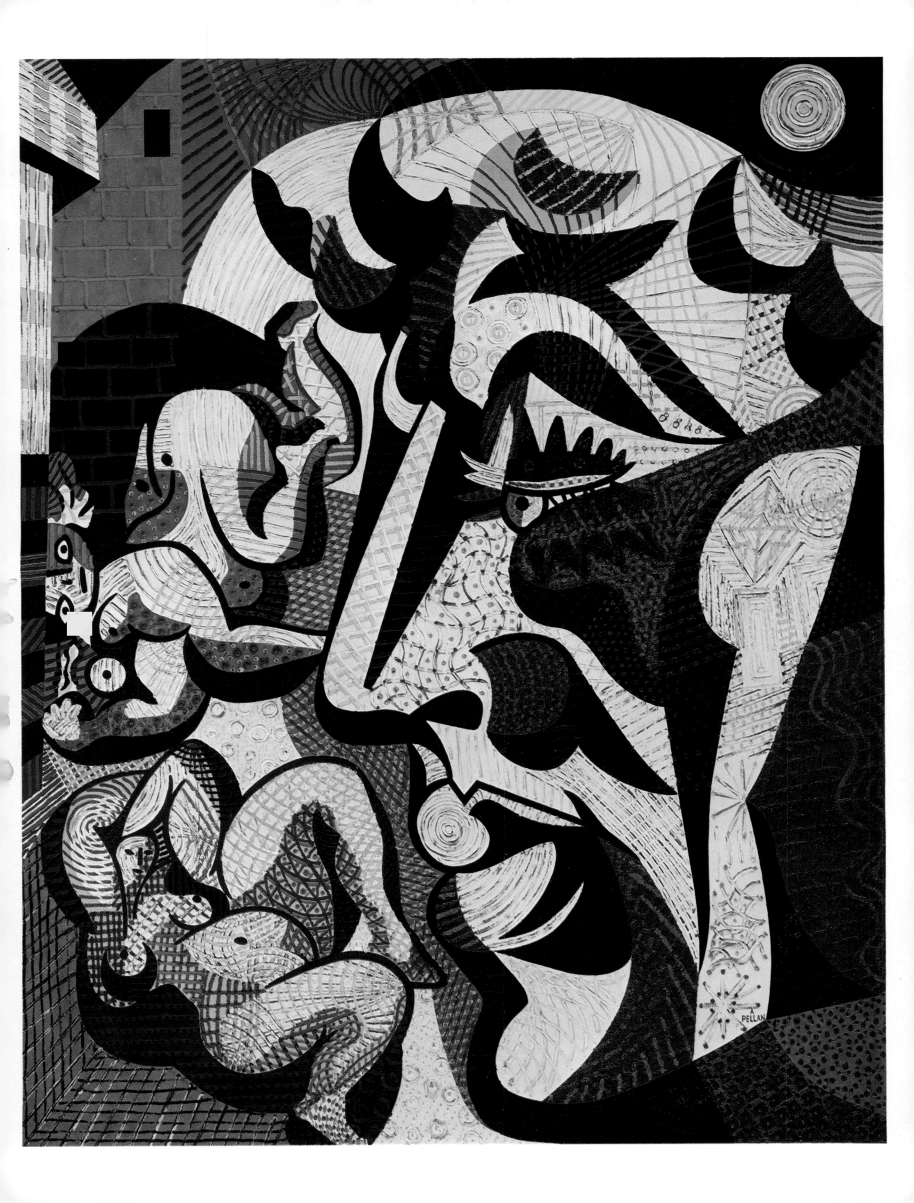

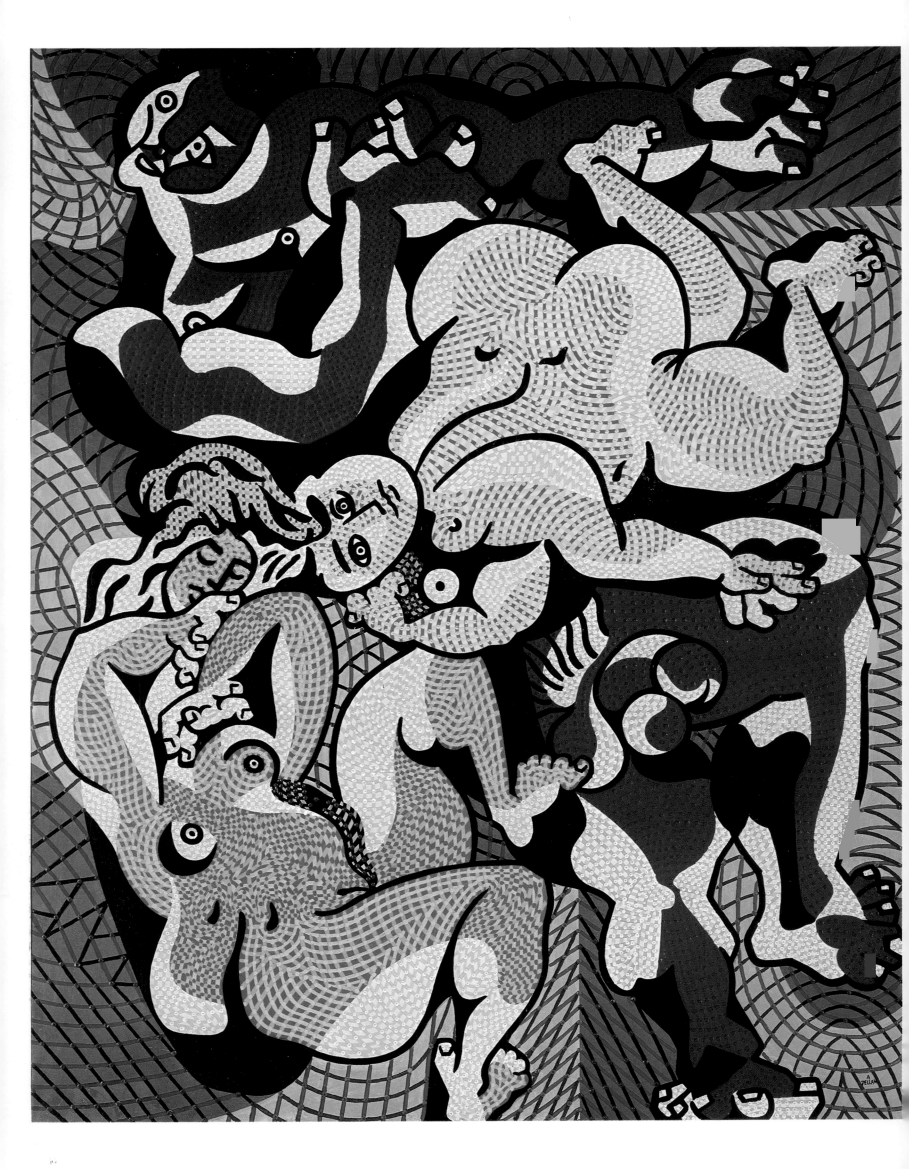

Trois personnes
1946
oil on canvas/ huile sur toile
82 × 66
Private collection/
collection particulière, Montréal

La maison hantée
1958
oil on paper/ huile sur papier
11 3/8 × 18
Private collection/
collection particulière, Montréal

Au soleil bleu
1946
oil on canvas/ huile sur toile
82 × 66
Private collection/
collection particulière, Montréal

Calme obscur
1946
oil, silica, cinder on canvas/
huile, silice, mâchefer sur toile
82 × 66
Private collection/
collection particulière, Montréal

Hommage à Ruggieri
1960
oil, silica on plywood/
huile, silice sur contreplaqué
14 1/2 × 22 5/8
Mr. and Mrs. J. Wildridge, Toronto

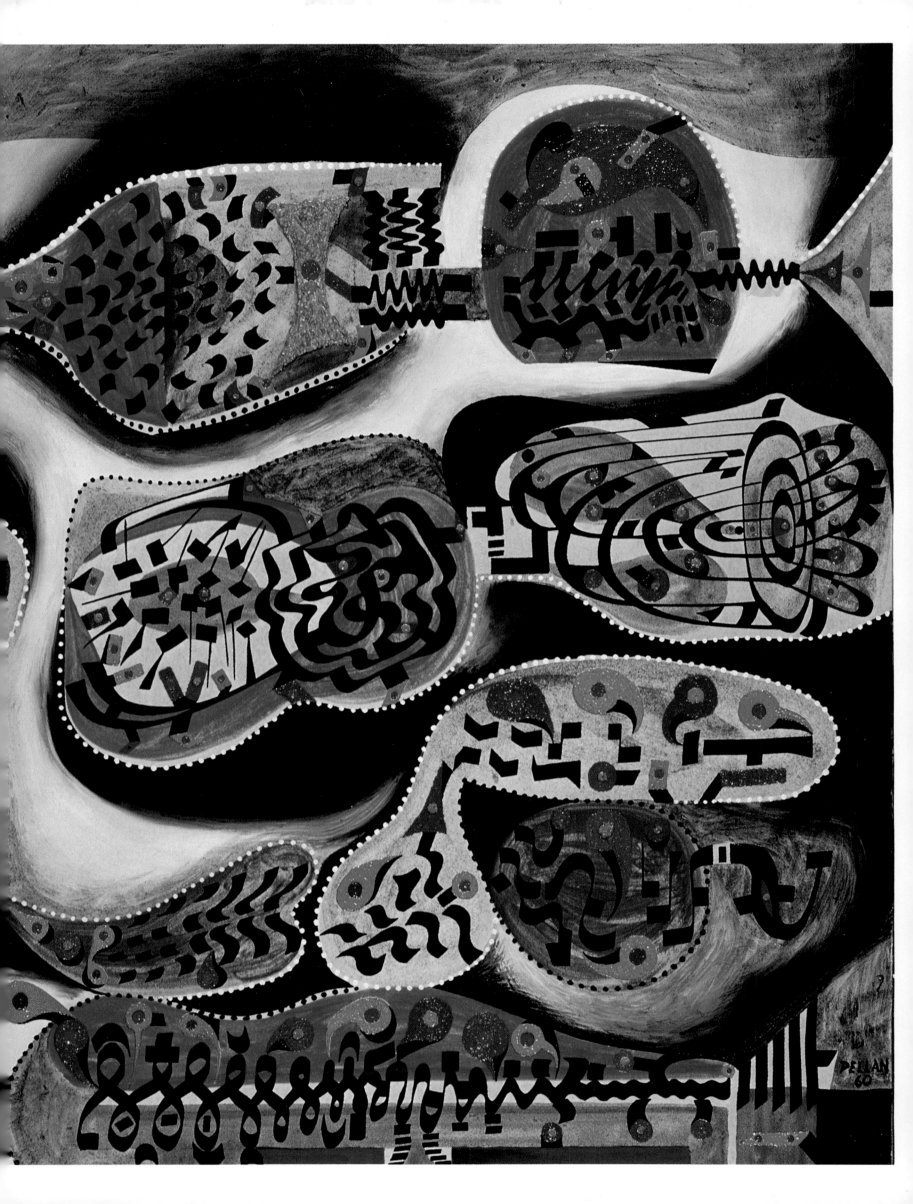

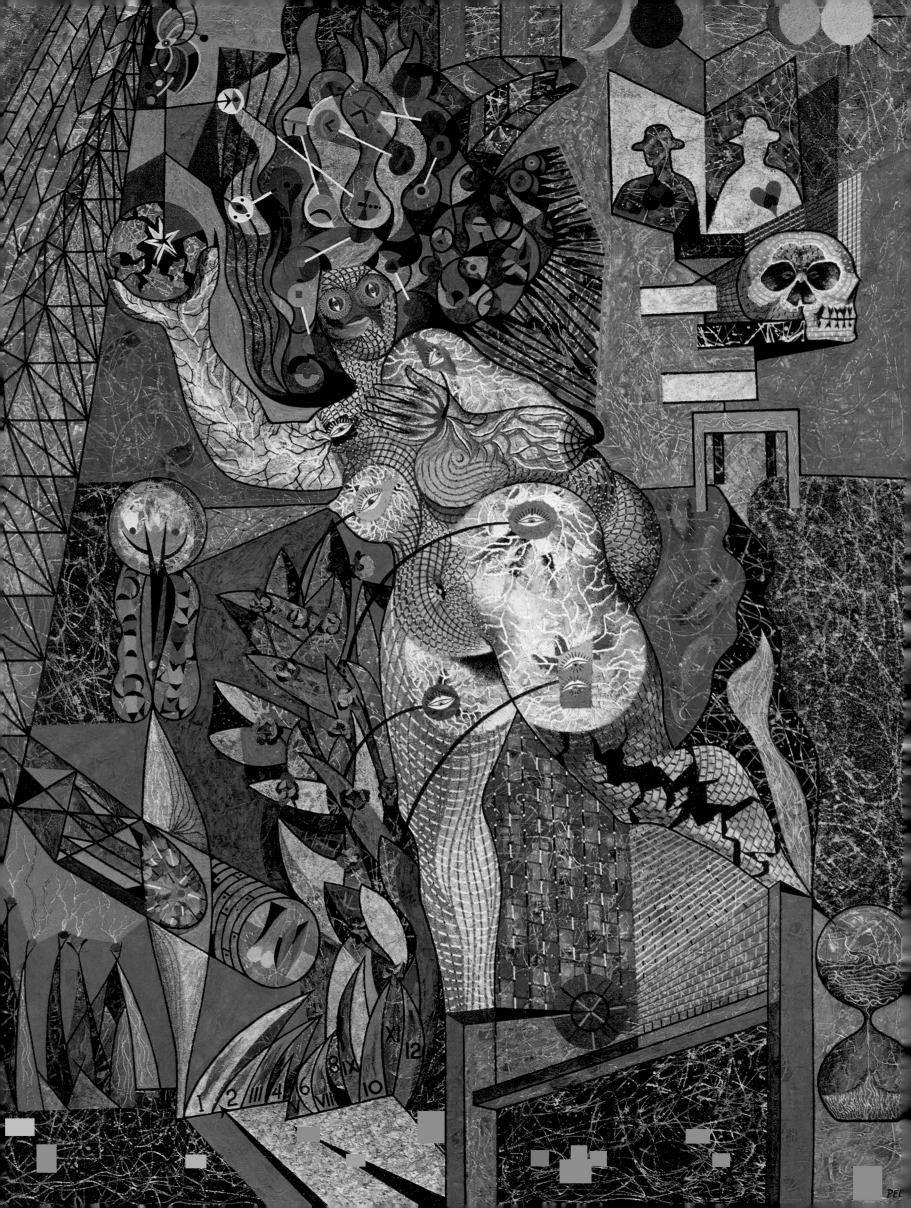

La chouette
1954
oil on canvas/ huile sur toile
82 × 66
Musée national d'Art moderne, Paris

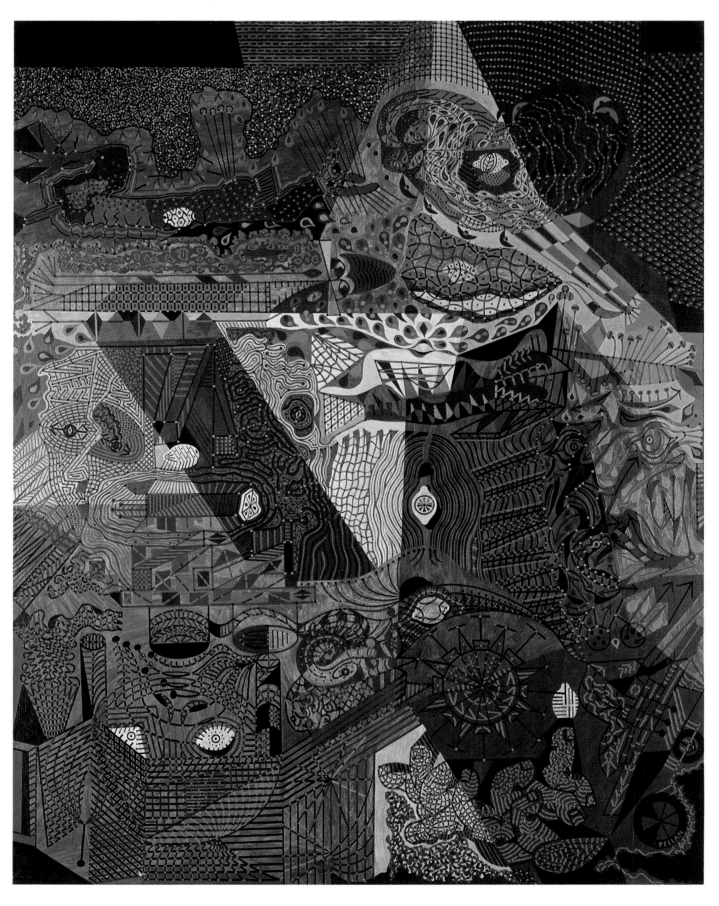

Citrons ultra-violets
1947
oil on canvas/ huile sur toile
82 × 66
Musée du Québec, Québec

La brise
1957
oil on paper/ huile sur papier
12 3/4 × 9 3/4
Mr. and Mrs. Peter Duffield, Toronto

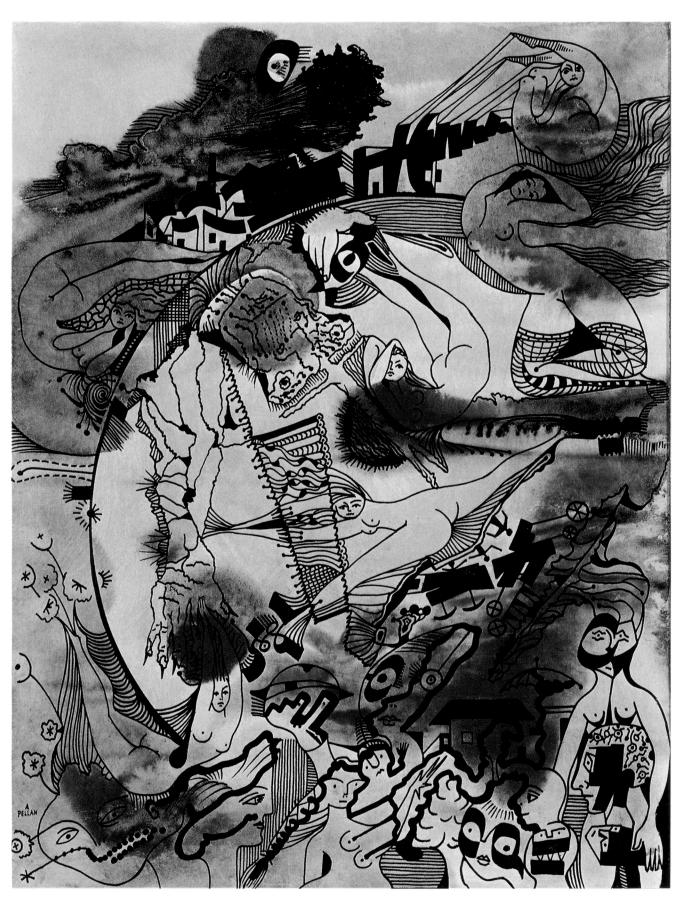

L'amour fou
1945
oil on canvas/ huile sur toile
45 1/2 × 32
M. Pierre Roy, Montréal

Les voltigeuses
1959
oil on cardboard/ huile sur carton
14 1/2 × 22 5/8
Réjane et Champlain Charest, Montréal

Le couteau à pain
1942
36 × 25
oil on canvas/ huile sur toile
Private collection/
collection particulière, Montréal

Nature morte aux deux couteaux
1942
39 3/4 × 30
oil on canvas/ huile sur toile
Private collection/
collection particulière, Montréal

demanded; the name, the successes Pellan had achieved in Paris were not enough. They wanted to see his work. Pellan agreed to do a few paintings and sculptures so that the jury charged with selecting teachers could judge the quality of his work. Official taste in Quebec, however, had not greatly evolved in the last ten years. For the judges of 1936, the brilliant student of 1926 had gone sour. He had ruined his talent and he could not be allowed to disturb the climate of the school or to pollute its young students. "The jury decided I was too 'modern.' And yet, the members of the jury included Clarence Gagnon and Horatio Walker who in 1926 had been among those responsible for awarding the bursary to me."

It was clear that Pellan could not hope for the support of these two men who had expressed a fierce hostility towards any form of avant-garde art. In an article in the form of a conversation with his friends Eloi de Grandmont and Robert Lapalme, Charles Hamel reported an anecdote to the effect that the two masters of Quebec art had participated a few years before in an international painting competition in a major American city and had been outclassed by Braque and Matisse. Since then, the story went, they no longer could stand to even hear the names of these artists without becoming furious.

Mr. Simard summoned Pellan and questioned him about his tastes in painting. Pellan suspected what the jury's verdict would be but he resolved to see the matter through to the end: he expressed admiration for Picasso, Matisse, Braque, Juan Gris, Miro, Klee and Léger. He was told offhandedly that with ideas like that, he could not be a teacher.

Pellan returned to his father's home and told of the setback. Immediately, the father supplied him with a return ticket to Paris. The enfant terrible of Quebec painting was walking on air. He returned to Paris, taking with him the paintings he had done for the jury. A few weeks later, they were exhibited with other of his works at the Galerie Au Carrefour.

The false alarm in Quebec a thing of the past, Pellan took up his work again and rediscovered a public which admired both his abstract and sober portraits and his solidly conceived still lifes vibrating with colour. Soon after his exhibition, he received the unexpected visit of two highly important persons. They were Huysman, then Minister of Fine Arts, and Rey, curator of the Musée de Fontainebleau. "They turned up one day without notice. It wouldn't have taken much for the trip to prove pointless and for me to have missed my chance. I was getting ready again to take part in one of those memorable outings with hand-carts through the streets of the quarter. A friend was moving that very day. I received the two visitors in shirt-sleeves. I hadn't had time to get the studio or my thoughts in order. I was somewhat taken aback with surprise."

Among the paintings Pellan showed them, they chose for the Musée du Jeu de Paume the very still life that the judges of the Ecole des Beaux-Arts had rejected with disdain and it now hangs in the Musée national d'Art moderne in Paris. The distinguished visitors lingered in the crowded studio, visibly interested in the works Pellan had hurriedly assembled everywhere. By the time they left, they had acquired a second painting for the Musée de Grenoble. Thus did Pellan, barely thirty-one years old, enter museum collections. For his first contact with the official art world, it was certainly noteworthy.

Pellan rediscovered the joyous existence of the Quartier Latin with great pleasure. On his return to Paris, his friends had prepared a welcome for him which was nothing if not memorable. He thus resumed his Parisian career with renewed energy.

But he believed he deserved a little rest and decided to travel to Greece. People had been telling him of its charms for a long time. He had not often gone beyond France's borders since moving there. Once in 1935, he went to Florence on his motorcycle, accompanied by the actor Alain Cuny. Mostly he took long trips on the motorcycle he loved in the French countryside, visiting the Loire valley, Brittany and Normandy.

There was no way he could take his motorcycle to Greece. It was simply too far. Besides, there were to be three of them. Pellan's companions were two young architects attached to Le Corbusier's studio.

The trip to Greece proved enchanting: the luminosity of the sky, the savage beauty of the steep cliffs plunging into the sea, the arid soil burned by the sun and, of course, the ancient, majestic architecture. Pellan was moved, enraptured. The visions marked him profoundly. He would especially recall the small island, Santorin, where the three companions stayed nearly three weeks. Indeed, years later, he was to create a small, mysterious painting based on it.

In Paris again, the creative experiences resumed, as did the exhibitions. A number of works created during the period show a clear break in respect to subject, a concern for purification, a simplification of forms bordering on the abstract while suggesting a still tentative tendency towards the enigmatic exploration of surrealism. Surely, such work would have been decried with growing indignation by the Quebec censors. Indeed even some years later, they shocked the sensibilities of many a Montreal and Quebec collector. Once again, however, the critics were enthusiastic. A Dutch journalist, H.W. Sendberg, wrote early in May, 1937, following the exhibition in The Hague: "Pellan by nature is free, strong beyond anything one can say, original, a painter above all. In his fantastic compositions, the colour sparkles and confronts you. He is a modern painter and one realizes immediately that he knows how to paint. The enigma of his composition is in no way an

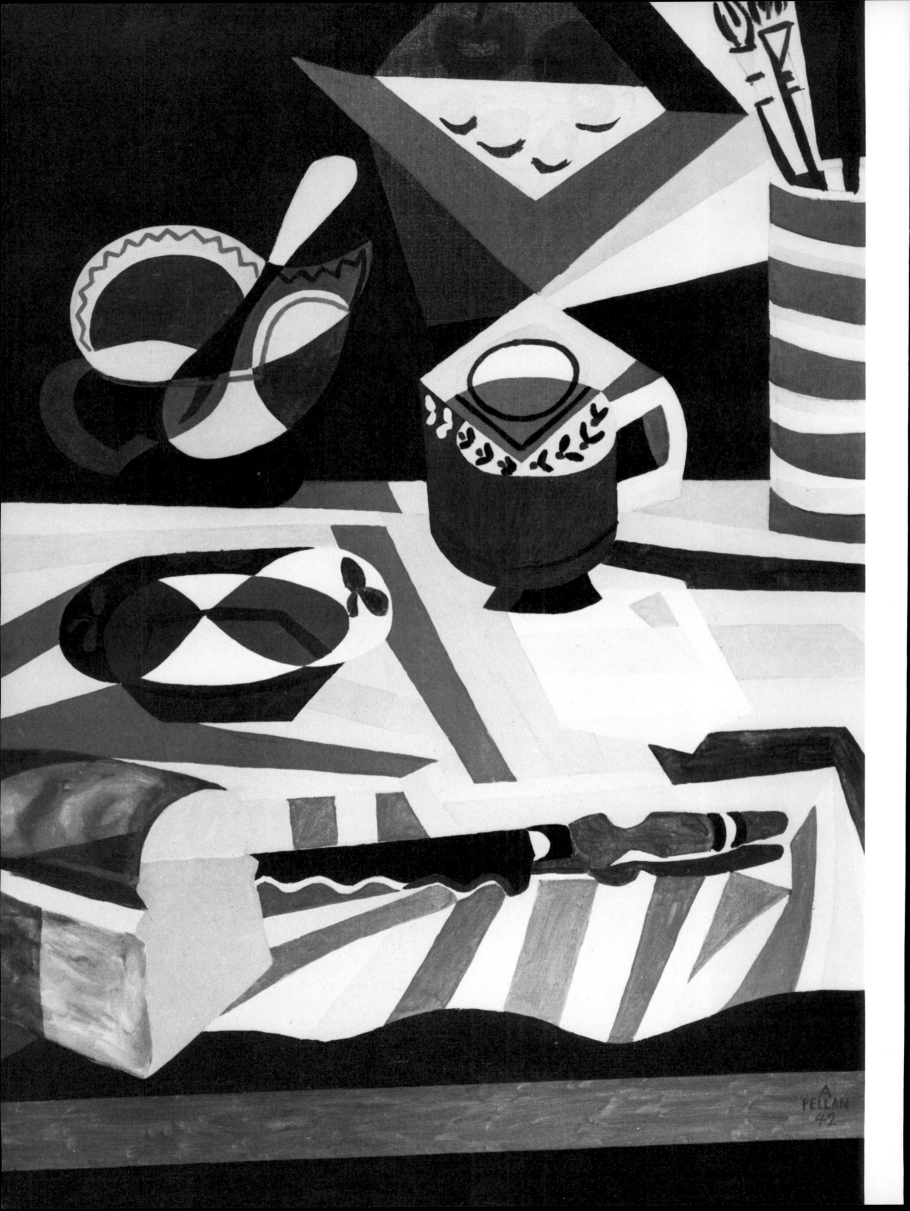

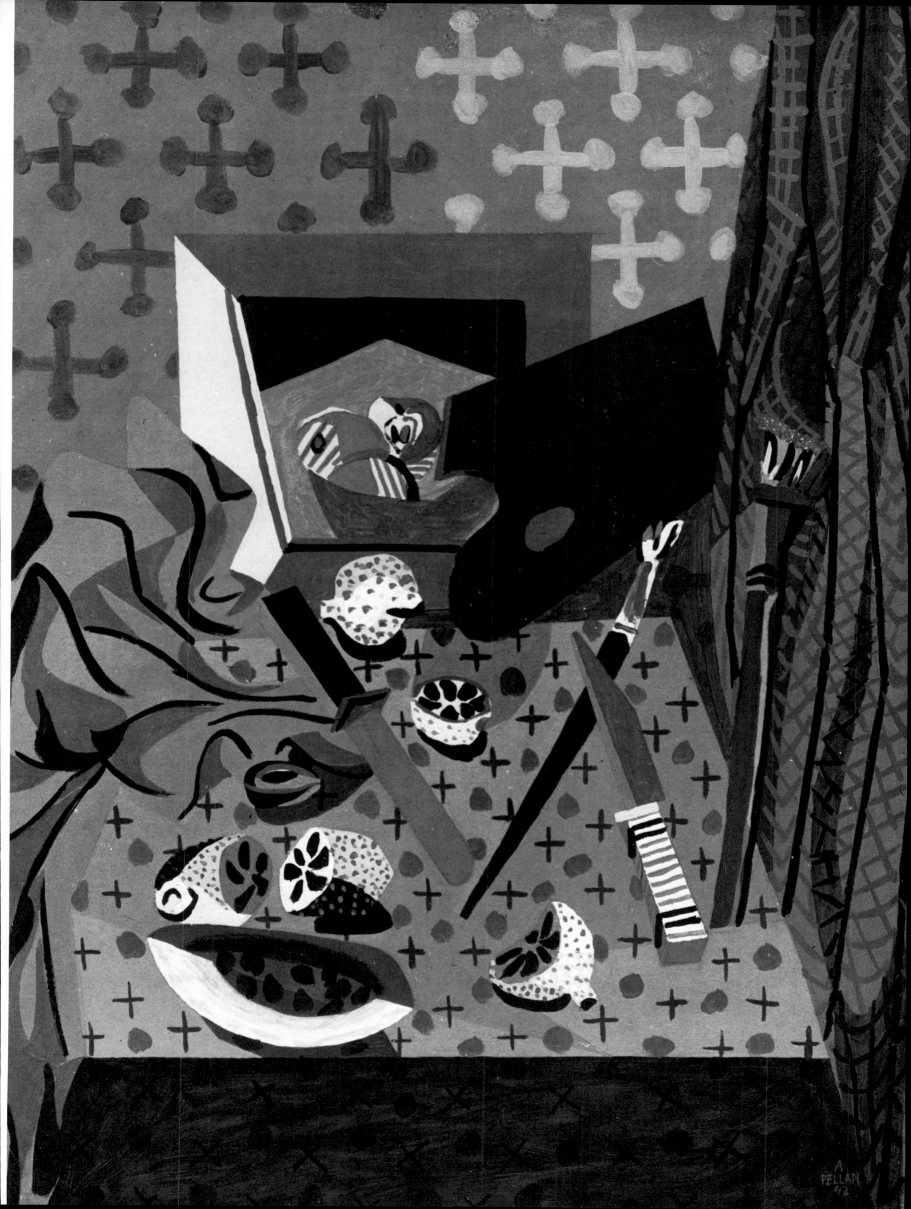

Sous-terre
1938
oil on canvas/ huile sur toile
13 × 21 3/4
Musée d'Art contemporain, Montréal

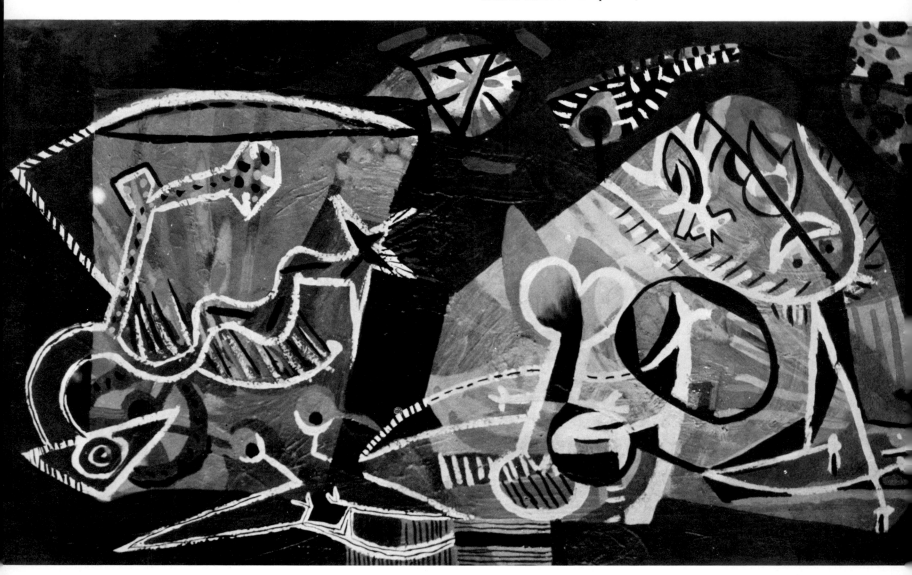

obstacle to a clear understanding of the beauty presented.''

Many other articles in the same vein celebrated Pellan's rise. They appeared in dailies as well as in periodicals – *Mercure de France, Miroir du Monde, Revue Hebdomadaire, Comoedia, Sept, Sud Magazine,* of Marseille, *Avonblad,* a Dutch publication . . . the list could go on.

Pellan truly was on his way, recognized among the most important painters of the French School. Alongside Derain, Dufy, Dali, Fautrier and Picasso, he took part in an exhibition called *Paris Painters of Today,* presented at the Museum of Modern Art, Washington, in 1939. The choice of one of his works by a jury of international calibre, knowledgeable in respect to developments in the capital of the arts, revealed the maturity which Pellan's art had achieved.

Some months later, in fact, he won the honour of being named *peintre de la galerie* at Jeanne Bucher, one of the most highly rated galleries in the whole of Paris. Who among the thousands of young artists who frequented the studios of Montparnasse and Saint-Germain-des-Prés did not dream of one day being part of a gallery which showed the work of Braque, Ernst, Kandinsky, Léger, Lurçat, Marcoussis, Picasso, Arp, Giacometti and Lipchitz? Who did not dream about the possibility of a one-man exhibition of his work? Pellan had achieved both and even now was given to understand that a great exhibition could soon follow at Maratier, at the Galerie de Beaune. Certainly, his father did not regret his generosity of 1936. On the contrary, he was pleased to have understood that the artistic climate of Paris was more suitable to his son's talent.

But the three years drawing to an end were to prove a short respite in Pellan's Parisian career. The year was 1940 and the war was coming dangerously close to France's borders. Foreigners as well as many French painters, poets and musicians resigned themselves to the idea of leaving the capital of arts and letters shortly to escape the menace. Pellan held on. He continued to hope that the advance of German troops could be halted. He could not bring himself to flee the place where he had enjoyed such intoxicating freedom. Ultimately, he would have to be reasonable. His soul in mourning, he agreed to gather together his work

48

Homme-rugby
1937
oil on canvas/ huile sur toile
21 1/4 × 25 1/4
Private foundation/
fondation privée, Montréal

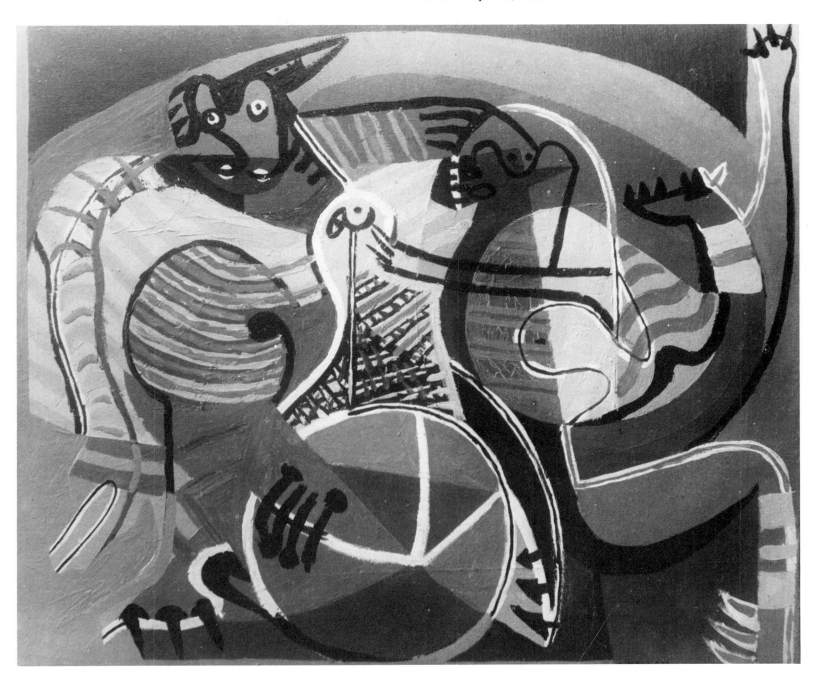

and personal effects and shipped them home as the first bombs lashed Paris. The Canadian legation, then led by Jean Bruchési, facilitated his repatriation. On May 16th, 1940, he was en route for Quebec.

Pellan's return to his native land at the beginning of June, 1940, came at a decisive moment in the cultural emancipation of Quebec and even of Canada as a whole. During the years which were to follow, the foundations of a crushing and sclerosed culture maintained too long by laziness crumbled as plastic expression was liberated. Narrow-mindedness, too, was rejected. Pellan was in the front rank of the shock troops who tore down the barricades of coagulated academism to proclaim the republic of arts and

letters. No other option was possible, it is obvious, for the energetic painter who for nearly fifteen years had experienced the atmosphere of absolute creative freedom in the artistic milieu of Paris.

Pellan was not the first Quebec artist to have spent time training in the French capital. Many others had had the same experience before him and benefitted from it. Maurice Cullen, Suzor-Côté, Marc-Aurèle Fortin and Clarence Gagnon, among others, had carried out not long before enriching exploration into European art, reaching out for new horizons. Some of them were influenced by, or assimilated, lessons from the Impressionists. They did not, however, capture the inventive spirit which guided the

49

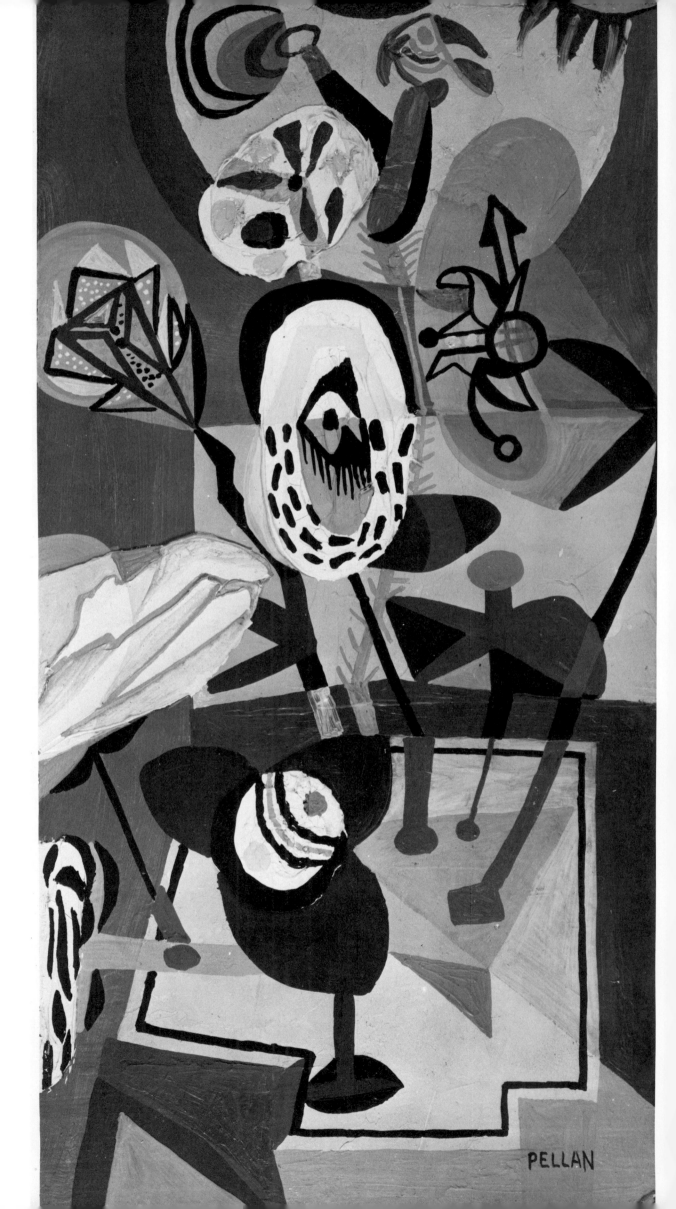

Fleurs
circa/ vers 1938
oil on canvas/ huile sur toile
15 × 7 1/4
Private collection/
collection particulière

50

efforts of the innovators and which constantly pressed them forward towards new boldness. Though they were able to promote a timid progression in pictorial research on their return home, they did not give rise to a lasting movement nor prevent a return to "the eternally redundant picturesqueness of small Canadian houses under great oaks in which one was pleased to live and die. . . . "

James Wilson Morrice – Pellan recognizes him as an authentically creative painter – had, upon coming into contact with the French schools, become deeply involved in the adventure of art by adopting its vital mainstream. An inveterate bohemian, he had never shown the slightest interest in shaping the Quebec milieu where, in reality, he spent little time. Morrice had opted in favour of France, Italy and North Africa, seeking above all sun and warmth.

The more recent experience of John Lyman had achieved happier results in the sense that he was one of the first Quebec painters to attract the fire of critics comfortably settled in their dusty mediocrity. During a long stay in France, Lyman had become the close friend of Matisse; he worked with him regularly, sharing the same aesthetic ideas, rendered concrete through the use of pure colour and a new concept of form. It was the paintings he sent to the *Spring Exhibition* of the Art Association of Montreal in 1913 which raised a storm of protest from the art censors.

He was not disturbed. On his return to Canada in 1931, determined to free Canadian art from the rut in which it found itself, he founded, with André Bieler, the *Atelier.* He invited artists of all ages to work there with complete freedom of imagination and execution. In 1936, he began to publish articles in *The Montrealer* underlining the urgency of artistic renewal. Within a year, a group of English-speaking artists had joined him to support his activity: Prudence Heward, Fritz Brandtner, Goodridge Roberts, Marian Scott, Jack Humphreys were among them and two years later participated in the establishment of the Society of Contemporary Artists. Paul-Emile Borduas also joined.

The first major event organized by the group was an exhibition presented in Montreal in May, 1939, entitled *Art in Our Day.* Among the artists represented were Derain, Dufy, Kandinsky, Marc, Kisling, Lhote, Modigliani, Pascin, Rivera, Utrillo, Vlaminck, Zadkine and Matthew Smith. Contemporary art in all its diversity and the novelty of its recent trends appeared on the Montreal scene with great *éclat.*

Pellan, on his return, was not the first to threaten the shaky foundations of Quebec art. He has never claimed this. Nor has he sought to claim the glory of being the first Canadian artist to have introduced abstract art to Canada. Painters from English Canada, such as Bertram Brooker, L.L. Fitzgerald, Fritz Brandtner, Lawren Harris, James W.G. Macdonald, most of them influenced by Kandinsky's theo-

ries, became interested in abstract art while Pellan was still in France. Such attempts, however, remained virtually unknown in Quebec and had not yet succeeded, any more than Lyman's repeated efforts, in seriously challenging the peaceful indolence of the Quebec public. Like an electrical charge of one hundred thousand volts, Pellan in 1940 provoked a shock which is still remembered – an uproar which echoed for a long time amid the columns of the ancient temple of Quebec culture. He can legitimately claim to have been more effective than the stars of French art represented in the 1939 exhibition in shaking the chronic apathy of the milieu.

Pellan brought back from Paris more than four hundred paintings and drawings. After lengthy reflection, he selected 161 of them for the masterly exhibition he presented at the Musée de la Province de Québec immediately upon his arrival.

"When I walked into the galleries of the Musée, I found them gloomy and crowded. Paintings were stacked up everywhere. I told them that they would have to clear several galleries, that I needed space. Then it became even more discouraging. The walls were covered with wine-red fabric and wherever pictures had hung before, dark spots appeared. It was terrible. When the hanging was completed, the show nevertheless held together. It was a good exhibition."

In the fall, it was presented at the Art Association of Montreal but due to lack of space, the number of works had to be reduced appreciably.

The vast repertory of works on view even after the Montreal amputation undoubtedly constituted the broadest, most coherent and most consistent survey of contemporary art born in the School of Paris that had ever been assembled until then. If one adds to this the undeniable maturity achieved by Pellan in the conception and execution of his works, which often dazzled because of their perfect technique, and again the prestige attached to his name because of the heights he had attained in a Parisian career, one is not astonished by the intensity of the various movements which emerged as a result of the exhibition. In a strongly structured language, intensely matured and developed, Pellan displayed amazing splendours – some fauvist, some cubist, some surrealist. Along with a penetrating understanding of pictorial reality in all its virtualities, the works revealed a rare power of assimilation serving an overflowing imagination.

The exhibition contrasted sharply with those of the Royal Academy of Arts. According to Jacques de Tonnancour, artists represented in the latter were " . . . castrated individuals trying to make love. The result is nil, more than nil perhaps because they are royally castrated. It is from these people that Pellan and the others demand independence, sad and poor adults who, comfortably sheltered,

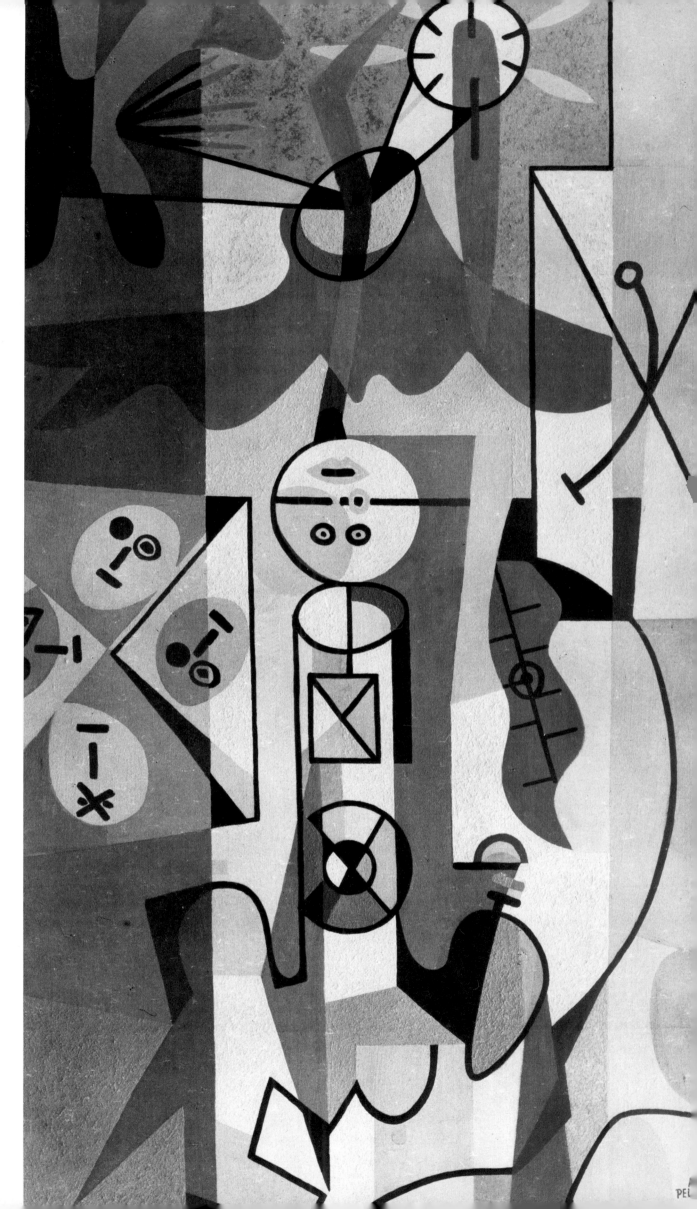

Paysage à la femme-devinette
1937
oil, silica, rice on canvas/
huile, silice, riz sur toile
73 1/2 × 41
Mr. and Mrs. Norman Lupovitch,
Montréal

Au clair de lune
1937
oil on canvas/ huile sur toile
63 3/4 × 38
National Gallery of Canada/
Galerie nationale du Canada,
Ottawa

Fillette aux lunettes
1941
oil on canvas/ huile sur toile
22 × 17
Mr. Alan O. Gibbons, Ottawa

Fillette en rouge
1941
oil on canvas/ huile sur toile
22 × 17
Mme. Nicole S. Boisvert,
Loretteville, Québec

of celebration, Pellan held his public at the foot of the wall, the walls of the gallery of art. For the first time, one of our painters pressed the indolence of the spirit and made it necessary to reflect on pictorial art. He hurt the public, hurt it a great deal . . . It's true that the public grew afraid of him. A man who has power, a sorcerer, gives rise to fear. He has power, this is conceded, and he uses it frenetically, with passion, a heart and an intelligence which are crushing . . . Pellan is a man of his century. Sooner or later, we will become aware of it . . . His painting satisfies all his being, and he delivers himself in it of oppression, truth, his interior truth. He spares nothing to express it . . . We rediscover Pellan alive, bewitching as always, crying with joy or with pain in colours which belong to him alone, electrified colours which come alive in your view and in your spirit, which haunt you like a cry of anguish. After having seen these paintings, nothing seems to be happening anywhere . . . "

Pellan had hardly arrived and already he was causing many other "pains" and "fears" for the timorous and the rearguard. But he also provided much joy and excitement for the free of heart and for his admirers. Until then, Pellan had not had much time to consider organizing his new framework of life or to set himself up properly, so swamped was he by preparations for his double exhibition in Quebec and Montreal. Then, during the exhibitions, he had no mind for such matters as looking for a studio. The reactions his work provoked occupied his time much more. He also reestablished contact with old friends and met new ones. He was trying to get his bearings. Temporarily, Pellan lived in the house of his father who, one readily imagines, was in no rush to see him leave after an absence of so many years. They had many things to tell each other. Present events especially provided them with matter for long discussions. The father was not unaware of the importance newspaper columns accorded his son. Undoubtedly, he felt legitimate pride.

But this period of non-creativity could not go on for long. Pellan, the superactive man, began to grow impatient. He was upset: too many images were pressing on his mind. The desire to paint gnawed at him. He had to unpack his boxes of colours and set up and prepare his canvasses, rediscovering his essential pace of life in their whiteness. Pellan did not stop to think about any occupations other than painting. Teaching left him indifferent. His deplorable experience with the administration of the Ecole des Beaux-Arts in 1936 further cooled his already tepid feelings towards teaching and especially towards the heads of the system and the environment in which they worked. In fact, it did not even occur to him to make any attempt to become part of the staff of his *alma mater.*

Pellan wanted to paint and to do that, he needed a studio. He preferred to establish himself in an active

paint outside of life and art." The most enlightened people were only beginning – fearfully, at that – to taste the strange sweets of the Group of Seven. Pellan's substantial banquet inevitably provoked cases of indigestion.

Even though many visitors, as observers of the period report, remained open-mouthed, looked with panic-stricken eyes, laughed uproariously or manifested complete contempt, the critics were unanimous in their praise. Maurice Gagnon, Marcel Parizeau, Robert Ayre, Reynald all pointed out Pellan's originality, force, and craftsmanship. They rejoiced that he was back home. They acclaimed him as a hero who had conquered the sophisticated public of the City of Light and his glory now reflected on the people of Quebec.

De Tonnancour again best illustrated the reaction of visitors to the exhibition by emphasizing both the provocative nature of such an advanced concept of art and by testifying to his own admiration for such stimulating nourishment for the senses and for the spirit. He evoked this troubling experience in the *Quartier Latin,* the official student organ of the Université de Montréal.

" . . . It was impossible, here and elsewhere, to present an art as unpopular as that of Pellan . . . At this moment

environment, a place where things were happening, a place where he could combine with his creative activities undertakings and relationships likely to stimulate his temperament. An artist who hopes to live from his art must also provide for clients – a sufficiently large market to sell what he produces. It was not long before Pellan realized that the climate of his home town was not for him. Since there was little from the artistic viewpoint to hold him back, he decided to establish himself in Montreal. Certainly, Montreal wasn't Paris, but compared with Quebec it was another world. While his exhibition was on view, he met many artists and collectors and saw that things were happening in Montreal. Movements were under way to liberate art. Pellan was warmly invited to join his enthusiastic admirers and place a new imprint on their still limited struggle.

Pellan accepted Philip Surrey's invitation to share the latter's studio on Sainte-Famille Street. He remained for a few weeks, long enough to find his own place. He did not know the city well – he had spent only brief periods in Montreal since he was a child – but he nevertheless quickly succeeded in finding a proper apartment for himself. It was at 3714 Jeanne Mance Street, a block away from Surrey's studio.

Socially structured around the Ecole des Beaux-Arts, the sector was the stamping grounds of a large number of members of the Montreal artistic community. Many painters lived or had their studios there. Actors, poets and musicians also were part of the community. Pellan found a warm environment and rediscovered some of his old friends, among them Jean-Charles Harvey and Dr. Dumas.

Pellan was not one to isolate himself and his circle of friends widened in no time. "I didn't have time to get bored in Montreal. Philip Surrey introduced me to Jean Palardy and Jori Smith who lived nearby and through them I met John Lyman with whom they were very close friends. Jacques de Tonnancour brought me in contact with Goodridge Roberts and many others. The situation snowballed and soon I knew just about everyone actively interested in the evolution of art."

Unlike Paris, the artists' get-togethers did not take place in cafés or public places but rather at parties given by the various artists. Frequently, they visited the Jeanne Mance studio and the reception was always cordial. Pellan set up a comfortable studio in his flat and gladly welcomed friends who wanted to work there from time to time, or who simply wanted to look at the host's latest paintings and discuss art with him over a bottle of wine.

Some of the younger members of the group were more or less committed to the Ecole des Beaux-Arts because they were students there. But it was at the Ecole du Meuble, on Dorchester Street, that the progressive trends in art crystallized around a nucleus of committed professors. Paul-Emile Borduas taught drawing; the librarian, Maurice Gagnon,

taught the history of art and Marcel Parizeau, architecture. Pellan, like his friend François Hertel, though he was not part of the staff, maintained close relations with members of the group. Gagnon and Parizeau would always remain highly receptive to his personal efforts until their death. Though somewhat torn between their friendship for the two protagonists, they avoided taking sides when Pellan and Borduas drew battle lines.

Group exhibitions, particularly those involving the work of avant-garde artists, were being poorly attended. But the show presented in the municipal gallery of the Palais Montcalm in Quebec City in April-May, 1941, and again immediately afterwards in the gallery of the Henry Morgan store in Montreal, assumed singular importance. Presented to the public as the *Première exposition des Indépendants,* it was made up of paintings by John Lyman, Goodridge Roberts, Philip Surrey, Eric Goldberg, Louise Gadbois, Louis Muhlstock, Paul-Emile Borduas, Mary Bouchard, Jori Smith, Stanley Cosgrove and, obviously, Pellan. Eight of the painters belonged to the Society of Contemporary Artists with which Pellan was loosely affiliated in the sense that he shared the same progressive convictions. But he was not officially a member.

It was through the initiative of Father Marie-Alain Couturier that the exhibition was prepared. Already well-known in the Montreal artistic milieu, Courturier had arrived from Paris, via New York, in the spring of 1940. A Dominican and an artist, he had devoted his entire energy since his arrival towards stimulating and encouraging the development of an art free of the shackles of academic conformity and of any other form of political or ideological enslavement. He gave many lectures at the Ecole des Beaux-Arts, as well as a series of courses at the Ecole du Meuble. Barely a few weeks before the exhibition – in March, 1941 – he had amazed his audience at the Université de Montréal by basing his lecture on the divorce between artists and public. The uncertainty he manifested in his foreword to the exhibition catalogue regarding public reaction to the works of the *Indépendants* appears truly astonishing today in view of the fact that the aesthetic audacity they displayed now seems indeed discreet.

The only truly revolutionary artist was Pellan, and in the whole of the exhibition the painting which most upset perceptual habits was undoubtedly *Sous terre* of 1938. The portraits, still lifes and landscapes of the other exhibiting artists, frank and personal in their statements, undoubtedly could appear bold in relation to the Impressionist lingerings still fashionable in Quebec art schools. But Pellan's radically abstract composition stood out dramatically from the others. Furthermore, it is interesting to note that the painting belongs to one of Pellan's rare periods when he clearly moved away from figurative allusion. In his work as a whole, one finds persistent reference to visible reality,

Quatre femmes
1945
oil on canvas/ huile sur toile
82 × 66
Musée d'Art contemporain, Montréal

Les îles de la nuit
1945
oil on canvas/ huile sur toile
45 1/2 × 35
Private collection/
collection particulière

transposed and schematized as it may appear.

After participating in another group exhibition – the annual presentation of the Society of Contemporary Artists – Pellan went on holiday for several weeks to initiate an experiment he had been considering for some time and which brought him back to the heart of his figurative concerns. He left Montreal in the summer of 1941, accepting the generous hospitality of the Palardys who were vacationing at their country house in Charlevoix county.

"I had a specific purpose in going there. I wanted to work. But the country was so beautiful and my hosts so charming that I didn't open my paint box during the first weeks. We could take long walks, chat, and sunbathe. I couldn't bring myself to work. Then, during the last two weeks, I started. I painted a whole series of small canvasses – landscapes of the surrounding area and portraits of young girls of the neighbourhood who came to visit the Palardys. That was my secret project. At the time, my current production was rather 'modern' but I had become conscious of the gap separating my colleagues and myself from the public. By showing people that I was also able to do realistic painting, I wanted to bring about something of a *rapprochement*. I was sincere."

Pellan is not a theoretician and even less a rhetorician. He is a painter, passionate about art, and rejects the idea that one may dictate to the artist the direction he must take in the creative process. He feels such an approach is completely opposed to art "since art is exactly the quality that appears only when an individual is free of all constraints and works with love, passion and joy, allowing himself to be guided by his intuition and the needs within him. Whether the image be figurative, surrealist or abstract, art can manifest itself if the painter is true, if he knows how to bring into the world what he carries inside him."

Paradoxical as it may appear to the strict logician, the "modern" Pellan in no way abdicated his autonomy in wishing to create images which were more easily accessible for his public. He simply changed register. Certainly, he found it more interesting, more engaging, to explore the unknown paths of painting in order to bring out new realities and to surprise even himself. But when he painted the children and the landscapes, he was nonetheless totally committed as an artist. He was not amusing himself lightly; he painted with conviction. Indeed the paintings bore proof of this conviction, illustrating undeniable qualities far removed from the poor formula paintings, be they Impressionist, Expressionist or otherwise.

The history of art places its seal only on what appears new to it; it does not tolerate breaks in continuity. Too often, it even demands the right to show the proper course to follow. Pellan's was difficult to accept. He, however, chose art itself, rather than the history of art.

On his return from holidays, Pellan was in no hurry. It was only in December that he opened his studio to the public for a few days. Among the works he had hung was a large selection of his Charlevoix paintings. They went well with the developments of a newer spirit. Critics endorsed Pellan's initiative, as shown by newspaper articles of the period, including the daily *Le Canada:* "Go there! Pellan himself provides proof that he can, as well as anyone, do painting that an untrained eye recognizes at first glance. . . . But direct expression, the ease of processes, the variety of means, the male emotion, sudden sensitivity always dominate. . . . "

The critic also underlined Pellan's happy idea of presenting his one-man house exhibition and expressed the hope that the artist would increase his contacts with the public. Pellan enjoyed nothing more than to show his work and he surely did not object to broadening the base of dissemination of his painting.

The following year, in addition to participating again in the annual exhibition of the Society of Contemporary Artists and to sending paintings to a group show in Joliette, he was represented in the exhibition *Contemporary Painting in Canada* at the Addison Gallery of American Art, in Andover, Mass.

But the major event of the season for Pellan was surely his one-man exhibition at the Galerie Bignou, of New York, an exhibition residents of Quebec City later could see at the Palais Montcalm. In the American metropolis, visitors reacted well to the Pellan show. A good number of them were French nationals who chose exile in the United States over Nazi occupation of their homeland. Pellan, in a sense, was among his own and could recall the still fresh memories of his Paris existence. Articles published in *The Brooklyn Eagle* and *The New York Sun* were lavish in their praise, linking Pellan's work with that of the great masters of the School of Paris. The critic of *Art News,* describing the works exhibited as " . . . semi-abstractions of splendid composition and painted with colours from Matisse's palette," added a special flavour to his commentary by saying that Pellan was "more French than the Frenchmen of Paris are. Pellan, born in Quebec, is Gallic to the bone."

Undoubedly, it would have been more helpful to Pellan to have visualized him as an authentic product of American civilization, since an advertising campaign was then being conducted in the streets of New York to convince people to encourage American artists. Pellan recalls seeing long banners with slogans promoting this cause. He sold nothing but he was not the only one: Braque, also presenting an important exhibition of his work in a New York gallery, was no more successful.

With a group of ardent companions – Hertel, Parizeau, Gagnon and others – Pellan led an existence fertile in

imagination. Creation, exhibitions, joyous meetings, stimulating conversations all became part of his life. There was no unrest in the group. Montreal was awakening, ridding itself of some of its torpor. The efforts of progressive nuclei, still more or less clandestine, already were injecting revitalizing forces into its cultural organs which only recently had been moribund, allowing one to look forward to new frontiers. There was, however, the possibility of a relapse, and radical action was increasingly considered to permanently do away with the problem.

Pellan was to be in the front rank when intervention came in the very heart of the ailing system – the Ecole des Beaux-Arts. Reversing his position regarding a teaching career, he ended up succumbing to the attraction of the adventure, accepting a teaching post in the stronghold of the artistic status quo though he remained highly conscious of the dangers he ran and the opposition he would have to overcome. The climate in the institution was anything but desirable. The director, Charles Maillard, adopted a rigid and suspicious attitude in regard to attacks originating mainly from the group of animators who had vigorously begun to bring fresh air into the classes of the Ecole du Meuble. He maintained vigilant control over his troops, rejecting even the slightest suggestion of originality in the teaching methods of his subordinates.

Pellan did not in any way share the director's views – neither his basic concept of art, nor the results of this position, namely, the means to be used to promote the successful development of the students' individual talents. Though he had not yet personally attacked him openly, Pellan already had manifested his disapproval of the outdated and coercive system which Maillard maintained in the institution which he had directed too long. Pellan's disapproval came after an incident during the 1941 *Indépendants* exhibition. Maillard had taken advantage of the fact that a good number of the exhibiting artists were former students of the Beaux-Arts in order to emphasize the success of his teaching methods. The group had reacted immediately, publishing a vigorous protest in *Le Devoir* on May 28th, 1941. It ended with this: "Personally, we ask for nothing. We simply want to be left to work in peace. But we do not want our names and our work, modest as it may be, to be used to maintain the prestige of outdated teaching principles which create illusions for the public and compromise the future of young artists in this country."

Pellan had been among those who signed and this did not escape Maillard's vigilant attention. Maillard kept track of the slightest rumours, the slightest commotion which might disturb his reign. Nor could he ignore the fact that Pellan continued to maintain excellent relations with the recalcitrants of the Ecole du Meuble. Pellan was a force to be feared, perhaps a threat. Maillard chose to attempt to make an ally of him while it was perhaps still possible.

Since Pellan's name already was well known, was Maillard hoping to improve the tarnished reputation of his school by adding Pellan to the faculty? This, in any event, was Borduas' contention. He warned against Maillard's manoeuvring. Maillard, undoubtedly after some hesitation, decided to take a chance. He preferred to run the risk Pellan represented to his still intact authority in the school by inviting him to work by his side. He allowed the wolf to enter the sheep pen, to keep a closer eye on him.

Maillard showed a poor understanding of Pellan in believing that the latter would allow himself to be quietly manipulated or eventually converted. Pellan had been clearly forewarned and had firmly decided not to yield an inch on anything. From the start, he laid down his conditions: he declined the post of professor of drawing and more or less demanded the major painting course which Maillard had always given himself. Furthermore, he was determined to continue to pursue his personal work with complete freedom of action. There was no question of giving more than two courses per week. An agreement finally was reached: alternating with a colleague, he would give two courses one week and three courses the next.

Maillard obviously was aware that his life would not be easy. Soon he decided to bring Stanley Cosgrove from Mexico where he had been studying to assign him another painting class set up in order to reduce Pellan's influence by dividing his group of students. For a time, the strange arrangement did not cause too many problems. There was tolerance on all sides. Pellan clearly felt he was under constant surveillance and he was at times harassed. At the beginning of the academic year 1944-45, for instance, there was an attempt during enrolment to reduce the number of students in Pellan's class to only 14 while Cosgrove was given 22. The year before, Pellan had had 35. Maillard also turned a deaf ear to Pellan's protests that he had been jeered at and threatened in his own classroom in front of his students by arrogant and hefty employees of the supportive staff. Pellan chose not to make a big issue of it. As long as he was given complete freeom in the orientation of his courses and there was no attempt to modify his pedagogy, he was prepared to put up with the internal intrigues. "I was arousing attention. I was sowing disquiet. I was encouraging research. The students learned to see, to question, to discover, to create." In a recent work, Guy Robert summed up Pellan's pedagogy in this way:

– the teacher must respect the freedom of the student, promote the latter's development and stimulate him if need be;
– the teacher is an animator who encourages the student to work intensely, to use his imagination to the fullest, to develop his discernment, to be self-critical;

Et le soieil continue
1959
oil, silica on canvas/
huile, silice sur toile 16 × 22
Musée du Québec, Québec

Au soleil noir
1958
oil, silica on cardboard/
huile, silice sur carton
14 3/4 × 19 3/4
Private collection/
collection particulière, Montréal

Les téméraires
1958
oil, silica on canvas/
huile, silice sur toile 21 × 15
Mr. Bram Garber, Montréal

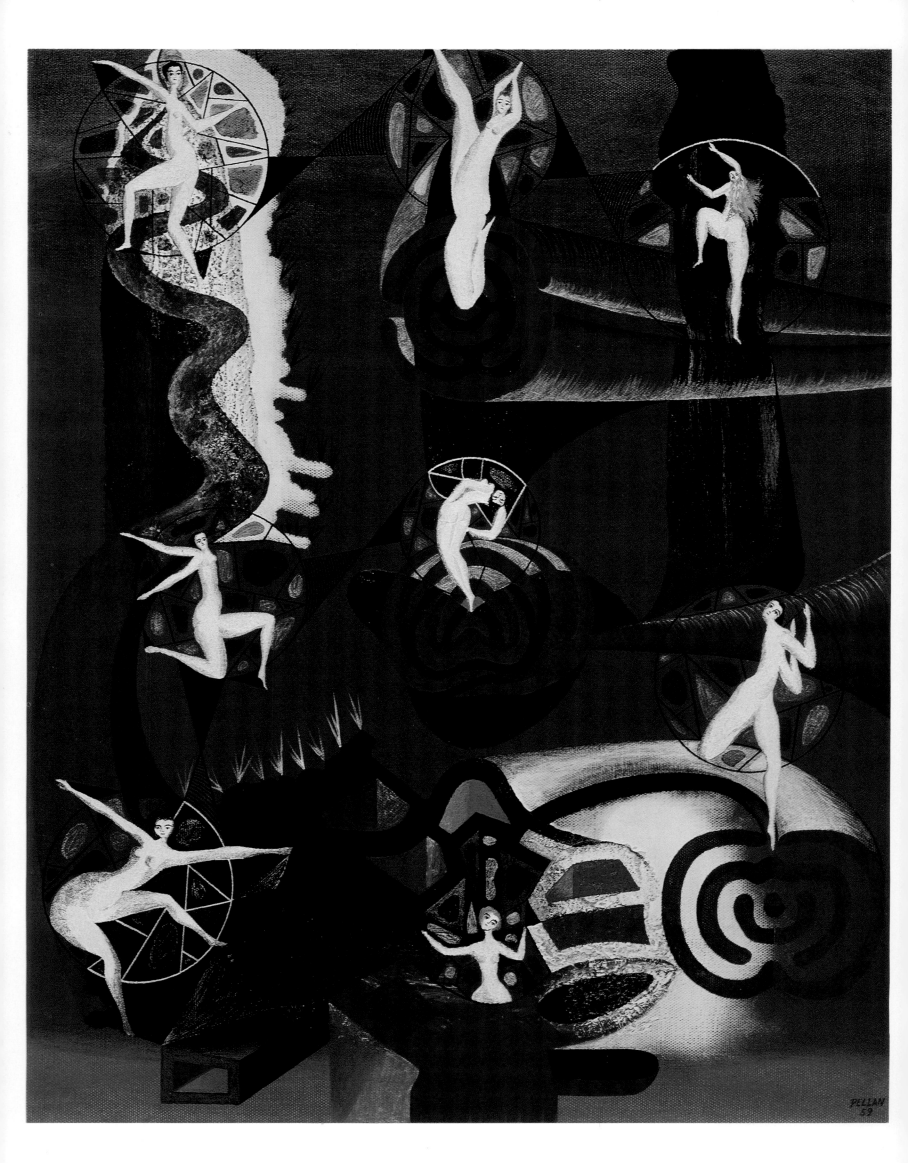

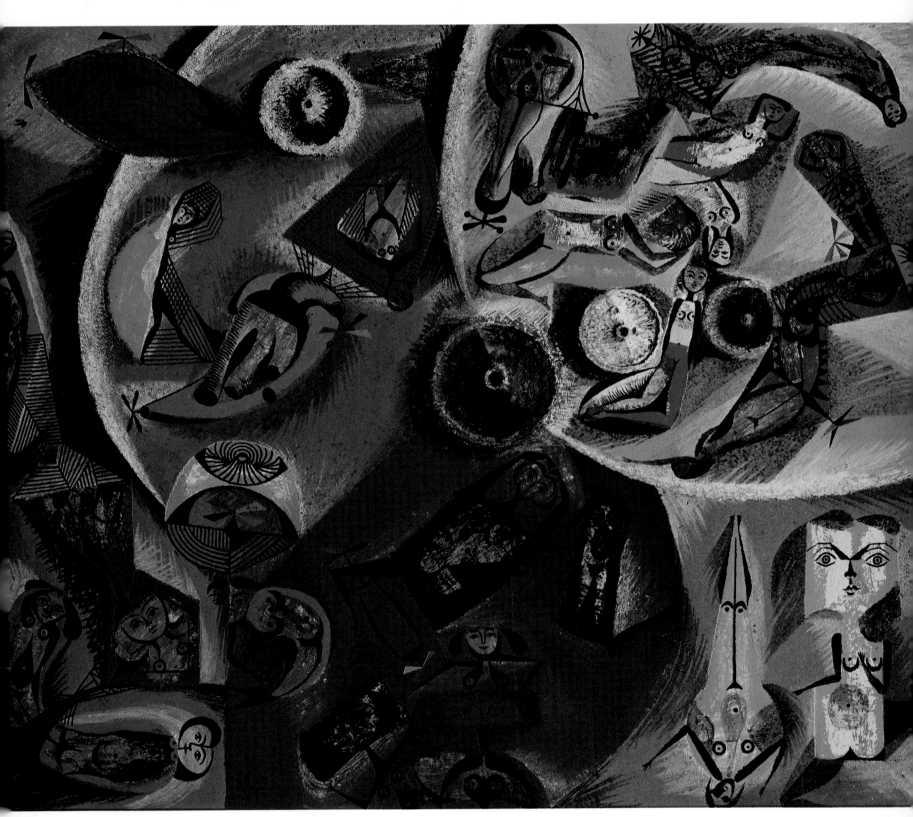

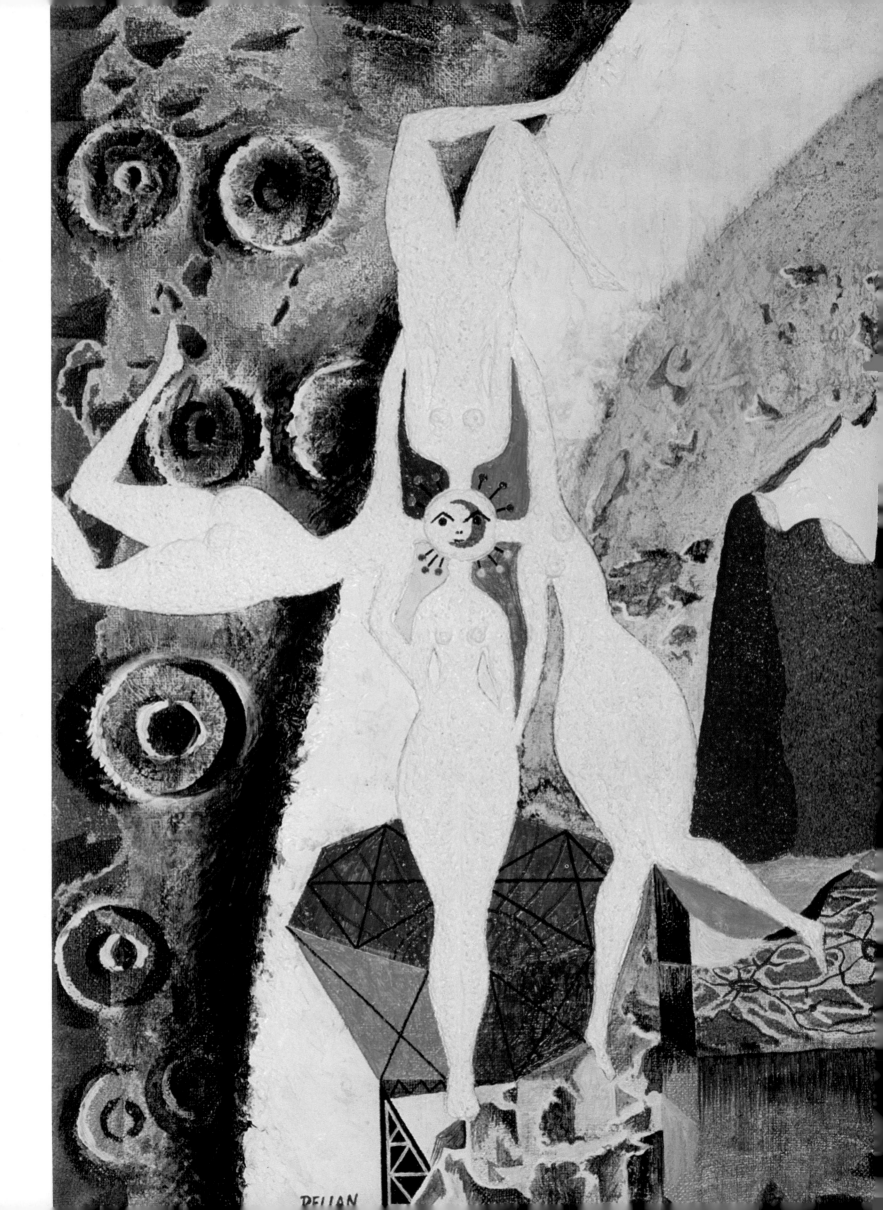

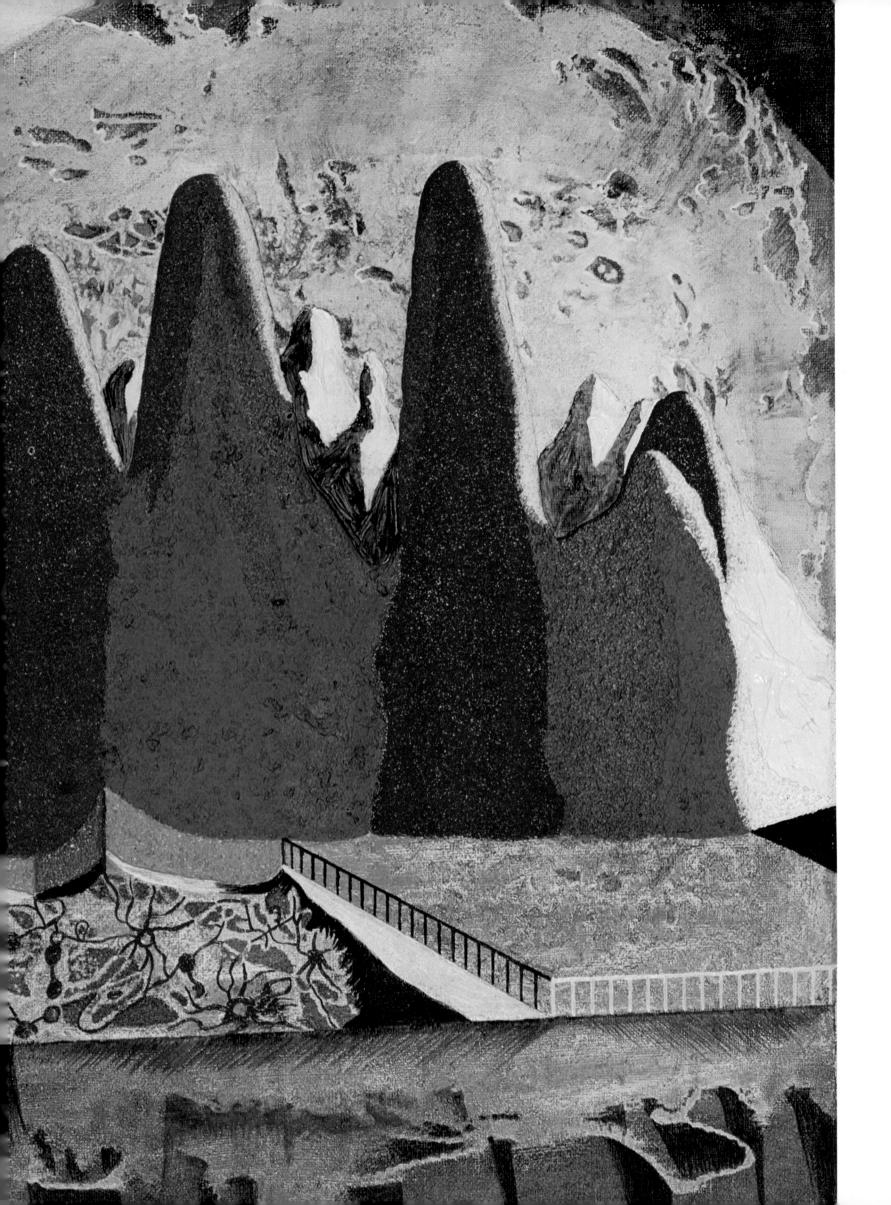

Piscine de jouvence
1960
oil on paper/ huile sur papier
12 3/4 × 12 3/4
Mrs. Esther Goldstein, Toronto

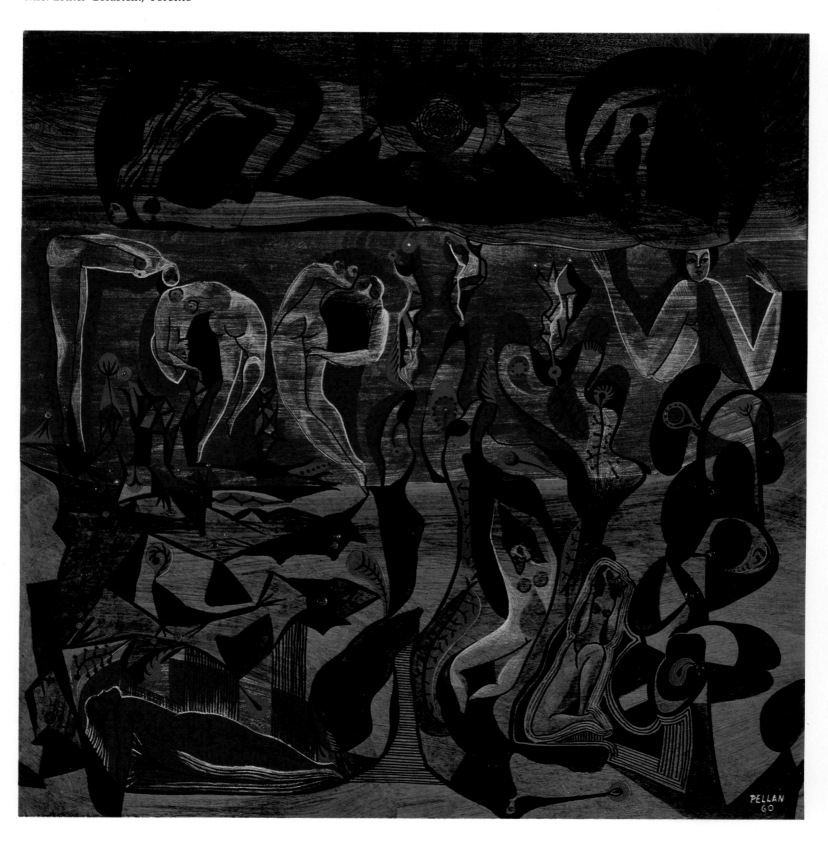

Les mini-J
1968
oil on paper/ huile sur papier
20 1/8 × 24 3/8
Private collection/
collection particulière, Montréal

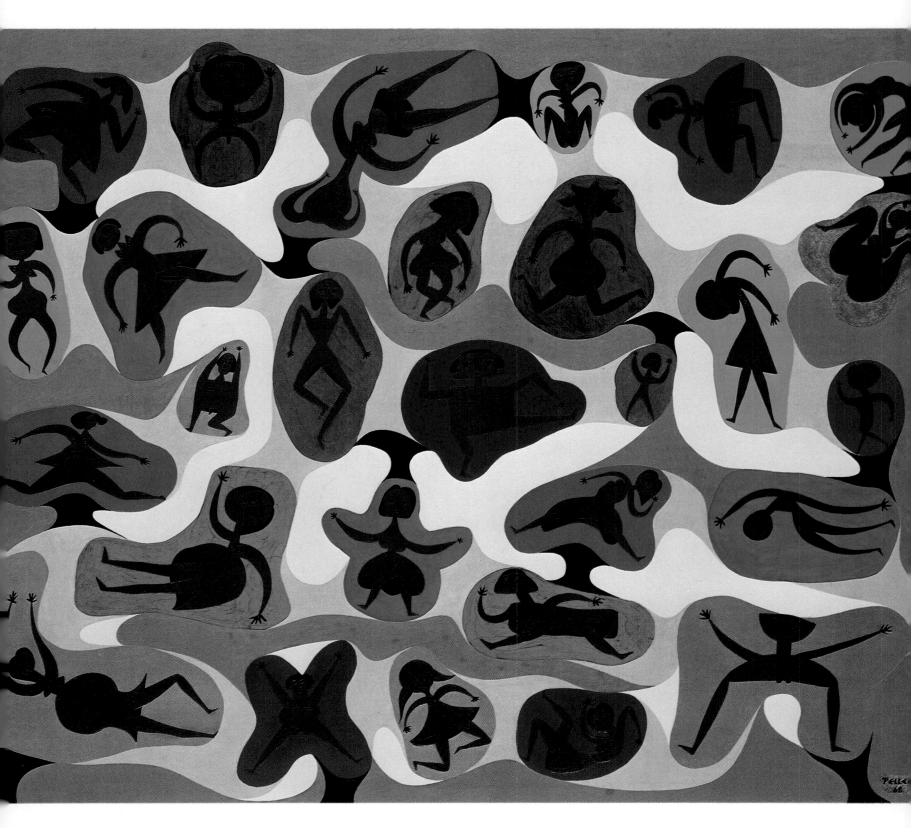

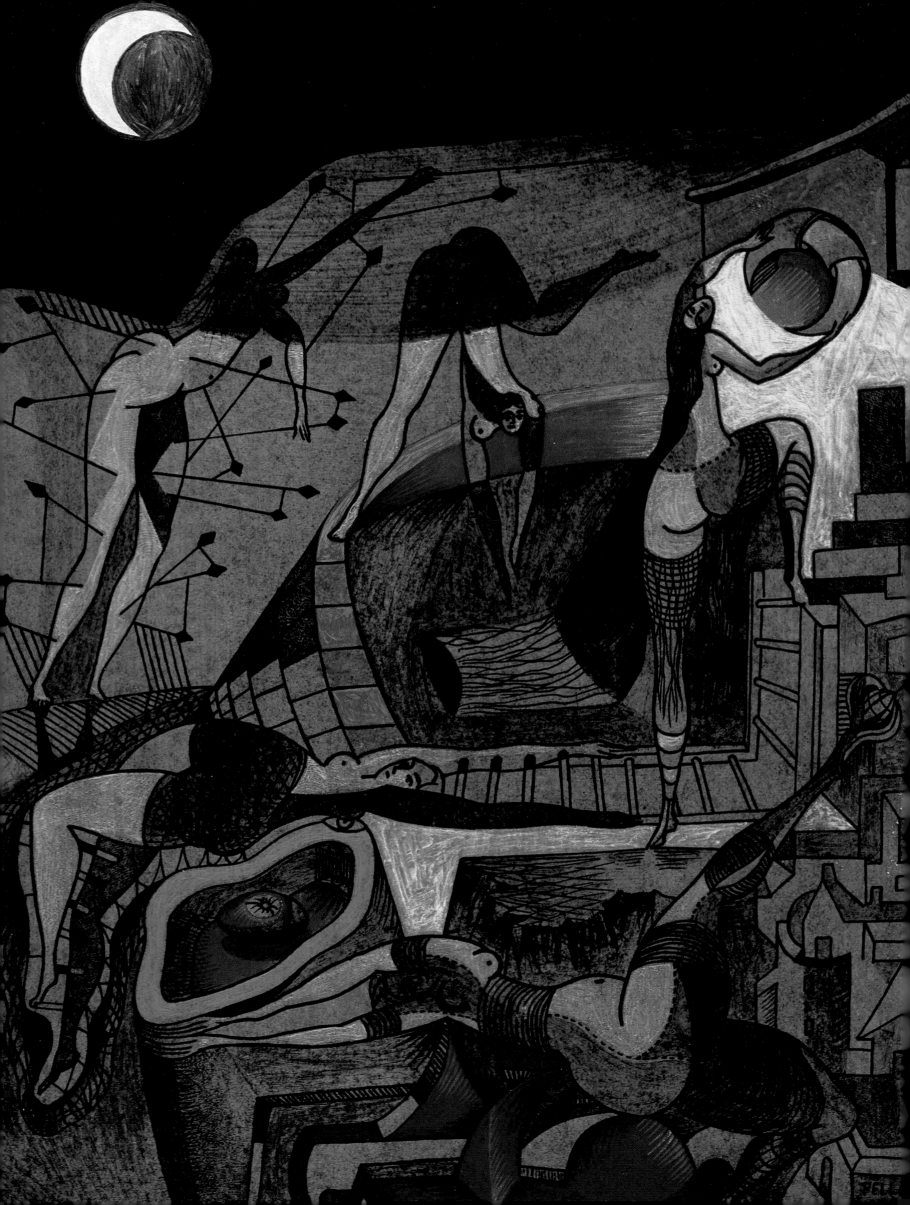

Croissant de lune
1960
oil on paper/ huile sur papier
11 5/8 × 8 1/2
M. Thomas Laperrière, Montréal

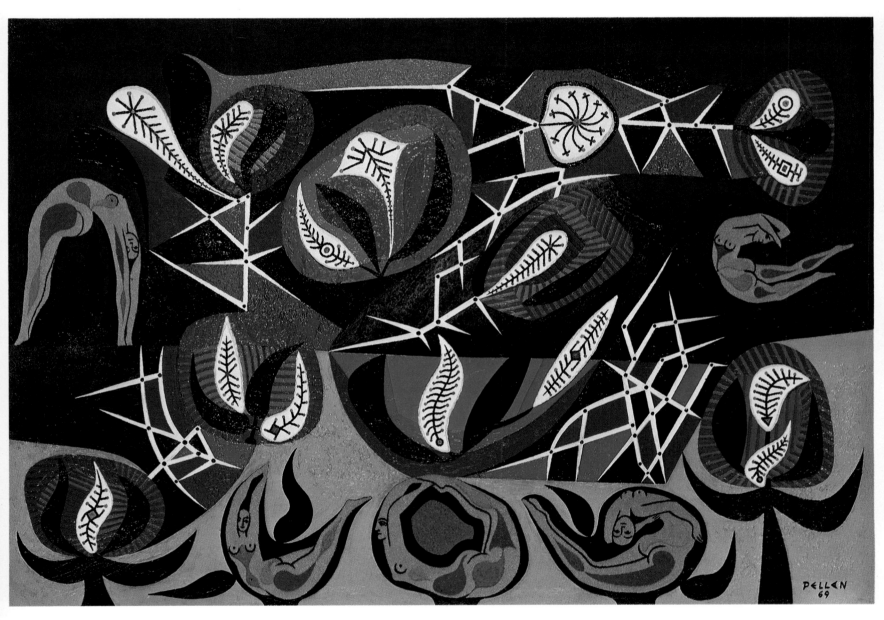

Environnement
1969
oil, silica, tobacco on plywood/
huile, silice, tabac sur contreplaqué
12 1/4 × 17 7/8
M. Edouard A. Bourque, Lucerne,
Québec

Discothèque
1970
oil, silica on canvas/
huile, silice sur toile
23 × 27
Société Perchol, Montréal

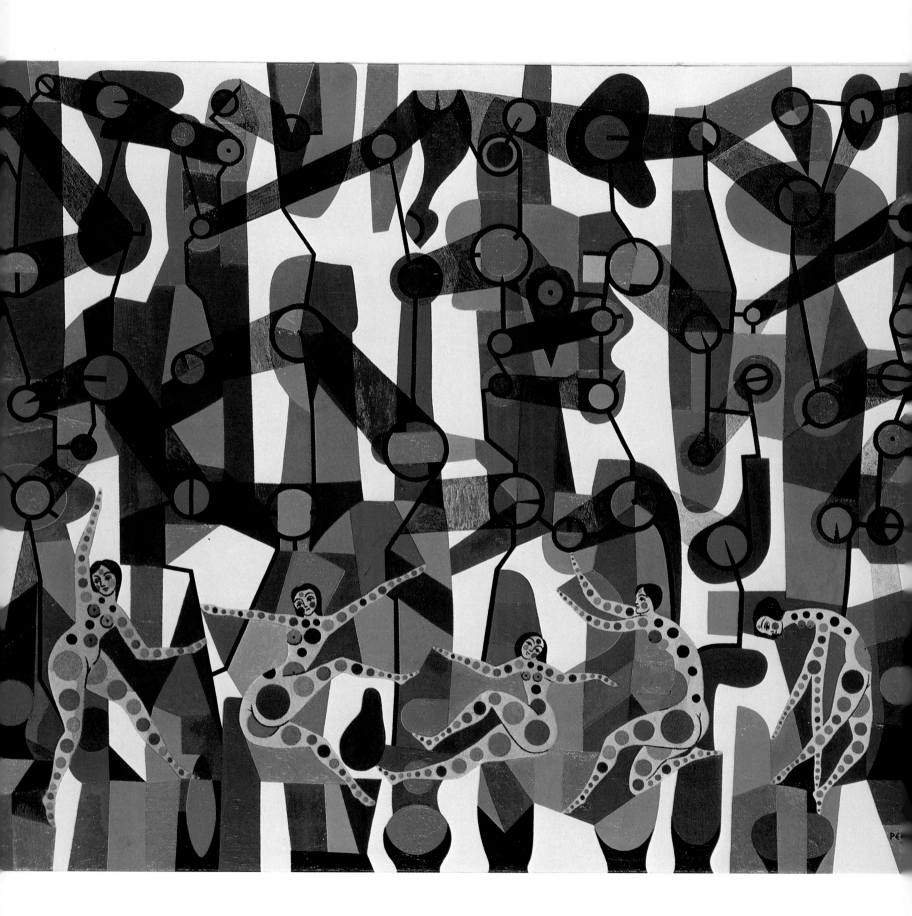

Le tout mobile
circa/ vers 1948
oil on paper/ huile sur papier
11 3/4 × 9
Yvette et Paul Gladu, Rosemère, Québec

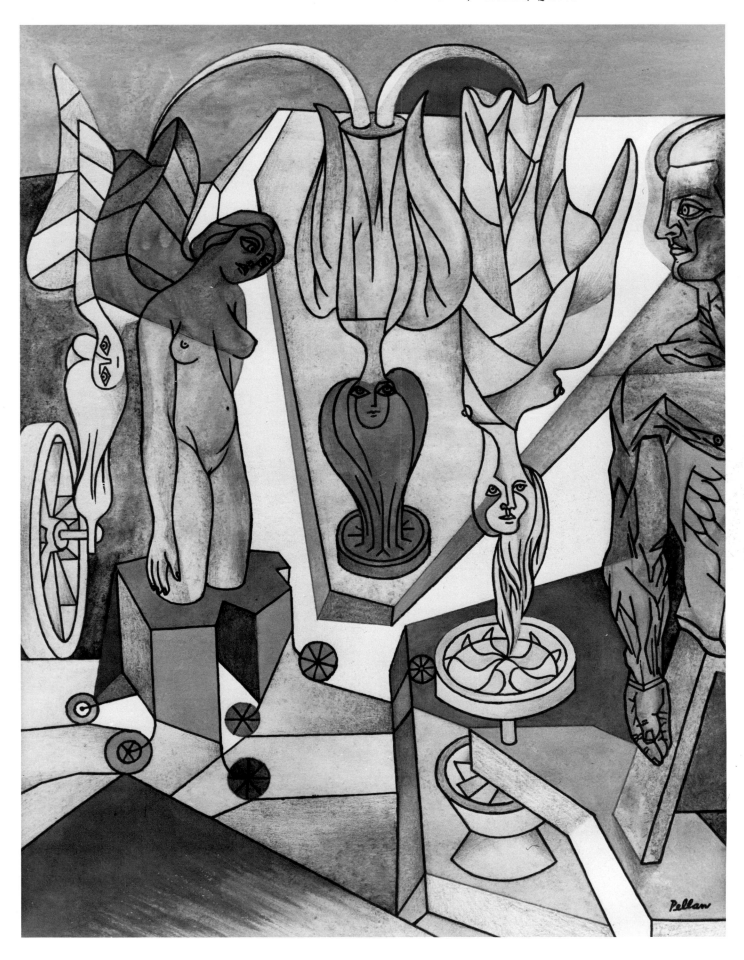

Surprise académique
1943
oil, silica, tobacco on canvas/
huile, silice, tabac sur toile
60 1/4 × 51
Collection Maurice et Andrée Corbeil,
Montréal

Ephémère
circa/ vers 1948
oil on canvas/ huile sur toile
11 3/4 × 9
Private collection/
collection particulière

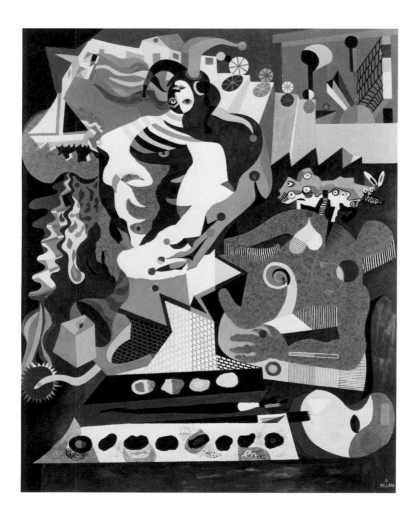

a lecture at the Montreal Botanical Garden, heatedly decrying academic art. The atmosphere in the hall was tense. Young partisans of the revolt against the sterilizing régime of the Ecole des Beaux-Arts grew inflamed. Hostile cries rang out. *"A bas Maillard et l'académisme!"*

It was the final straw for Maillard. He moved to the attack. "Maillard knew I was present at the lecture. He also knew that I was very close to Léger since he was living at my place. During a meeting when all the professors were present correcting students' work, he brutally called me down and demanded an explanation. He wanted me to say things he could use to crush me with later. I replied that it was impossible. I was alone against many. I was prepared, however, to discuss the matter with them on condition that there be an even balance, that is, that all competent persons seeking the progress of art be allowed to take part in the discussion. He called me names and as I got up to leave without permission in the middle of my work, he tried to hold me back. I slammed the doors."

The war which had been threatening for many months was declared. Its most violent engagements were to take place at the end of the academic year 1944-45 when the annual exhibition of student work was held. An unexpected event during the official opening set the situation ablaze, unleashing a veritable storm of statements and accusations between Pellan and Maillard which were published in newspapers in the following days. At one point during the opening, a group of students took up the Botanical Garden war-cry, *"A bas Maillard! A bas l'académisme!"* Stickers bearing the slogan appeared everywhere.

No doubt an incident a few days earlier when the exhibition was being hung had added to the rising exasperation of the Pellan group. It at least partially explains the explosion of anger at the opening. In the exhibition gallery, half the space had been reserved for Pellan's students. In the rest of the gallery was the work of Cosgrove's students and it was noted that the nudes in that section were pictured from the back, or were partially clothed. The nudes from Pellan's class were complete in every sense. He quickly realized a trap had been set. The reaction set in before long. Maillard summoned Pellan to his office and, citing the daring character of some of the paintings which might create a bad public impression, asked that the works be removed. Maillard furthermore quoted the opinion of Monseigneur Albert Valois, Archbishop of Montreal, whom he had consulted without Pellan's knowledge. The first painting, representing a nude black woman, was fully realistic and was deemed too bold; in the second, portraying the Last Supper in a contemporary idiom, a parody was seen.

Under pressure, Pellan first gave in. But he changed his mind and, summoning the authors of the paintings, showed them how to camouflage the works with gouache and soap in order to satisfy narrow-minded moral exigen-

– there are no imposed programs or theories. It is the student who determines the orientation of his research and it is in this sense that the teacher must encourage him;

– art is never static nor stationary; on the contrary, it is pure movement and dynamism, like life itself and art thus cannot be dissociated from life;

– art is free, independent, open, and free of all literary, ideological, philosophical and political interference.*

One can readily imagine that this concept of teaching did not in every way coincide with that of the director of the Ecole. Relations between Maillard and Pellan deteriorated. The "marriage of reason" was close to the breaking-point. Maillard became increasingly exasperated with the unbending oak who stood up to him. He already knew that he could never make an ally of Pellan. Now he considered ways of bringing Pellan down, of getting rid of him.

In the spring of 1945, a significant event regarding the promotion of new ideas in art cast more oil on the fires. The celebrated French painter Fernand Léger – he was a friend of Pellan and was his guest during his Montreal stay – gave

* Guy Robert, *Borduas,* Les Presses de l'Université du Québec, Montréal, 1972, p. 70. (Translation.)

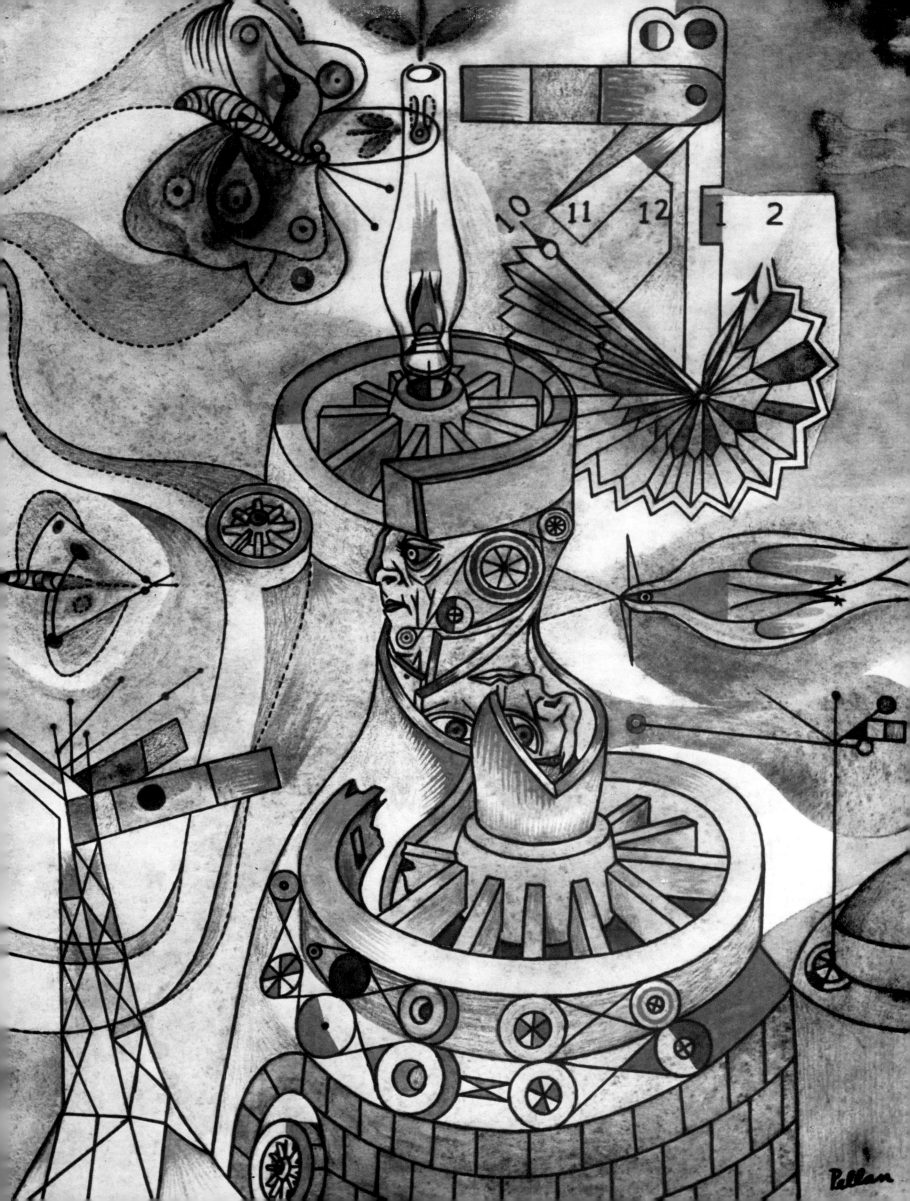

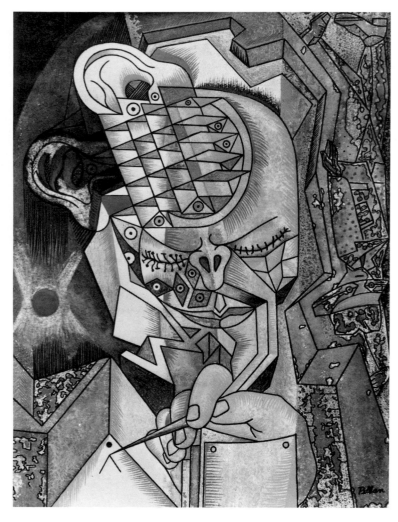

with pretending to remove the paintings, thus striking a serious blow against the students involved, he took advantage of the corrective work they did to misrepresent their intentions by envisaging it as a provocation." Pellan seized upon the occasion to emphasize that the root of the problem was far deeper, involving the fundamentally retrograde attitude to teaching at the Ecole des Beaux-Arts: " . . . this manifestation (at the vernissage) was the outcome of a constant and meditated movement on the part of youth and all serious art connoisseurs against narrow-mindedness, intrigues and Prussianization in art."

The quarrel had taken on alarming proportions. People became more worked up. Serious support from critics, particularly that of Charles Hamel, consolidated Pellan's position. The intervention of the Secretary of the Province, the Honourable Omer Côté, was necessary to reestablish precarious order. Though he urged all students of the school to cooperate with the director and the teachers, it became clear that either Pellan or Maillard had to go. It was Maillard who resigned.

Pellan had won. So had the avant-garde. Named as director succeeding Maillard was Marcel Parizeau, the progressive teacher of the Ecole du Meuble and a friend and supporter of Pellan. Finally, it was hoped, the Ecole would move forward and make up for lost time. At last, it could catch up with the twentieth century! But as the students began to envisage a happier future, fate struck a cruel blow: Parizeau died suddenly a few weeks after his appointment. Roland Charlebois, a miniaturist painter recently demobilized and virtually unaware of the progress of contemporary art in Quebec, succeeded Parizeau. The new start had been blunted. The dull routine of the Sherbrooke Street school would continue for many years to come. Improvements undoubtedly were made but the change was far too slow. Pellan continued to teach until 1952 when he again left Montreal for Paris.

But what of Pellan the painter during his years of teaching? What had he done in his studio during those harassing years of struggle? He had continued to paint and even painted a great deal. As a result of the reduced schedule of teaching he had been careful to establish, he had had time enough to develop his own work.

When he began teaching, he had only recently completed an important official commission – two mural panels to decorate the reception hall of the Canadian Legation in Rio de Janeiro. The theme he had been given provided him with a rather broad margin for personal interpretation: one panel was to depict the Canadian West while the second was to be devoted to the eastern provinces to illustrate the motto *A mari usque ad mare.* He was required to limit himself to a realistic aesthetic but the freshness of his whimsical description of all the elements – lakes, hills, sailboats, small

cies. A damp cloth would restore the paintings to their original condition. According to the description given to newspapermen by Maillard the day after, "the nude was rigged out in a blue and red bathing suit with white dots and the Supper became a drinking scene, that is, a French friar's beret with a red pom-pom was placed on Christ's head; a pipe was painted in his mouth and the chalice was converted into a beer jug." Maillard was furious that the two disrespectful paintings had not been withdrawn. However, he did not dare to remove them without the support of the authorities. Concluding his version of the facts to newspapermen, the director said "there is a margin between the cliché, parody and certain daring in teaching. It is up to me to see that this margin is respected. The incident is closed."

Pellan did not see things the same way. He had been bullied too long. He had kept silence too long. He had had to brake his *élan* because of lack of understanding and bullheadedness on the part of the administration. He resolved to bring the whole affair into the open. Replying to the statements of his accuser through the newspapers, he charged that Maillard was in bad faith: "I was not aware of the scandal M. Maillard was preparing. Not satisfied

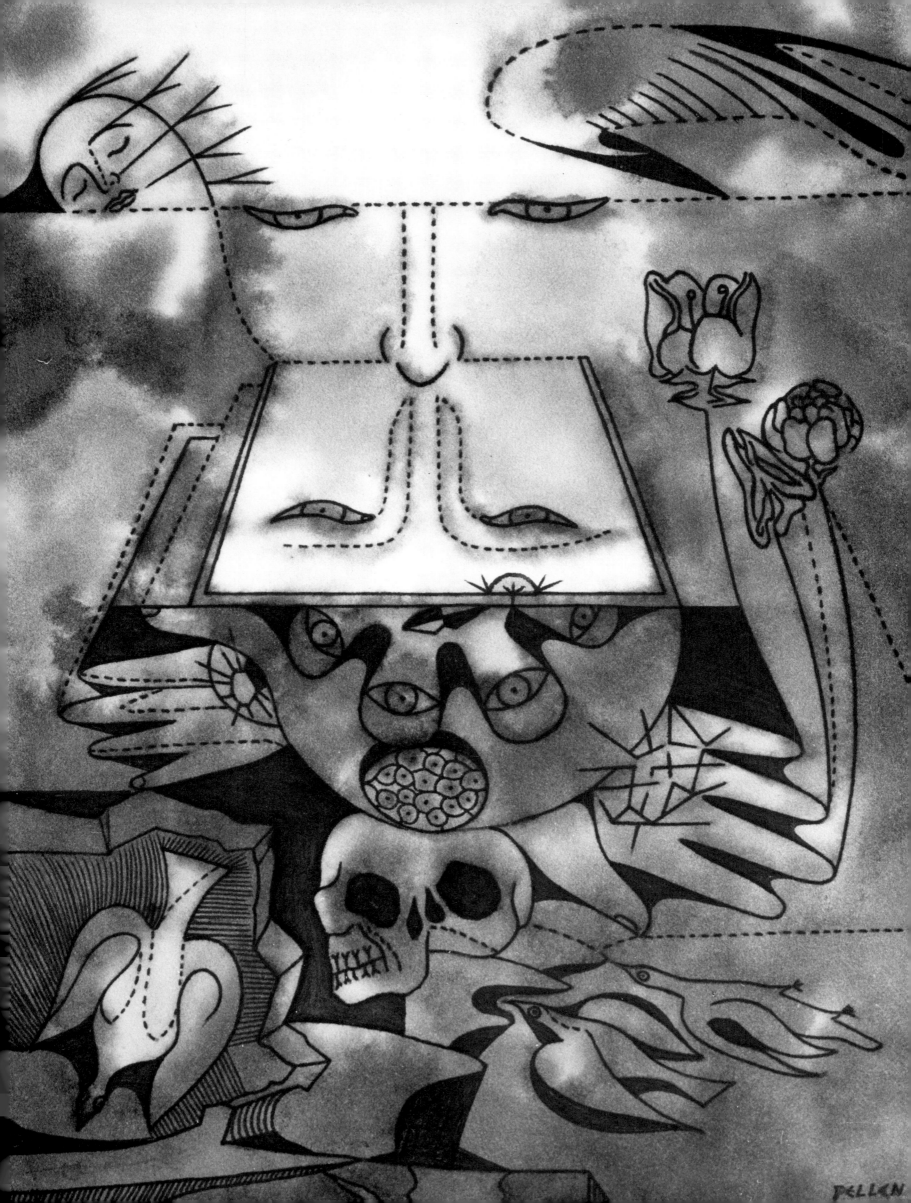

Le sixième sens
1954
oil, silica on canvas/
huile, silice sur toile
74 1/2 × 62 1/2
Private collection/
collection particulière, Montréal

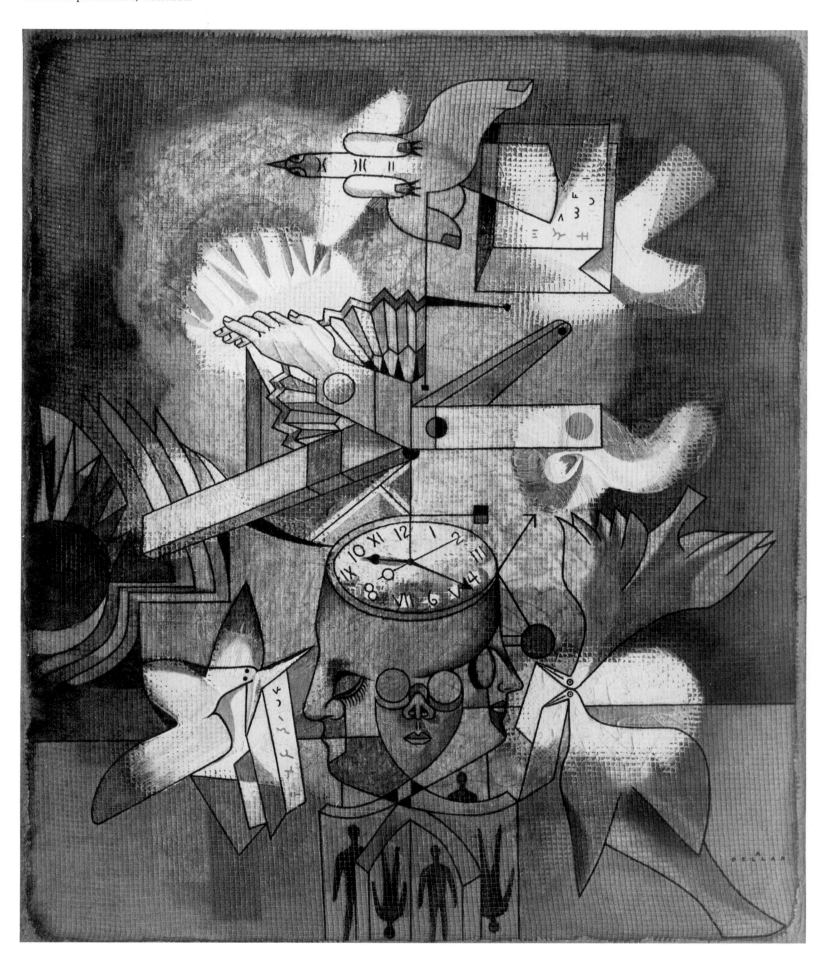

Jardin au fond du puits
circa/ vers 1953
oil on paper/ huile sur papier
8 × 7
Mr. Wilson Mellen, Montréal

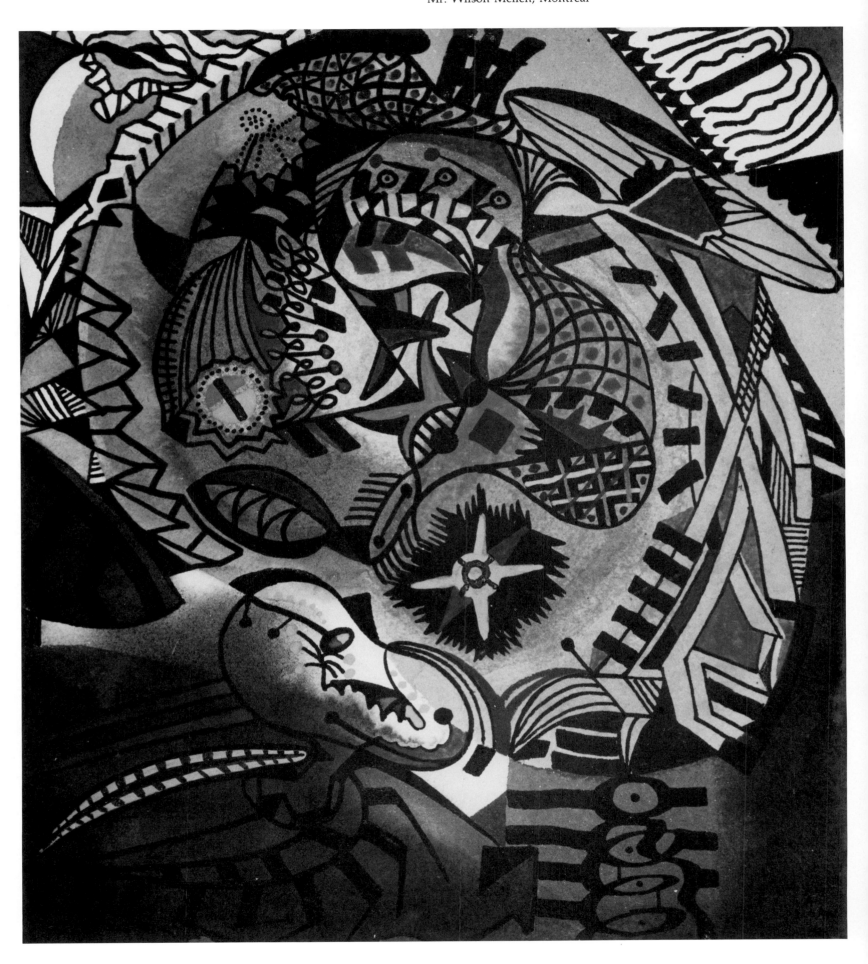

Vertige du temps
1957
oil on paper/ huile sur papier
11 × 13
Dr. Sean B. Murphy, Montréal

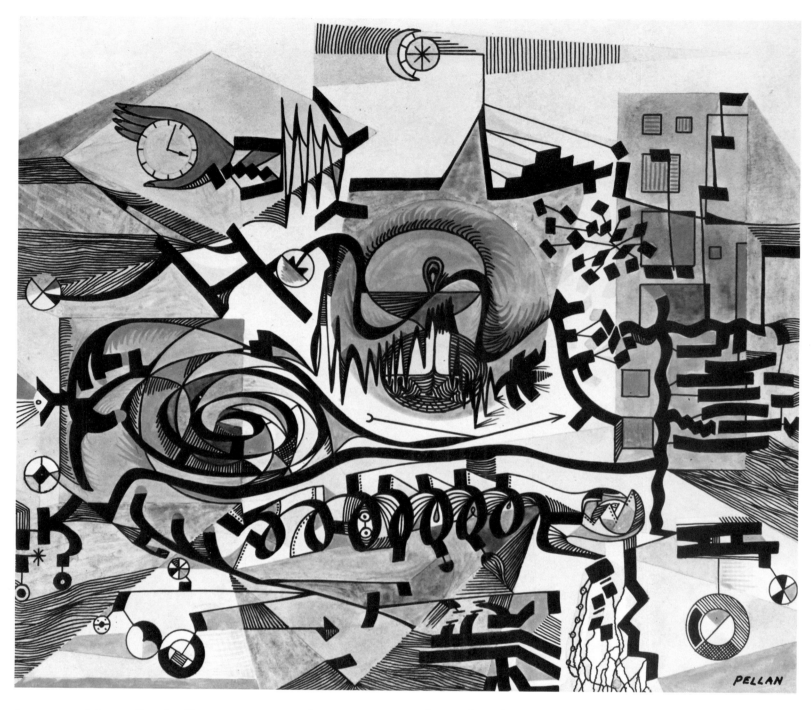

houses and farms for the East; snow-covered mountains, coniferous forests and totemic carvings for the West – as well as the vigorous composition and the knowledgeable harmony of his lively colours produced spectacular effects. In preparing his painting on the western theme, Pellan engaged in thorough research on the art of West Coast Indians so as to respect the spirit of the totemic figures. He was deeply impressed by the eminently decorative symbolism of the monuments, by the bold colours and the powerful drawing. There is no doubt this experience played a determinant role in the exploration of certain pictorial solutions demonstrated by his work. The totems gave rise to reverberations in Pellan. In them, he found a

form of aesthetic communion with his own preoccupations and personal discoveries.

A generosity in creation influences Pellan's work – an expansionary force which drives him to confront large surfaces. He can give free rein to his overflowing imagination and develop the most complex and tumultuous dreams by exploiting the irradiating energy of vast stretches of vibrant colour assailing the viewer and delighting him in a dizzying saraband.

During the period 1943 to 1947, Pellan executed a series of large-sized paintings which were an outgrowth of his experience as a muralist. Now, however, he adopted a radically "modern" approach. The female figure constituted

Derrière le soleil
1957
oil on paper/ huile sur papier
11 × 13
Private collection/
collection particulière, Toronto

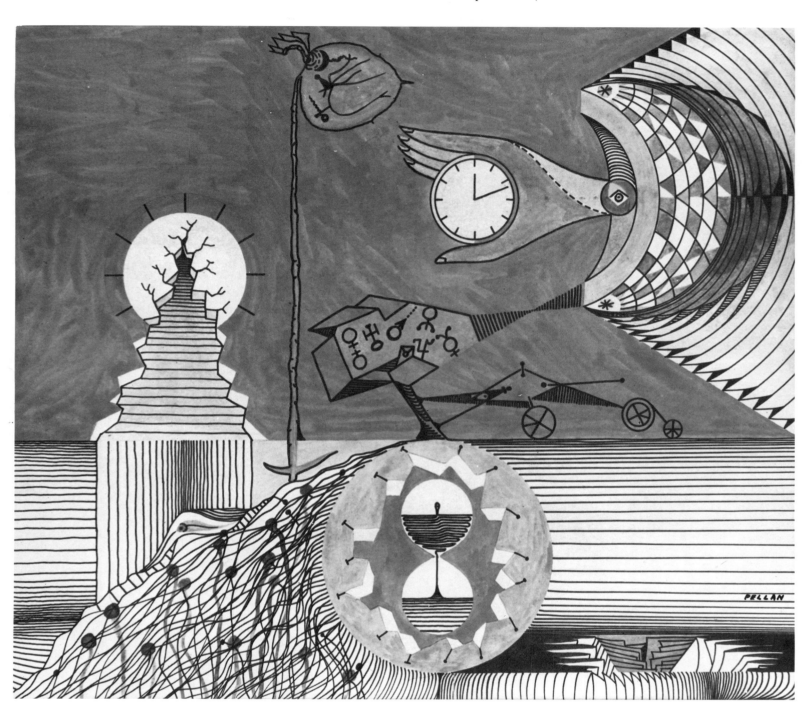

the principal theme of the series. But the figure appeared completely transformed, distorted and entirely submitted to the rules of drawing-colour dialectic. Pellan proved his extraordinary creative power, his extreme virtuosity, in no way diminished by the challenge of size and field of application. Indeed Pellan's paintings never suffer from the limitations of the frame. From the smallest to the largest, there is always balance, an adequation in drawing, forms and colours which defy supportive dimensions. Many small paintings he produced concurrently with the large-scale works easily prove the theory. The same involved world, the same complex drawing, a similar chromatic energy appear everywhere.

In addition to a proliferating production of paintings, varied experiments pinpointed the release of Pellan's reserves of imagination. In 1944, he created original drawings for a collection of poems by the Quebec author Alain Grandbois entitled *Les îles de la nuit.* A secret affinity established itself spontaneously between the language of articulated sounds of the poet and the coloured apparitions of the painter. Each seemed to emerge from the same obscure layers of the conscious or, one should rather say, the sub-conscious, with the same violence: "the day flowing between the columns of nights," chests swollen "with harsh cries", "the beaches of dawn", "the planetary tunnels" and the "mortal moment of a fleeting eternity" of the

81

Magie de la chaussure
1945
oil on canvas/ huile sur toile
84 × 37 1/2
Private collection/
collection particulière, Montréal

Bestiaire
1972
collage on masonry/
collage sur maçonnerie
69 × 51
House of the artist/
maison de l'artiste

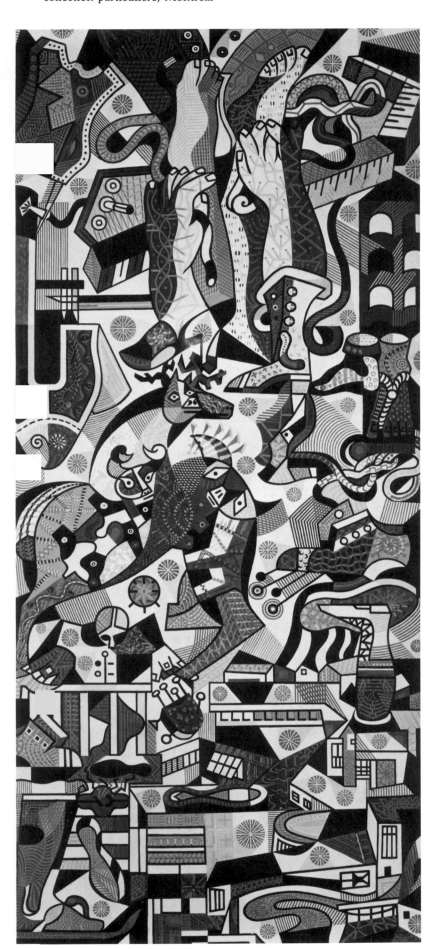

word magician were transformed into visions under the brush of the conjurer of reds, blues and greens.

The same year, Pellan for the first time took his place in the wings of the theatre at the invitation of André Audet, author of a radio series called *Madeleine et Pierre.* Pellan was asked to handle the conception of all visual supports for a play involving the same whimsical characters familiar to radio audiences but who had never yet been seen. Pellan made certain that this initial experience would remain engraved in people's memories. He designed everything – costumes, décor and properties. In this pioneer period in the history of Quebec theatre, technicians and set designers were virtually non-existent and Pellan himself executed the models. While he was new to the field, Pellan's success was convincing: he displayed a veritable fairyland of splendours based on a sensitive interpretation of the theatrical innovation of André Audet.

Pellan was fascinated by the breakthrough into another universal in which painting became a total environment, in which sculpture came alive, moved, constantly modifying the relations of colour. He did not hesitate for a moment to begin the adventure anew in 1946 when he was invited by les Compagnons de Saint-Laurent to conceive the décor of their next presentation at Gésu Hall. The troupe staged *Le soir des rois,* a French translation of Shakespeare's *Twelfth Night,* written by the French author François Marie Hugo.

Originally, Father Emile Legault, director of the company, was not terribly enthusiastic about the idea of entrusting a modern artist with the visual concept of the play. However, he gave in to the arguments of Jean Gascon and Jean-Louis Roux, both faithful admirers of Pellan. Father Legault perhaps still secretly entertained some concern when he saw the artist's sketches but if he did, he gave no such indication. The boldness of the metamorphosis Pellan carried out regarding all the elements of the period costumes, dresses, trousers, coats, hair styles and even the physiognomy of the actors was based on the wildest fantasy; Sir Andrew, clothed in dungarees, his limbs articulated, resembled a runner – red, green, green, red, a runner bursting from the cube surrounding his waist. On his shocking red mop of hair was a red-green apple. And what could one say about the skeletal appearance of the sombre Malvolio, wrapped in a skirt of transparent vinyl, his hair crowned with a tombstone?

The colour everywhere was beyond description. Each character became a surrealist or abstract painting adorned with decorative, at times symbolical, motifs defined in the liveliest colours. The faces of the actors did not escape the multi-coloured invasion. Each was divided vertically into two sections based on the nose line. One side was painted white, the other half green in some cases, yellow, red or blue in still others. Such an approach also accentuated the fairyland atmosphere – in their case, Pellan sought to

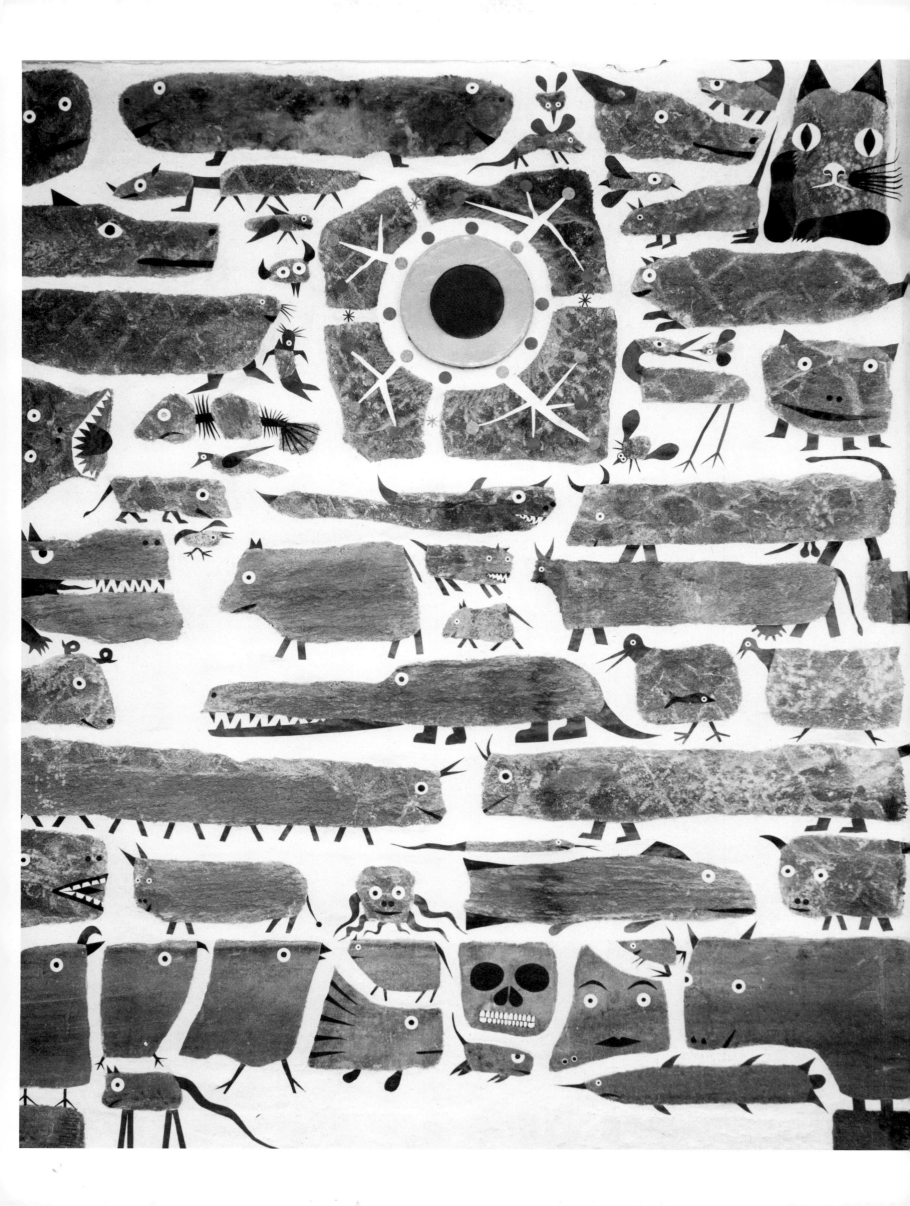

Les tréteaux
circa/ vers 1958
oil on paper/ huile sur papier
11 1/4 × 18
Private collection/
collection particulière, Montréal

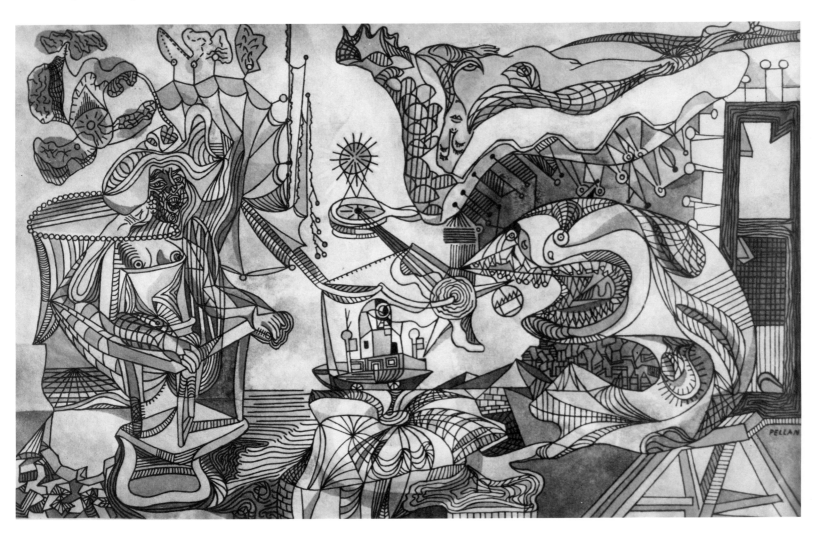

evoke the Peking Opera and the Bali theatre. The live paintings strolled in front of backdrops which were equally delirious in outline – coloured geometrics in movement continually recreating a visual symphony. The artist divided his canvasses into two horizontal regions: dark colours dominated in the lower part while lively colours exploded in the upper sections, thus bringing out, on the one hand, the colours of the costumes and, on the other, providing a more effective play of colour between the costumes and the upper sections.

Certainly, the unfolding of the dramatic action as well as the poetic content of Shakespeare's text, already considerably altered in translation, faced a severe test in the confrontation with the Pellanian fairyland. One may ask whether the public had greater appreciation for Shakespeare or Pellan. Pellan's spectacle clearly created a sensation and the play marked a milestone in the brief history of the Gésu company. Beyond the partitions of artistic disciplines, the vehicles of expression, word, movement and image, in a magical place where wild imagination reigned, had not a happy encounter taken place, sparked by

poetry, between two incomparable enchanters, Shakespeare and Pellan?

Yet it had not been an easy adventure because Pellan had had only one month to conceive and develop everything. It had been a wild race against the clock. A group of students helped him in the execution of five huge backdrops. He had had words with the recalcitrant wardrobe mistress. He had had to convince pretty actresses to allow "strange" makeups to be applied to their faces.

The brilliant achievement was not soon forgotten. In the spring of 1967, Jean-Louis Roux, who had become artistic director of the Théâtre du Nouveau Monde, was commissioned, on the occasion of the Stratford Festival, to present a collection of theatre costume and stage set designs for an exhibition called *One Hundred Years of Theatre in Canada.* He remembered the dazzling visions of 1946 and immediately called upon Pellan to participate. The sketches and models were still available, as fabulous and admirable as twenty years before. Roux was impressed by their artistic actuality. After all that time, they had retained astonishing avant-gardism. Created long before the expression,

Vitrail
1960
oil, ink on paper/
huile, encre sur papier
8 × 7
Mr. and Mrs. Arthur M. Maron,
Montréal

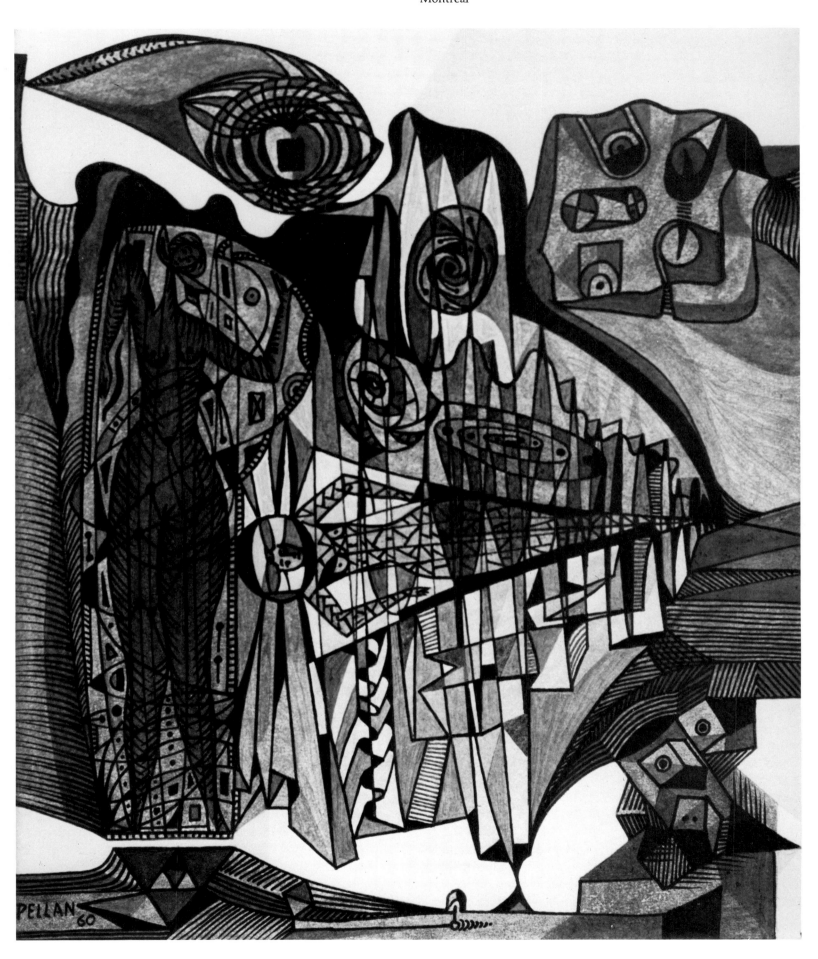

Vitrine
1960
oil on paper/ huile sur papier
8 5/8 × 11 5/16
Private collection/
collection particulière

Fées d'eau
1957
cil on paper/ huile sur papier
14 1/2 × 10 1/4
Mme. Monique Lepage, Montréal

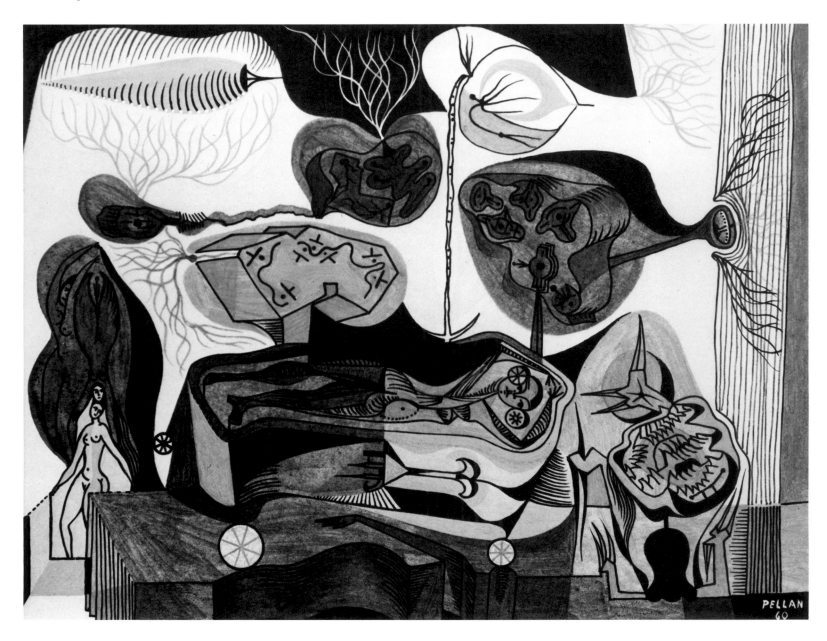

they rivalled the boldness of the psychedelics of the day. Roux's early enthusiasm was restored and he conceived the idea of presenting the play again, using the same visual content.

Pellan refreshed his drawings, retouched the sets and properties to satisfy the requirements of the new staging, even added three costumes for extras. The artist's task, compared with the first experiment, was considerably easier. He now was surrounded by a competent professional team: Lydia Randolph looked after the making of the costumes, Peter Gnass painted the sets, carpenters, stage hands, makeup artists all carried out their duties efficiently with magnificent cooperation. Pellan, however, assumed his responsibility to the very end. He conscientiously supervised the progress of work. On the night of the première, he himself applied the makeup to the cast.

La nuit des rois – the title was slightly modified – came alive again on the stage of Théâtre Port-Royal in Montreal's Places des Arts in December, 1968, and January, 1969, in an original adaptation by Roux.

In an article entitled *Nuit des rois au TNM ou l'Epiphanie de Pellan,* Martial Dassylva, theatre critic of *La Presse,* reported on a conversation he had had with the artist. He underlined Pellan's onmipresent whimsy and the effectiveness and originality of his plastic interpretation of the Shakespearean universe. How to classify this achievement among artistic phenomena? The critic did not try. "Is all this surrealistic? Psychedelic? When one speaks with Pellan, there is a feeling that he is beyond easy categorization or rather that categories have no hold on him because in the final analysis he trusts solely the resources of his imagination."

Since then, Pellan's costumes, admired as authentic

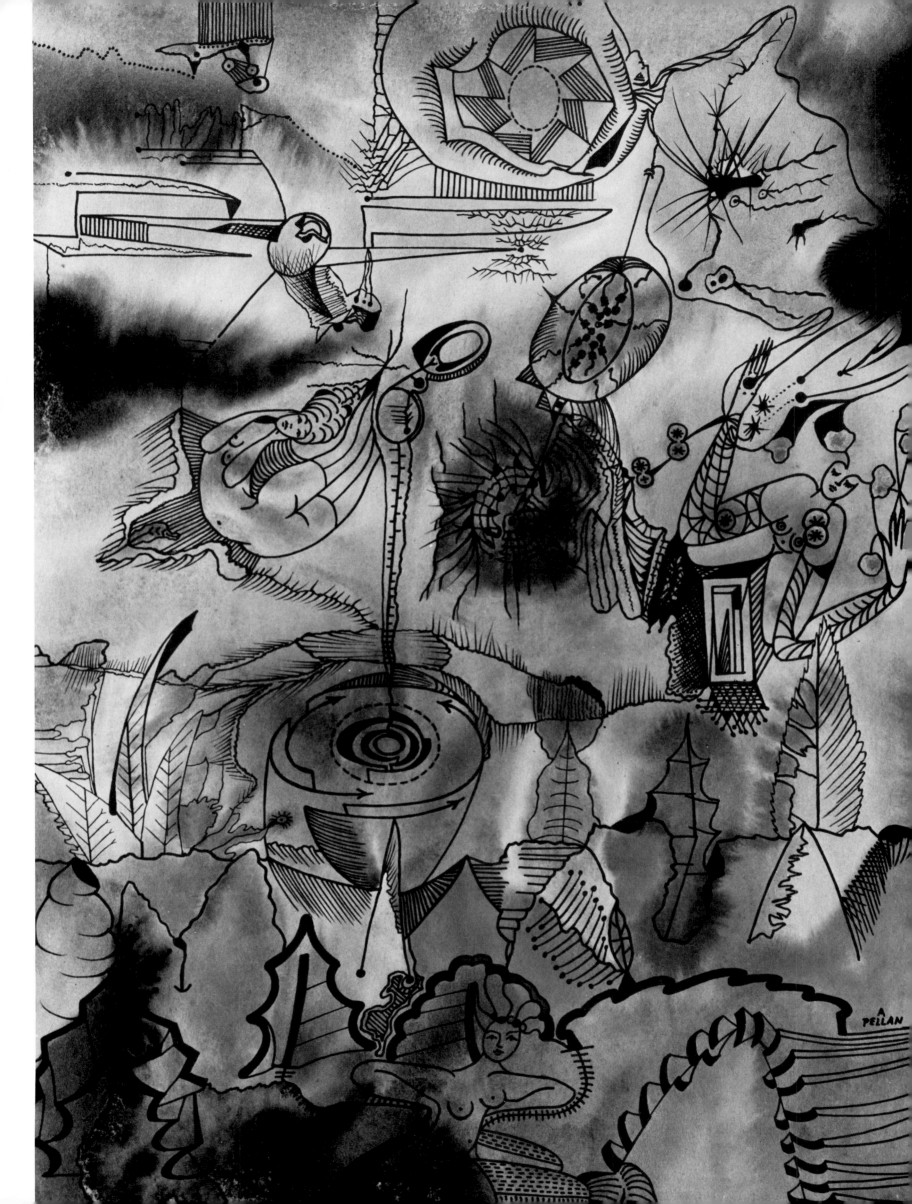

works of art, were shown in exhibitions, first at the Musée d'Art contemporain, in Montreal, in 1969; the Canadian Cultural Centre, in Paris, in 1971 and, more recently still, sixteen of them were included in the Pellan retrospective presented at the Musée du Québec, The Montreal Museum of Fine Arts and the National Gallery of Canada, Ottawa. Since the actors' makeup obviously disappeared with the end of each performance, a problem developed in 1970 when it was decided to show the costumes on mannequins in the exhibition. The solution arrived at was to paint the faces of the corresponding twenty-six characters on light masks of moulded plastic. Pellan meticulously coloured the masks and when he was through, his interest in the decorative game persisted. A good supply of virgin masks remained and he pursued his experiments, creating forty-nine other whimsical heads sprinkled with flowers, stars or lace, illuminated with fireworks or bordered by astonishing outlines.

Though the reduced teaching load did not prevent Pellan from multiplying his experiments at the creative level, the sum of energy expended in his dual activity did not allow him to devote as much time as he would have wished to the dissemination of his work. He had no major exhibition during the long period from 1943 to 1952. It was not until the spring of 1952 in the Galerie l'Atelier, in Ottawa, that one again could enjoy a one-man exhibition of Pellan paintings. Few, in fact, could be seen even in group exhibitions in the region: The Montreal Museum of Fine Arts in 1948 within the framework of the first official exhibition of *Prisme d'Yeux* and the *65th Annual Spring Exhibition* in which he won first prize for painting; the *Salon de peinture* of the Ecole technique de Trois-Rivières the same year and the Musée d'art de Granby in 1951. Pellan essentially took part in cross-Canada exhibitions generaly held outside the Province of Quebec or again in international exhibitions abroad. He was represented, for example, in the important exhibitions *Fifty Years of Canadian Painting* at the Art Gallery of Toronto in 1949 and *Canadian Art* at the National Gallery of Canada in 1950. He also took part in group exhibitions at the Andover Museum, Boston; the Morse Gallery of Art, Florida; the *Premier Salon des Réalités nouvelles* at the Palais de New York, Paris; the *Exposition internationale d'art moderne,* at the Musée d'Art moderne, Paris, and in Rio de Janeiro, and finally at the *Ile Mostra Internationale di Bianco ed Nero,* in Lugano, Switzerland.

In 1943, an art historian for the first time devoted a book to Pellan's work. In his *Art Vivant* collection, Maurice Gagnon published a monograph in which he sketched the rising curve of Pellan's career, underlined the great heights he had reached and especially reflected on the involved style of the work. Evoking the dream-world, surrealist poetry of Pellanian inspiration, he wrote: "Pellan knows of and desires the presence of his angels and monsters who multiply, rise and destroy themselves in him, which impose themselves on us with the inescapable force of enigmatic beings from whose toils there is no escape for their prey. Pellan's world is a world which follows us, which haunts us until it conquers us. We cannot be indifferent to it nor can we be led into it at the first contact."* The quality, the mastery of the plastic language which expressed visions of his unusual world, of his reverie, all aroused Gagnon's lyrical admiration: "What enchantment is Pellan's colour!" he wrote. " . . . We are carried from one joy to another: it shines, it bursts, it vibrates and resounds with intensity. Pellan wants trowelfuls of colour, dense within the circumventing limits of a firm, massive drawing, a massiveness which splashes in the pots of colours."†

" . . . Pellan's drawing is incommensurabl., extraordinarily palpitating with life . . . the outline circles the colour, penetrates it or emerges from it subjacently in luxuriant lianas which develop the poetry of a marvellous world."‡

The book was lavish in its praise and it significantly contributed to the enviable reputation Pellan enjoyed among the proponents of advanced ideas in art. Marcel Parizeau adopted the same attitude regarding Pellan in his articles in the newspaper *Le Canada.* It was amid this climate of enthusiasm that Pellan accepted the teaching post at the Ecole des Beaux-Arts. He was surrounded by friends and supporters among whom was Paul-Emile Borduas. "At the time, Borduas and I were friends. We were part of the same group. We saw each other frequently. We exhibited side by side and I even remember a marvellous evening we all spent together at my place – Borduas, Father Courturier, Gagnon, Parizeau and myself – eating oysters and drinking white wine."

It was not to last, unfortunately. At the very time when the forces of contestation should have joined together to wipe out the immobility of the established order in art, a regrettable quarrel divided them instead, slowing down the liberating *élan.* The common front broke down and each of them – Pellan at the Beaux-Arts and Borduas at the Ecole du Meuble – led the struggle on his own, though they had been friends only yesterday.

"When my appointment was confirmed, I called Parizeau to announce the news to him. He seemed very happy and offered me his best wishes. I then naturally thought of calling Borduas who, from the very first words, became violently angry. He didn't want to know anything. He said I was changing sides, that I was going to play Maillard's game. I tried to explain that no such thing would happen – the results certainly proved it – but he refused to listen.

* Maurice Gagnon, *Pellan,* L'Arbre, Montréal, 1943, p. 20. (Translation.)
† Maurice Gagnon, *op. cit.,* p. 14. (Translation.)
‡ *Idem,* p. 19. (Translation.)

Santorin
1956
oil, silica, tobacco on canvas/
huile, silice, tabac sur toile
13 1/4 × 17 1/4
Private collection/
collection particulière, Montréal

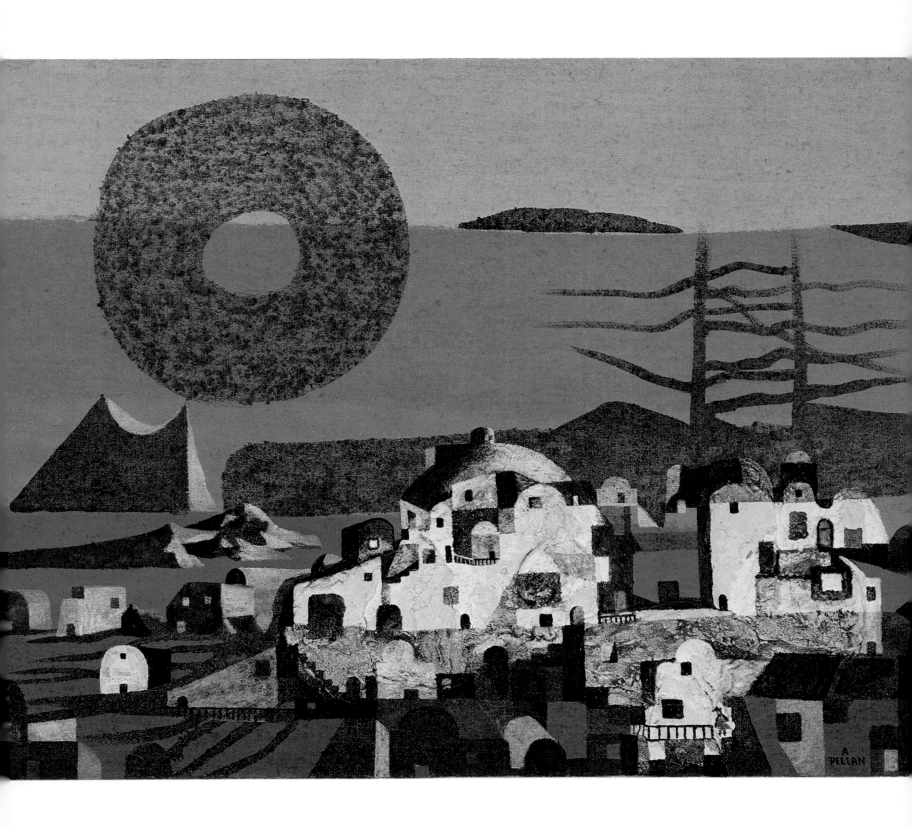

L'affût
1956
oil, silica on canvas/
huile, silice sur toile
35 × 51
National Gallery of Canada/
Galerie nationale du Canada, Ottawa

Icare
1956
oil, silica on canvas/
huile, silice sur toile
19 1/4 × 15 1/4
M. et Mme. Pierre Tisseyre,
Montréal

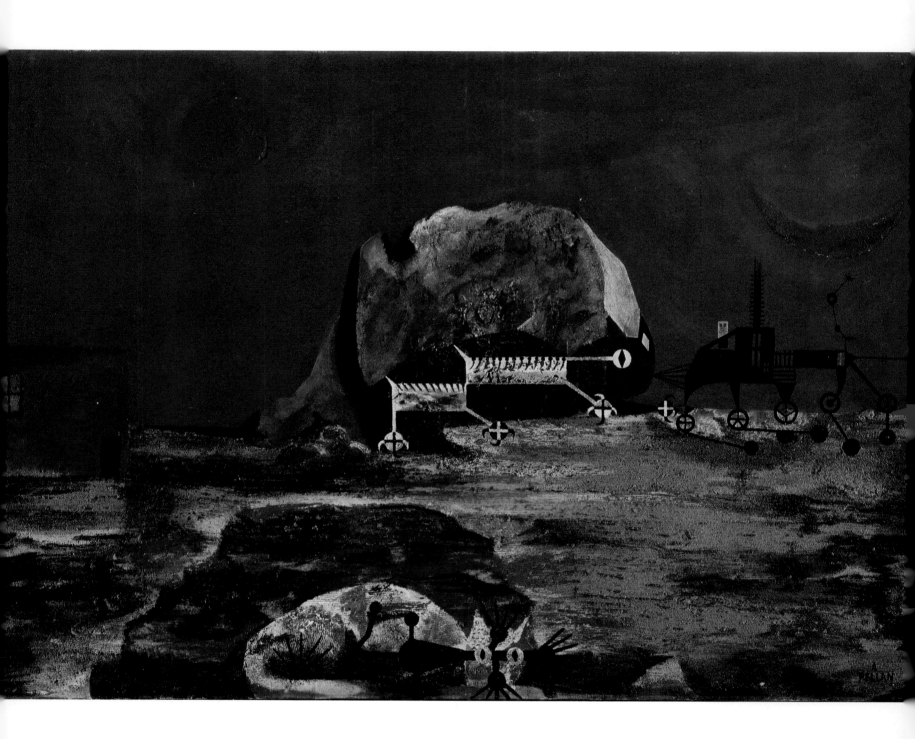

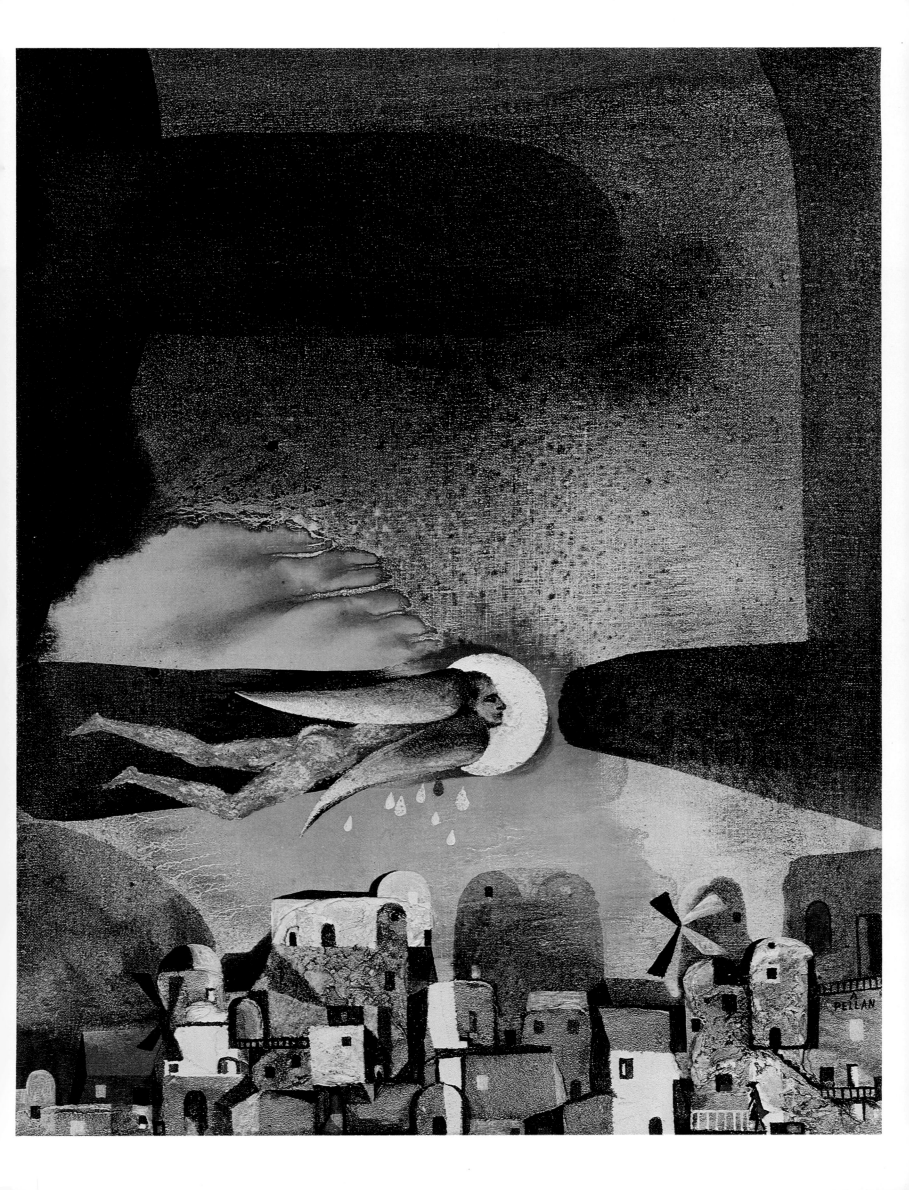

Adam et Eve et les diables
1962
oil on canvas/ huile sur toile
9 × 13
M. Guy Robert, Montréal

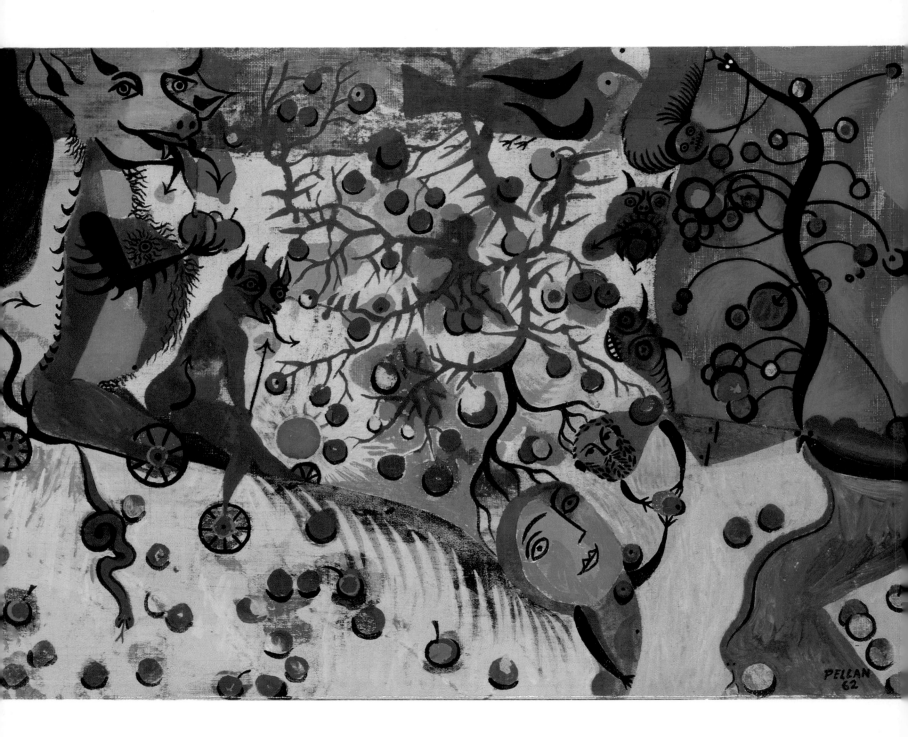

I even went to his house to clarify my position but it was pointless. It had become impossible to dialogue with him and I concluded that we had nothing more to say to each other." Pellan and Borduas never saw each other again. They did not speak to each other again. Their paths rarely crossed and the misunderstanding persisted, though no further verbal attacks took place.

What had happened which could explain such a sudden and violent reaction on Borduas' part? Rivalry between the two men for the same job? The collision of two radically different personalities at a time of great tension? An abrupt awareness of an ideological and aesthetic difference which insensitively until then had separated the two poles of animation of the Montreal artistic environment? Rather, it would appear that a complex dose of different elements was to blame. It is not easy to unravel the issue.

Borduas for a number of years had been giving drawing classes in public schools first of all, then at the Collège André Grasset and finally at the Ecole du Meuble where he had been for the last five years. His pictorial evolution had been long and exhausting. He had just begun to find his way and to experience his first success as a modern painter during his exhibition at the Ermitage in May, 1942. Pellan, on the other hand, as has been seen, had experienced a quick ascension. He had come back from Paris full of glory, sure of his knowledge and force. He even occupied an advantageous position in the mainstream of international art. Borduas admitted that the 1940 Pellan retrospective had strongly impressed him. Everything seemed easy for the dynamic, jovial Pellan. Everything seemed difficult for the worried and sombre Borduas.

Should one imagine a frustrated Borduas incapable of containing his jealousy any longer? It would be too facile and unjust an answer. Without too great a risk for his art, Pellan could allow himself to become part of the sanctuary of academism. He was convinced he could change things and it did not embarrass him unduly to rub shoulders with the retrograde elements of the milieu. It was important for him to be able to continue to paint freely and to pursue the development of the strengths which emerged in him during his Paris experience. He felt he could spread his acquired knowledge and promote the discovery of an original course in others. Borduas did not see things the same way. He was absolutely incapable of tolerating the presence of the forces of inertia. He thirsted for a freedom which, in his view, still appeared open to challenge. He felt everything had to be swept aside, that everything had to be rebuilt. His contestation went beyond the strictly artistic framework to deal with the social structures themselves, as evidenced in the 1948 manifesto *Refus global.* In Pellan's attitude, he saw a compromise with the establishment, with the old order.

Borduas closed the ranks of his students and disciples who shared his revolutionary views. Little by little, the group of painters who would identify themselves with the Automatist movement took shape – Jean-Paul Mousseau, Pierre Gauvreau, Fernand Leduc, Jean-Paul Riopelle, Marcel Barbeau and Marcelle Ferron. Little by little, too, they developed the terms of their pictorial aesthetics, of the automatic expression that Léon Degand defines in this way: " . . . advantageous submission to the solicitations of spontaneity, of pictorial freedom from discipline, of technical chance, of the romanticism of the brush, of the over-

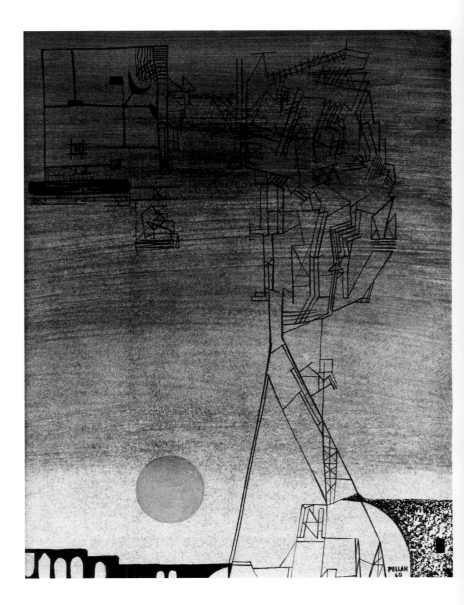

flow of lyricism." Its purpose was to express, directly and without the control of reason, the profound impulses emerging from the subconscious. Such aesthetics were rooted in the writing of surrealist authors, principally in the texts of André Breton.

If he believed in the value of chance revelations, Pellan rejected submission to its control alone: " . . . I had taken up automatism long before Borduas, and Monticelli had done so long before I did . . . In my view, automatism is

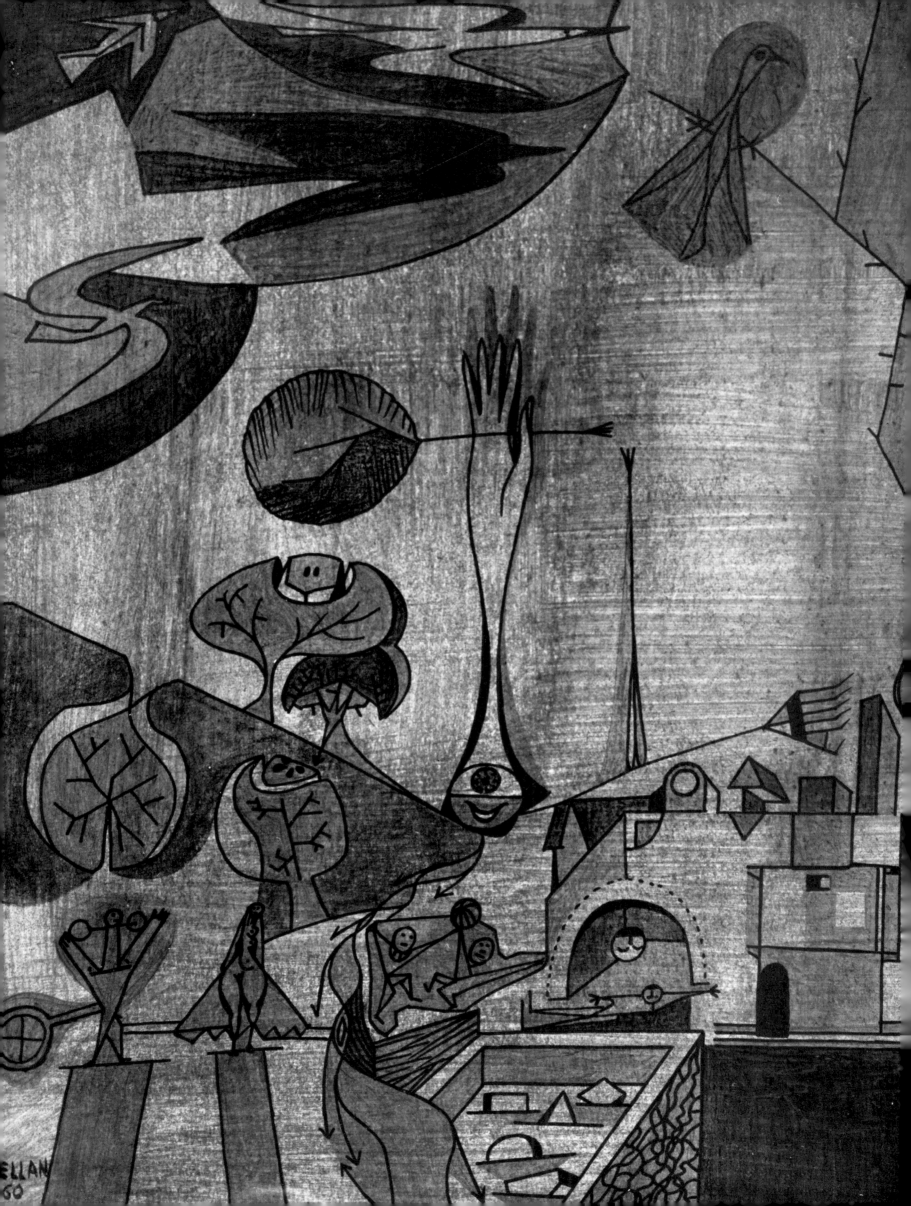

Par le bleu de la fenêtre
1960
oil on paper/ huile sur papier
11 7/8 × 8 7/8
Private collection/
collection particulière, Montréal

Joie de vivre
1960
oil on paper/ huile sur papier
13 × 10
M. et Mme. Jacques Vincent,
Laval, Québec

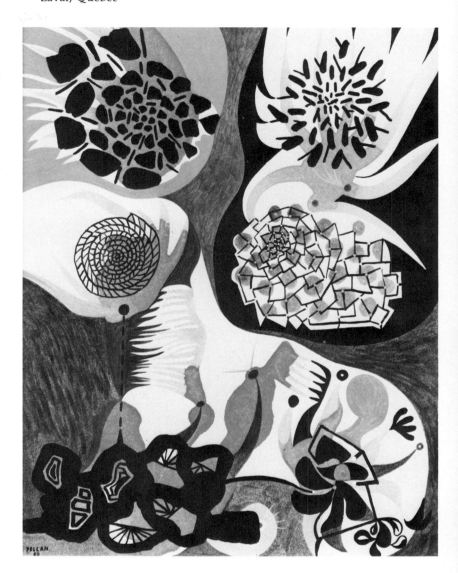

only a basic preparation; one must then elaborate the problems, develop and complete them. The example of Max Ernst is convincing. Automatism as conceived by the Borduas group is what I call facile painting." What seemed to affect Pellan most seriously was not so much the theories of the Automatist painters and their pictorial achievements but their progressive rejection of any other aesthetic proposition. Pellan could not accept Borduas' increasingly manifest authority over his disciples – Borduas, in a letter to Riopelle, did not deny his paternalistic intentions which had a tendency to grow. For Pellan, the struggle undertaken in the name of liberty paradoxically attacked the freedom of the artists and it was this factor which motivated establishment of the movement *Prisme d'Yeux:* "I have never had a tendency to organize seminars since it is not my work. I nevertheless joined a group of artists and we formed *Prisme d'Yeux* with the purpose of bringing together young artists, creating emulation and counterbalancing the Borduas movement. I wanted those who were working in another perspective not to become enslaved by Automatism and for them to be able to live from their art. Automatism had a great deal of influence on the young and was becoming their sole criterion."

The principal characteristic of the group assembled by Pellan was that it did not form a school. Pellan abominated schools. He never believed in them. "When I discovered European art, I did not make *a priori* distinctions among schools. I was fascinated by the diversified plastic solutions that artists proposed. I discovered contemporary art and not the credos of one movement or another." The text of the *Prisme d'Yeux* manifesto written by Jacques de Tonnancour and published in February, 1948, on the occasion of the first exhibition of the group at The Montreal Museum of Fine Arts is explicit:

From the movement of recent years, *Prisme d'Yeux:* a movement of various movements, diversified by life itself.

No new, special and specializing aesthetic! (regionalism at the spiritual level). The movement forces no one into a gallery where everyone, slaves of a possessive theory to be proven, will row without seeing ahead of them or behind them, without any hope of knowing where they are going.

On the contrary, *Prisme d'Yeux* rallies itself to the oldest, most tested, most contemporary aesthetic, today as it was in the caveman days; that which opens all paths, often opposed to one another but also possible and true as are day and night, fire and water. . . . Thus, the most revolutionary.

Prisme d'Yeux is open to all painting of traditional manifestation and expression. We think of painting which is subject solely to its deepest spiritual needs while respecting the material aptitudes of pictorial plastic art.

We seek a painting liberated from all contingencies of time and place, from restrictive ideology and conceived without literary, political, philosophical or any other interference which could adulterate expression and compromise its purity.

Pure painting? – Perhaps.

But to purify expression is not to diminish the human value of the work. It is rather a matter of raising it to a higher level from which its influence will extend even further.

The pictorial experience of each of us – this is our deepest wish – must be part of life and, consequently, become inherent in every other vital experience of which it will be the projection.

How else could it attain its claim to be universal?

Demanding on these points, *Prisme d'Yeux* wishes to grow by natural selection and bring together the sound forces of painting clearly oriented in this direction.

95

Danseuses en coulisse
1960
oil, silica on plywood/
huile, silice sur contreplaqué
11 1/4 × 8 5/8
Private collection/
collection particulière, Montréal

Jeunesse
1960
oil on paper/ huile sur papier
11 1/4 × 8 1/2
M. et Mme. L.-Jacques Beaulieu,
Montréal

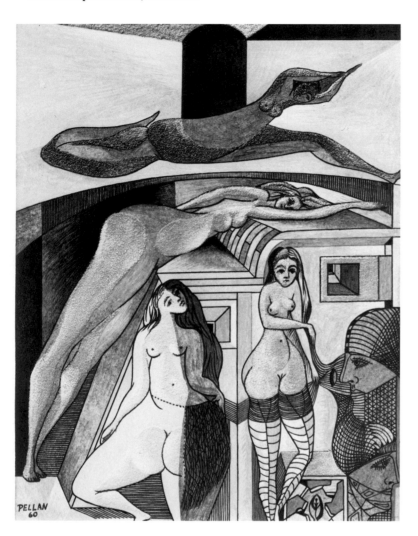

Prisme d'Yeux is not organizing against one group or another. It is being added to any other society which seeks the affirmation of independent art and in no way excludes the privilege of belonging to these groups as well.

It is with complete objectivity but also carefully that *Prisme d'Yeux* recruits its members. It judges only in terms of the intensity and purity of their works in regard to tradition.

The admission of a new member is not decided by the voice of a leader (*Prisme d'Yeux* has none) nor by an eligibility committee, but by the voice of the entire group, three-quarters of whom must be favourable.

In addition, we have unanimously rejected the jury formula which filters the submissions of its members before each exhibition. Through this decision, we leave to each member accepted full responsibility for his works, a responsibility not shared – in the eyes of the public – by the others. But in the group's eyes, its honour is involved. In this way, we believe we promote self-criticism, maintain maximum values and live from this ambition.

Thirteen artists added their signatures at the bottom of the document to those of Pellan and de Tonnancour: Louis Archambault, Léon Bellefleur, Albert Dumouchel, Gabriel Filion, Pierre Gauvreau, Arthur Gladu, Jean Benoît, Lucien Morin, Mimi Parent, Jeanne Rhéaume, Goodridge Roberts, Roland Truchon and Gordon Webber. A number of them had been Pellan's students at the Ecole des Beaux-Arts. They were friends and colleagues who saw each other regularly but without forming a group with homogenous ideas. Undoubtedly, they thought alike on the points raised in the manifesto but they did not engage in a common struggle. They saw each other mainly during the years 1946-50 at the Ecole des Arts graphiques, then located on Kimberley Street, where Albert Dumouchel was teaching printmaking. Enjoyable moments were spent preparing the three editions of *Les Ateliers d'Art graphique*. In addition to those who signed *Prisme d'Yeux*, the people present often included Jean-René Ostiguy, Jean Léonard, Gérard Tremblay, Gilles Hénault and Roland Giguère. It was a warm and animated group and Pellan was happy to be part of it. He recalls having introduced an artistic and literary exercise which he had seen practised by surrealist painters and writers – Aragon, Eluard, Tanguy, Breton, among others – at sidewalk cafés in Paris, the game of "exquisite corpses."

As Jean-René Ostiguy recalls, "It involved folding a sheet of paper into four or six equal parts, based on the number of participants, so as to divide the height into that many horizontal bands. Then, using colour pencils, each of the players, without his neighbour seeing it, would execute the drawing of his choice. In the margin he would write a text related to the sketch. The second player received the paper folded over. He had to continue the drawing, using the lines or spots from the previous player which had spilled over into his section. He also had to add a few words, one of which was to appear in the next section."*

The *Prisme d'Yeux* movement, essentially because of its broad concept and lack of cohesion, crumbled bit by bit while the *Automatiste* group gained increasing importance following publication in August, 1948, of the explosive manifesto *Refus global*. A vehement denunciation of all oppressive forces of society, it provoked a violent reaction on the part of the authorities and Borduas, dismissed from the Ecole du Meuble, became a hero figure. Deep hostility swept the literary and artistic world because Borduas had been so severely repressed. The blowup propelled the *Automatiste* movement into the front rank of the art world, plunging into the shadows the individual achievements of artists not affiliated with the school. Pellan became more or less rejected by Quebec's intelligentsia which swore by *Automatisme*. "Snobbery was part of it," he recalls. "It

* Jean-René Ostiguy, "Les cadavres exquis des disciples de Pellan," *Vie des Arts,* no 41, été 1967, pp. 22-25. Translation.

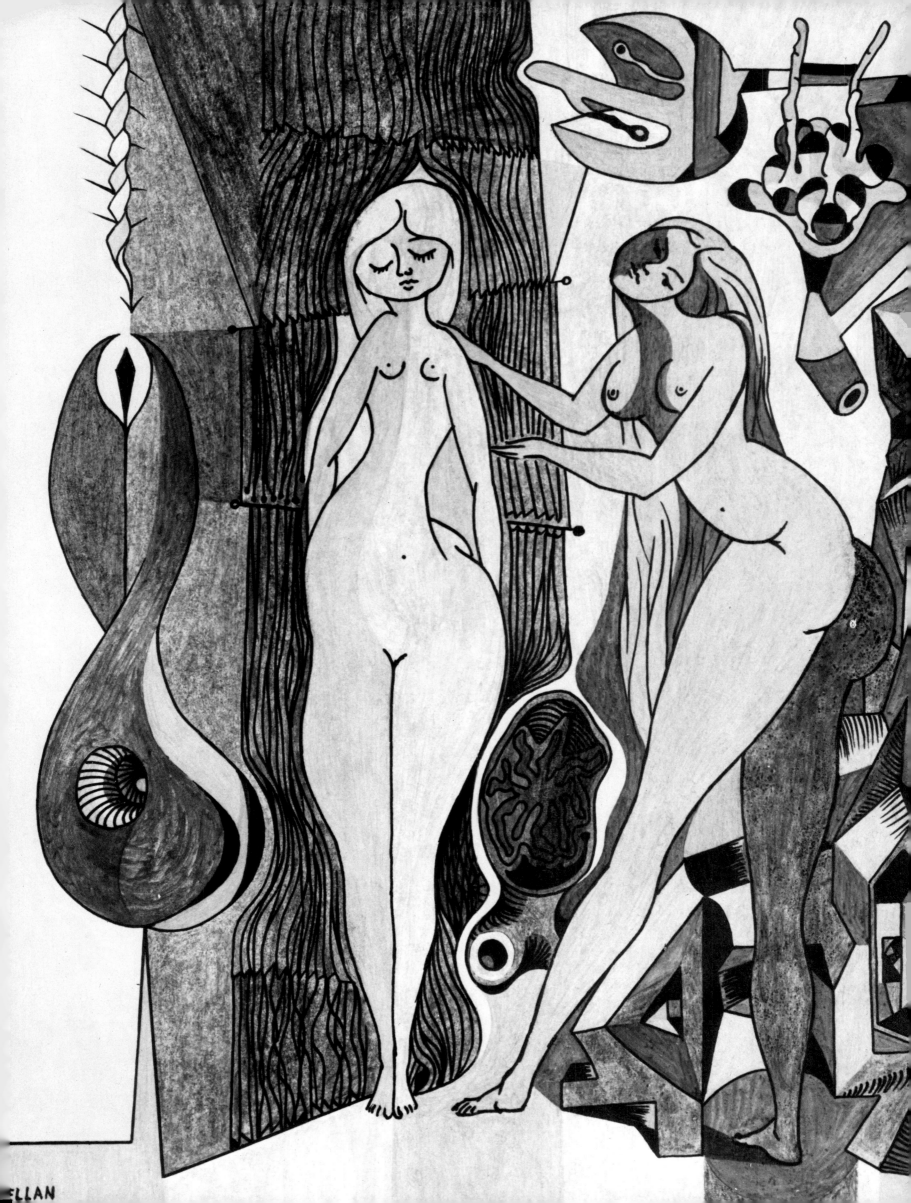

Les mécaniciennes
1958
oil, silica, polyfilla on canvas/
huile, silice, polyfilla sur toile
11 × 17
Sir George Williams University, Montreal
donated by/ don de Max and Hellen Steinman

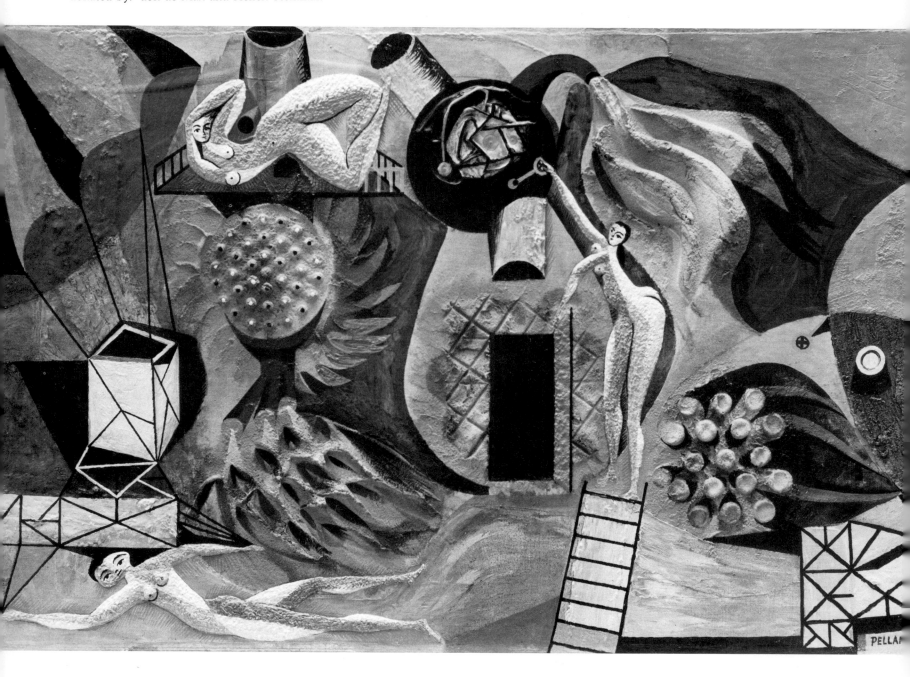

reached such a point that I was laughed at when I exhibited."

Certainly, Pellan maintained some of his supporters, among whom were de Tonnancour, Gladu, Dr. Paul Dumas and, particularly, a charming young woman, Madeleine Polisena, who was to occupy an important place in his life. Pellan had noticed the slim, dark girl among the students of the Ecole des Beaux-Arts. One night in 1947, at a reception in de Tonnancour's home, he was delighted that he had a chance to get to know her better. He was bowled over by the girl and the first time they went out together, Pellan discussed marriage. At first, Madeleine was not convinced, even though she enjoyed the company of the colourful man. Later, looking beyond the seductive image of the committed teacher and celebrated artist, she discovered the sincerity and depth of his feelings. After a diligent courtship, Pellan married Madeleine on July 23rd, 1949.

The apartment-studio on Jeanne Mance Street where Pellan had lived for about ten years no longer was suitable. They began a search for a larger, more practical and, if possible, more modern dwelling with good lighting because Pellan wanted the vast studio he had dreamt about for so long. But it was not easy to find such a place, and finally Pellan decided to get a house of his own which he could set up according to his own specifications.

During a visit to the nearby countryside, he spotted an old Canadian house on a quiet road which hugs the meandering rivière des Mille-Iles. It was not really what he was

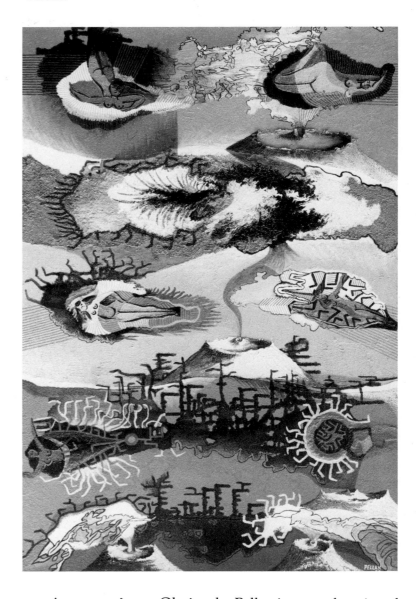

Mirage
1959
oil, silica on canvas/
huile, silice sur toile
36 × 25
Mr. and Mrs. John H. Pollock,
Toronto

looking for but the house was attractive and the calm around it appealing. He could paint there in peace and develop his work without constantly being disturbed.

The matter was settled. Alfred and Madeleine Pellan acquired the Auteuil house. They still live there. The antique house has been vigorously refurbished, making it youthful in appearance. It was not a simple job. Pellan, with his wife, spent hours and hours restoring the house and rearranging it according to his personal taste. The roof, the floors, the walls, the stairs, everything has been done over. He installed a superb *atelier* on the first floor after completely changing the divisions of the rooms on the main floor.

Mason and carpenter, Pellan also became a cabinet-maker. He conceived and built most of the furniture. It is solid, functional, and impeccably finished. "I lost a lot of painting time," he confides, somewhat regretfully. But the effort was well worth while. Pellan's house is unique. It is a painting, a habitable sculpture, a plastic environment – an authentic "Pellan." The interior shell is white. The walls, ceilings, moveable partitions, the chests, book shelves, coffee table, everything is white and in this immaculate field, objects dance a saraband of all the colours of the prism: shells, a long saw, an old lock, a Chinese abacus, old pots, a decoy garbed in rainbow stripes, dried flowers, the miniature locomotive, part of a fishing net with large floaters, books, masks, paintings certainly, multi-coloured stones, blue, red and mauve cushions. A whirling delirium of colour! On each of the objects and on their assembly reign the spirit and poetry of Pellan who arranges them, makes them confront each other, gives them life. They, in turn, become elements in the universe-painting.

Pellan's extreme concern for perfection in details, which always is evident in his paintings, is seen everywhere in the house. Everything has been done carefully; everything has been organized with the utmost planning. There is movement and celebration, but there is no garishness. A constantly alert sense of intuition ensures control everywhere. Pellan vigorously denies any categorization and systematization in his expression but he insists on seeing clearly by creating order around himself. A visit to his studio is most revealing: each tool, each pot of colour is clearly identified and on its proper place on the shelves or in the drawers. Each painting is catalogued in an index file and illustrated by a photographic reproduction. Pellan's universe is ruled by choreography and he is its sole master. It has never been otherwise.

In December, 1952, Pellan obtained a one-year bursary from the Canada Council. He left his teaching post, packed his bags and, accompanied by his wife this time, left for Paris again. His second stay in the French capital was to last three years, but it was not to have the same flavour as the previous experience. Obviously, Pellan immensely enjoyed the possibility of seeing once again the scene of his exalting discoveries, his joyous tours, and especially of introducing Madeleine to the marvels of Paris. But the soul of the Paris he had known twelve years before was gone. Paris had changed and Pellan had become a stranger. He was disappointed. Paris had not recovered well from its war wounds, its suffering, and its privations. Economic factors had altered the climate of relaxation and camaraderie, and the artistic milieu felt it. Art had become a stock market operation, in which each artist endeavoured to raise his own shares. Daily survival was often a struggle. Pellan, who had experienced the generosity of the pre-war years, felt Paris had become cold and narrow. He had tremendous difficulty finding a proper studio and comfortable flat. He lived at 19 bis Avenue Victor-Hugo, Boulogne-sur-Seine, just above the home of André Malraux, whom he met occasionally: "Malraux spoke dizzyingly of his trips, of prints and Chinese dynasties. He built fantastic worlds, tumultuous civil-

Luna Park
1960
oil, silica on canvas
37 × 29
Kitchener-Waterloo Art Gallery,
Kitchener, Ontario

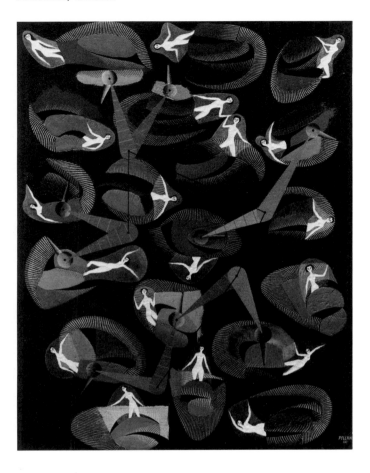

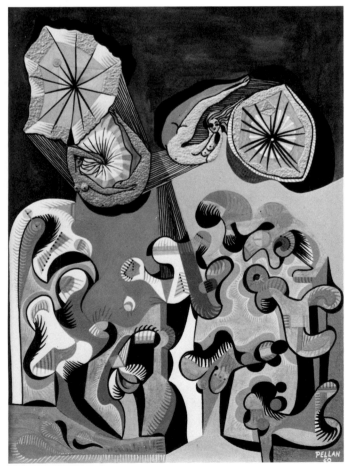

Joyeuses joaillières
1960
oil, silica on canvas/
huile, silice sur toile
13 × 9 1/2
André Martin, Q.C., Montréal

izations, with unbelievable nervousness and volubility.. . . . "*

But Pellan had not returned to Paris to stir up old memories. As soon as he found a place to work, he rediscovered his own world. It burst into life when his paint brush, impregnated with colour, touched the virgin canvas. He had brought with him a large collection of his paintings hoping to show them in Paris. In fact, a number of significant exhibitions paced his second Paris period. He presented a series of small paintings at the Cercle Paul Valéry, then a more substantial selection of works from different periods at the Coq Liban. During a visit to the latter exhibition, André Breton wrote a note of appreciation in the visitors' book: "Toutes les lampes intérieures au pouvoir de mon ami Pellan." The Quebec artist also had the pleasure of exhibiting with great European painters; he participated in the *Salon de Mai* of the Musée municipal d'Art moderne which included works by Chagall, Léger, Manessier, Picasso, Hartung, Soulages. But the most memorable event of Pellan's stay in Paris unquestionably was the important retrospective of his work at the Musée national d'Art moderne in Paris in February and March, 1955.

General Georges P. Vanier, Canadian ambassador to France, and René Garneau, cultural attaché, had made the initial approaches and then Jean Cassou and Bernard Dorival, curator and assistant curator, respectively, of the Musée, visited Pellan's studio and decided to open the galleries of their museum to him.

It was a masterly recognition of the value of his work and the place it had achieved outside Canada. Not any artist can exhibit in that celebrated museum. Only painters with a truly international status are honoured by it. Pellan was the first Canadian artist to enjoy the privilege. The exhibition of his work was the bridge between those of two painters known throughout the world: a retrospective of the work of Derain, who had died shortly before, and the Braque exhibition. The greatest number of Pellan works ever brought together until then were shown – more than 180 paintings, drawings and costume and stage set designs.

The reaction of critics was quick in coming and articles praising Pellan's work appeared in a number of French papers, including *Le Monde, Le Figaro, l'Information, Combat,* as well as in such periodicals as *La Revue française, Le Jardin des Arts* and *Cahiers de l'Ouest.* In an article entitled "Alfred Pellan and the keys of enchantment," published in the *Revue française* in August, 1955, Renée Arbour-Brackman recognized Pellan's stimulating effect on young Quebec painters: " . . . he accomplished in his milieu the same task as the Impressionists, the Fauves, and the Cubists when they began." Further on in the review, she made this comment about the painting *La chouette* which, following the

* Quoted by Guy Robert in "Pellan peintre magicien," *Le Magazine Maclean,* janvier 1963, p. 41. Translation.

Jardin jaune
1958
oil, polyfilla on canvas/
huile, polyfilla sur toile
51 1/4 × 73 1/2
Mr. William Shenkman, Ottawa

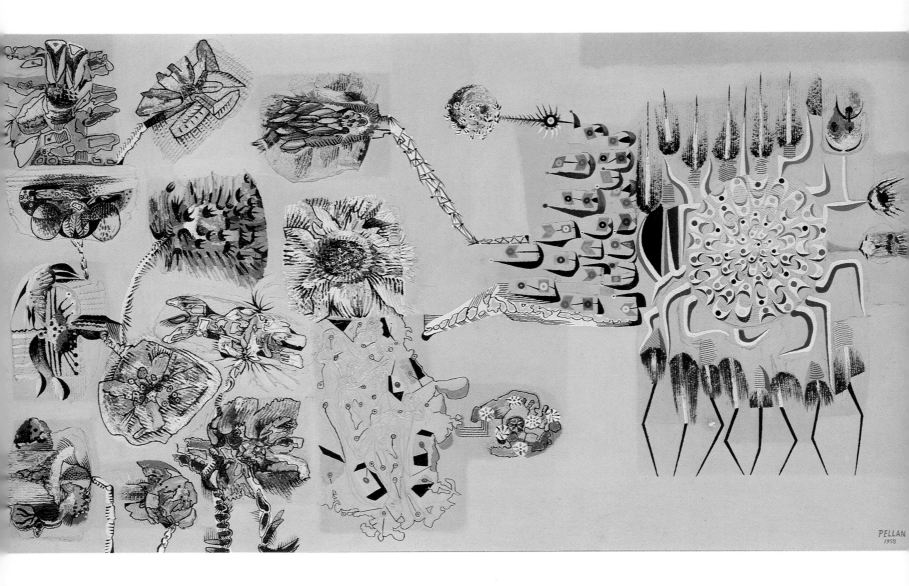

Jardin rouge
1958
oil, polyfilla on canvas/
huile, polyfilla sur toile
51 1/4 × 73 1/2
M. Doris Lussier, Saint-Bruno,
Québec

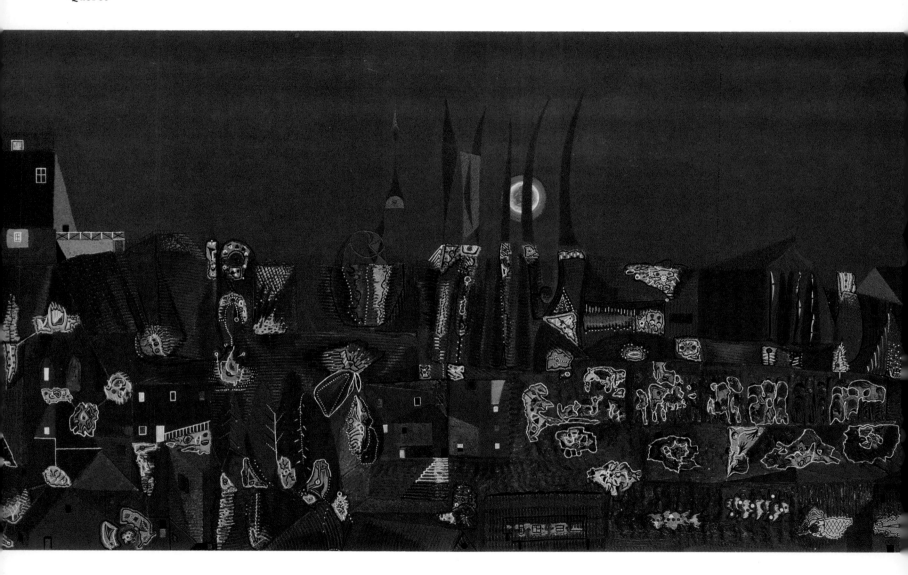

Jardin bleu
1958
oil, polyfilla, tobacco on canvas/
huile, polyfilla, tabac sur toile
51 1/4 × 73 1/2
Private collection/
collection particulière, Montréal

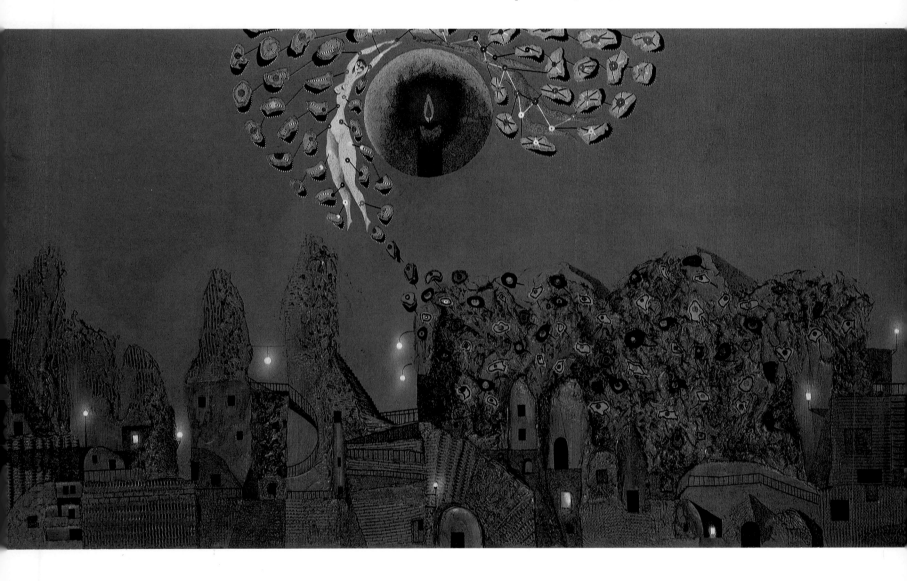

Jardin mauve
1958
oil, polyfilla on canvas/
huile, polyfilla sur toile
51 1/4 × 73 1/2
Private collection/
collection particulière, Montréal

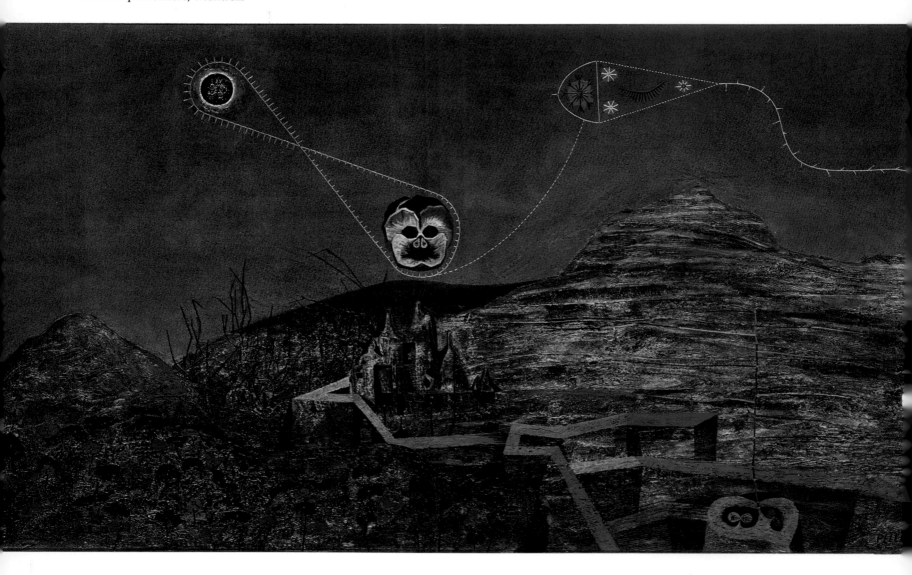

Jardin orange
1958
oil, polyfilla on canvas/
huile, polyfilla sur toile
51 1/4 × 73 1/2
Dunkelman Gallery, Toronto

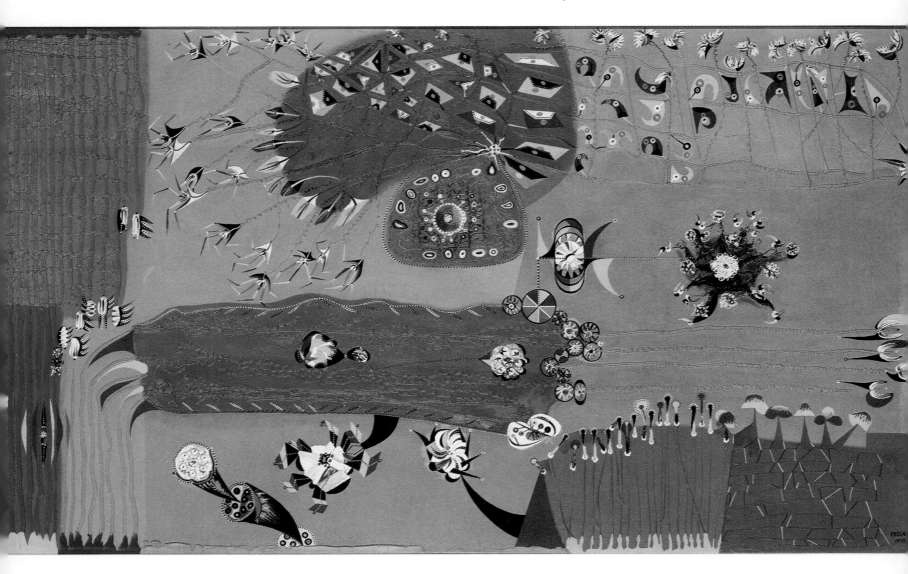

Jardin vert
1958
oil, polyfilla on canvas/
huile, polyfilla sur toile
51 1/4 × 73 1/2
Musée du Québec, Québec

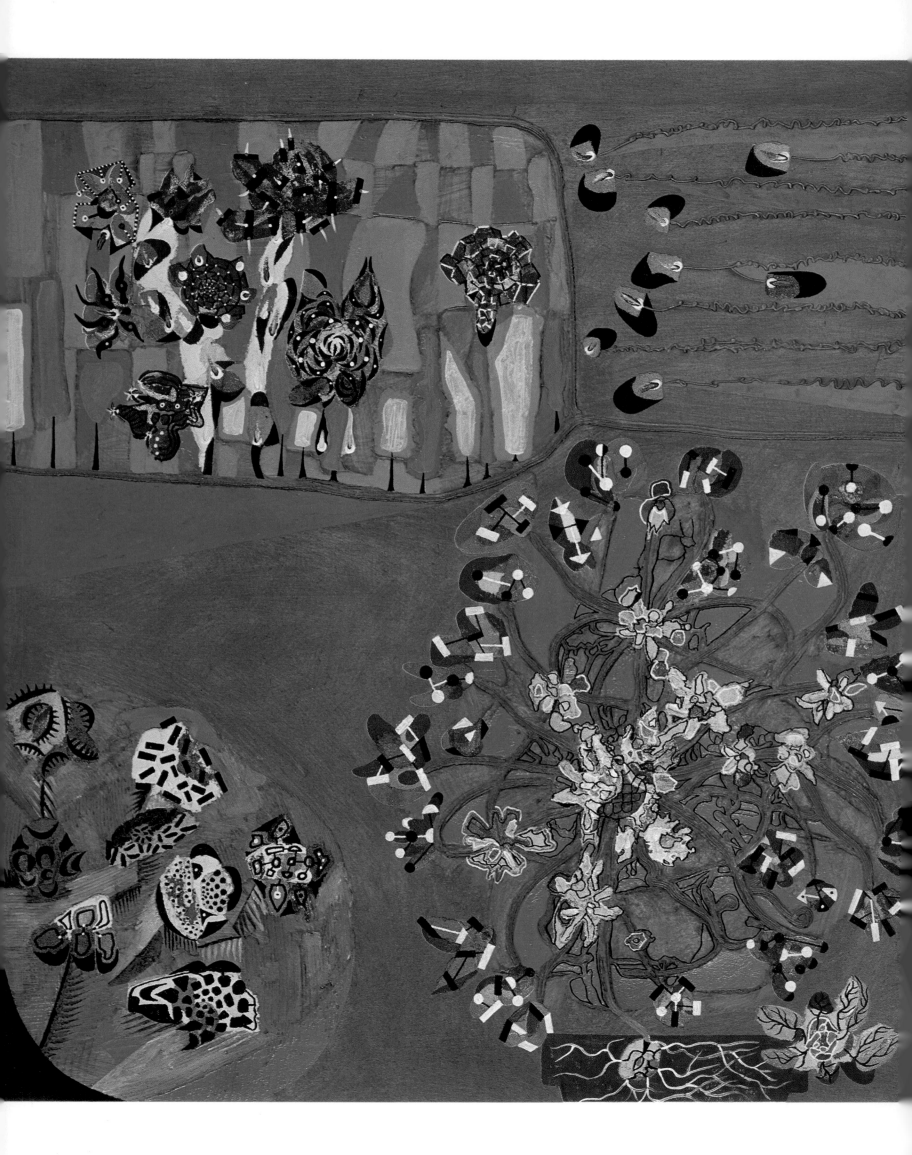

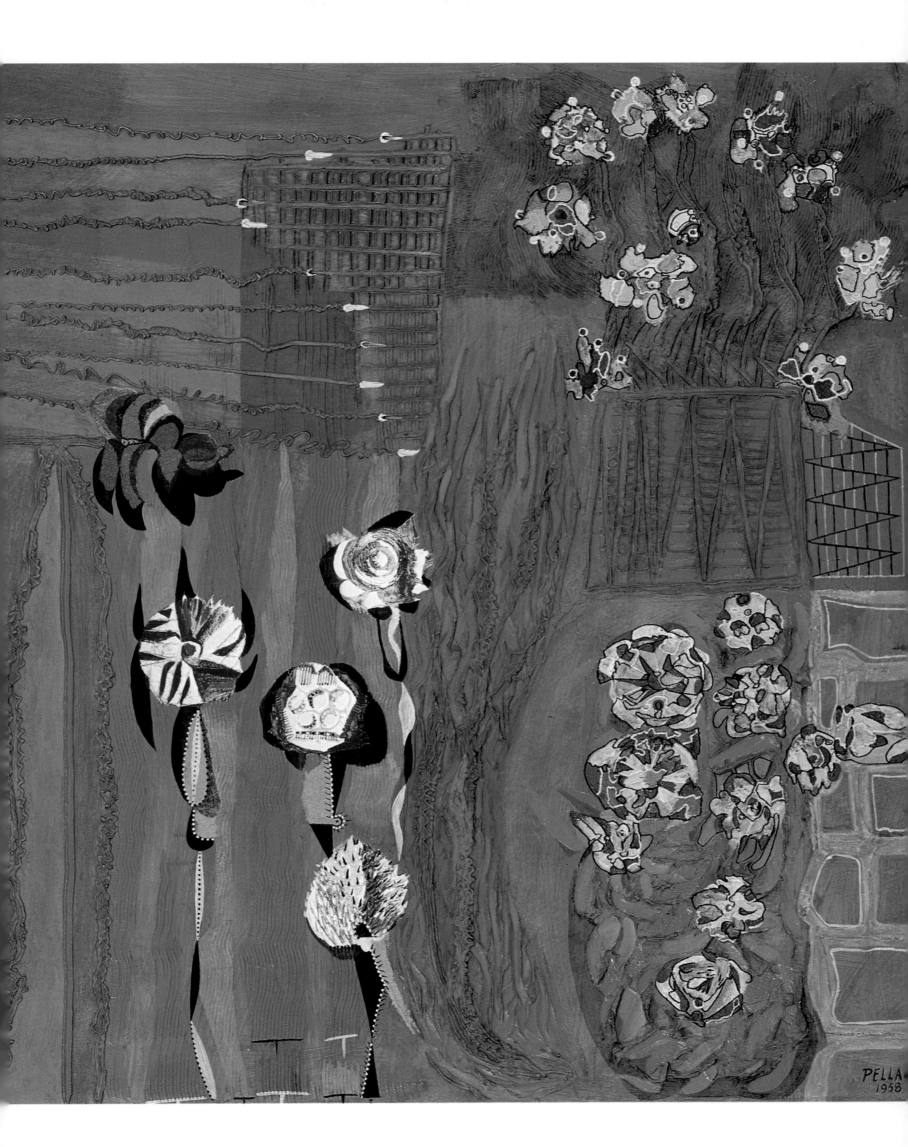

Jardin volcanique
1960
oil, silica, tobacco on canvas/
huile, silice, tabac sur toile
51 1/4 × 73 1/2
Musée des beaux-arts de Montréal
donated by the Ladies' Committee/
don du Comité féminin

Fleurs d'eau
1956
oil on canvas/ huile sur toile
15 × 19 3/4
Private collection/
collection particulière, Montréal

exhibition, was acquired by the Musée national d'Art moderne: " . . . it is a large canvas on which the green, rose, white and mauve risk the acidity of a spring countryside around an elegant aerial figure similar to one of Botticelli. The sensuality present in the whole of Pellan's work is more veiled here, less triumphantly displayed, closer to the tenderness of Donatello than the abundance of Rubens."

The vibrations of the Parisian triumph travelled poorly. The echoes had been muffled by the time they reached Montreal despite the zeal of Paul Gladu in *Le Petit Journal* – "Pellan represented us well" – to shake the lethargy of art lovers and critics. The conspiracy of silence continued to ignore Pellan at the very time he experienced one of his most glorious achievements. Gladu expressed the disquiet such a deplorable attitude caused in him: "Must our ignorance and envy always chase abroad those who, in fact, portray us in a flattering light? . . ."

The faithful friend could be reassured: Pellan did not remain in Paris but returned home. Deep inside him, he had never really left and despite his isolation, he had made a point of taking part in group exhibitions on Canadian circuits. In 1953, he sent works to *Festival de Montréal* and participated in the exhibition *Canadian Painting* of the National Gallery of Canada. Later, he was regularly represented in most important exhibitions at the national level. He was constantly invited to join Canadian delegations in numerous presentations abroad. His work was shown in such widely separated points as Jerusalem and Mexico, Utrecht and Australia, Cologne, Spoleto, and Japan.

When he returned from Paris in December, 1955, he had not had a one-man show of his work in Montreal for nearly fifteen years. It was more than time that someone in Montreal should offer him what an international centre had not hesitated to do a year before. Mayor Jean Drapeau took the initiative. Meeting Pellan during an opening, he proposed that an exhibition be organized in the Hall of Honour of Montreal's City Hall. Pellan gladly accepted and the exhibition was held November 6th to 30th, 1956. Pellan seized upon the occasion to publish a statement in which he briefly indicated his concept of art and warned the public against the facility of certain efforts:

"The pictorial effort is essentially free. Painting is based on emotion and revelation which, to express themselves, have at their disposal the 'unpredictable' means of plastic and poetic inventiveness.

"There exists in the present movement – without referring to the 'pompiérisme' always with us – a desire to escape, leading too often to cold abstraction or limited automatism both of which run the risk of sinking into academism. All these techniques can be excellent; the danger is that they become an end in themselves. The avantgarde has had these means of investigation available for a long time; humanization and development of painting are essential.

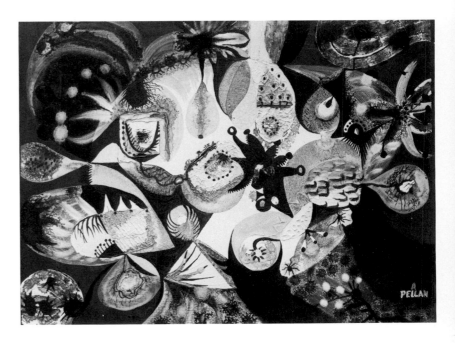

"Contemporary art will become decadent if it continues to be satisfied with facile endeavours. It is up to us to attempt to make a lasting work of it in line with the art of the great periods."

One might have expected a lively reply from the disciples of the theories Pellan challenged. But the howls came instead from a totally different quarter. A city councillor – formerly the chairman of the public morality committee – became the spokesman for a few colleagues who were horrified to see in the City Hall exhibit "a concept of woman which is certainly not in keeping with our mores." They accused the Mayor of having "converted the Hall of Honour into a pigsty for a month." Without the Mayor knowing it, contacts were made with the Archbishop's Palace to have certain works censored. The very next day, newspapers announced that some of the paintings were to

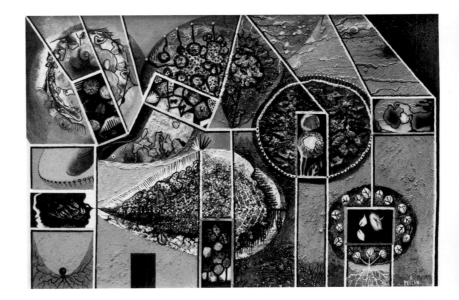

Maison de verre
1956
oil, silica, glass on plywood/
huile, silice, verre sur contreplaqué
20 × 30
Dr. Camille Jourdain, Chicoutimi

109

Jardin étang
circa/ vers 1956
oil, silica on paper/
huile, silice sur papier
15 × 20
Dr. and Mrs. Henry E. Duckworth,
Winnipeg

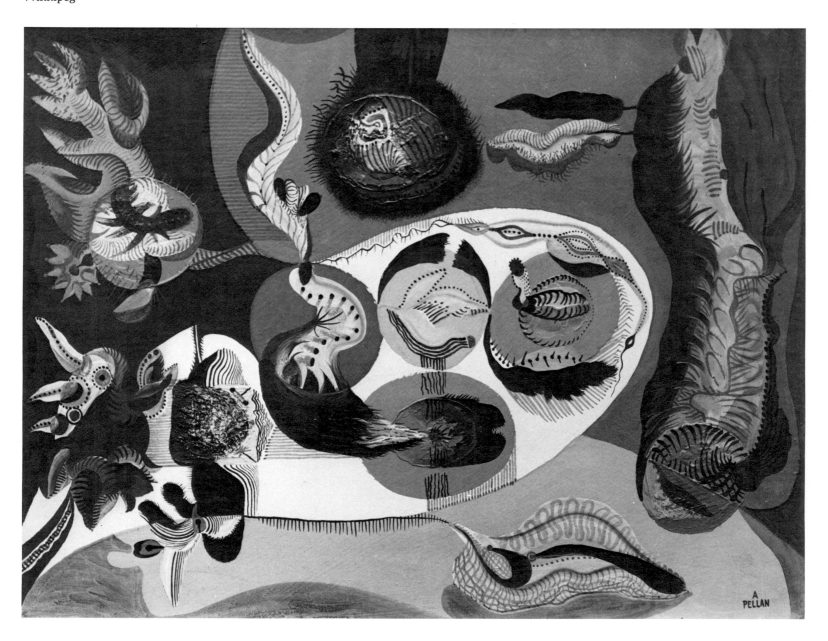

be withdrawn. Pellan went to the Mayor and told him that "the only acceptable solution is to hang the censored paintings with their faces to the wall and to clearly identify those responsible for the censorship." After consultation with the Archbishop's Palace, it was finally decided, climaxing days of suspense, not to withdraw anyting important: as a matter of form, one drawing, slightly more daring than the others, was removed.

It is difficult to assess to what extent this loony episode contributed to the success of the exhibition but great crowds went to see Pellan's work. The power of the large compositions exhibited produced a firm expression. René Chicoine gave the recipe in an article in *Le Devoir:* "Take a good portion of *Automatisme* and season with discipline. Add a firm pictorial sense and cover the whole with fantasy. Shake energetically and allow it to simmer in 'the sands of dreamland'. This does not yet give Pellan. One

must blow on the sands and unleash a sandstorm. Can one define a force?" As a general rule, there were few reviews. Pellan, in fact, recalls a small item in *Vie des Arts* which said roughly " . . . in regard to the Pellan exhibition, we shall discuss it another time." The other time never came. The wall of silence

In the following years, Pellan often found himself with his back to the wall – but not the wall of silence. Indeed, if this invisible, intangible wall really existed, the artist finally grew accustomed to it. The wall could not prevent him from exploring the unlimited horizons of his plastic universe. On the contrary, his world vastly expanded; visions broadened, spreading over immense surfaces. Pellan, the giant, covered the walls of his poetic peregrinations with proliferating coloured magic. His walls were clearly visible; they gave rise to dizzying optical sensations. They spoke aloud, for Pellan undertook a dialogue with them

Arbre persan
1960
oil, silica on plywood/
huile, silice sur contreplaqué
17 3/4 × 7 1/2
Mr. and Mrs. Elliot Morrison,
Toronto

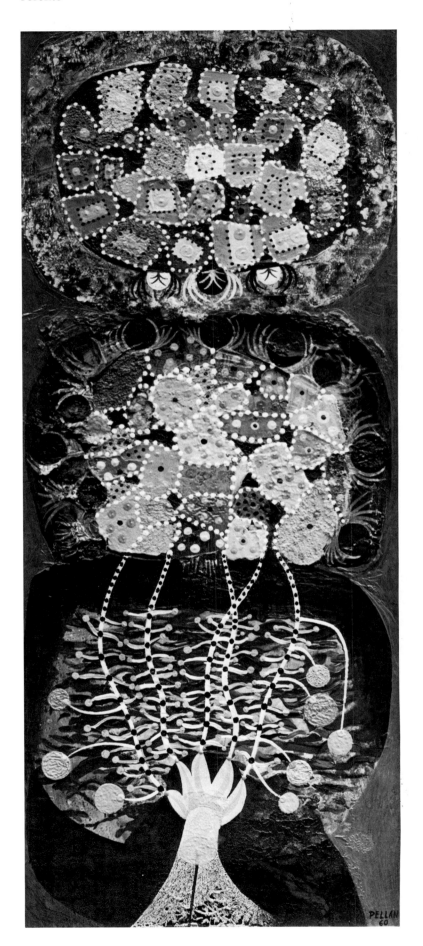

and in the exchange, his dreams were revealed – his obsessive perceptions of phenomena which govern the order of things. Pellan confronted the wall and painted murals.

Clearly, this was not a new form of pictorial expression. From the oldest times in history, there has been a tendency to cover the walls of habitations and meeting places with didactic, narrative or simply decorative images. Indeed, the presence of art in a popular and daily environment has assumed new significance in Canada recently and is to be seen in the streets, in Métro stations and in the halls of public buildings. There was a time, however, when only engineers, architects and financiers decided upon the content of the everyday environment. As a result, art appeared only infrequently.

Pellan for a long time had been dreaming about the possibility of incorporating images within the context of an active society and had attempted to convince architects to integrate the work of painters with their own utilitarian concepts. In 1957, he was given an opportunity to participate in a concrete project of this type. The designers and owners of the City Centre Building at the intersection of City Councillors and Mayor streets in Montreal set aside a wall in the foyer for a mural and opened a competition to Canadian artists. A jury made up of de Tonnancour, Arthur Lismer and Harry Mayerovitch made its choice from among the seventy-one drawings presented by thirty-one artists and Pellan was named the winner. His entry was a surrealistic interpretation of the theme, *Le Temps,* and it would be executed in mosaic.

Pellan summed up his approach to this mode of expression " . . . My concept of mural art is made up of four elements which are indissoluble: plastic, aesthetics, poetry, magic of colour. When the subject is predetermined, as in the present, the title being *Le Temps,* my first step is to invent symbols which recreate the proposed theme. The design of these symbols is sought in their plastic and aesthetic forms. The expression must rest on a projection of the human. And, it is in the fairy-like approach – that is, by a certain transposition of reality – that I propose to attain the poetry which must arise from the work, aided by the magic of colour. . . ."* A huge hand holding a clock, a broken globe containing a sand-glass, moon crescents, a cracked sun, a man, a woman stretched out at the end or at the beginning of life – those were some of the symbols floating in the vast space in which Pellan evoked inexorable time.

Such a well-conceived project deserved to be pursued: the same year, Pellan prepared a model for the stage curtain of the Montreal Theatre Ballet and designed another mosaic mural for the Ecole Saint-Patrice in Granby. In 1962, he supervised the execution of three ceramic and mosaic murals, based on his sketches, in private homes in

* Quoted by Guy Robert in *Pellan, sa vie et son oeuvre,* Editions du Centre de Psychologie et de Pédagogie, Montreal, 1936, p. 58. Translation.

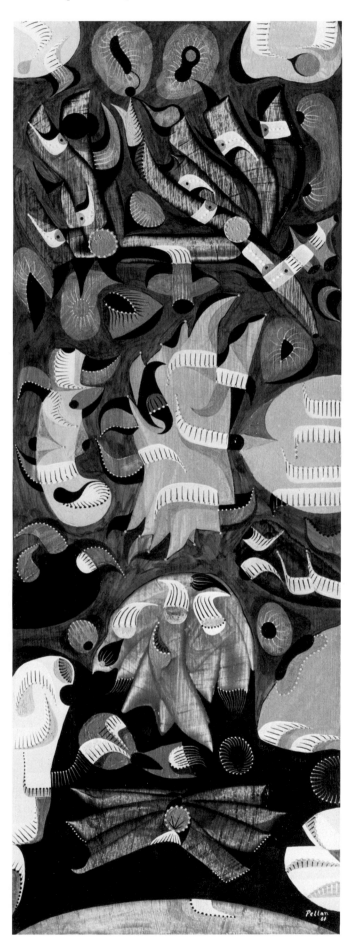

Le monde invisible
1961
oil on plywood/
huile sur contreplaqué
28 × 10
Private collection/
collection particulière, Toronto

the Montreal region. Pellan could not resist exploiting the infinite possibilities of coloured light and, in 1963, created the kaleidoscopic stained-glass window of the Grande Salle of Place des Arts. Pellan drew his inspiration from the movements of symphonic music and composed his work according to rhythms which at times were slow and full, at times lively and jerky, with sudden bursts of brass and percussion instruments; he moved from Bartok to Debussy, from Bach to Vivaldi to Mozart, the favourites in his own record library. Chromatic intensities matched the vibrations of sound.

The requirements of such large-scale work at times complicated his existence. For example, to paint huge sections of the curved mural of the Winnipeg Airport in 1963, Pellan had to radically alter the ceiling structure of his studio. The panels were too high. He had to do away with a complete row of transversal beams and introduce new elements of support. But Pellan stopped at nothing. Painting came first and foremost.

Another time, the problem was completely different. Though it involved less material difficulties, it was no less demanding from the viewpoint of research. Pellan had agreed to create two long murals to decorate the National Library, in Ottawa. One was a tribute to the writing of all civilizations, the other represented the various subjects of books forming the basic collection of the library: literature, law, medicine, art, science, etc. The latter did not give rise to too much of a problem. But the former was something else! Old books had to be consulted and ideas confirmed. When one is aware of Pellan's desire for accuracy and perfection, it is easy to imagine the efforts involved. His perseverance, however, led to unexpected comment not long ago. When a delegation of artists, professors and art publishers from People's China visited his studio, the model for the mural attracted his guests' attention. They immediately identified the Chinese characters and noted the accurate calligraphy. However, they could not help adding, through their interpreter: "You must have used an old book. These characters are no longer used in China. We have simplified our writing considerably."

In 1969, Pellan reached the culminating point in his efforts to integrate his pictorial vocabulary with architecture. In close cooperation with the architect Jacques Vincent, initiator of the project, he conceived a complete program of polychromatic decoration of a building, housing the head office of Vermont Construction in the Laval industrial park, in north-end Montreal. The achievement came years before the appearance of giant paintings on the outside walls of buildings in downtown Montreal, Quebec, Toronto and Winnipeg, all signed by young Canadian artists. Had Pellan shown the way? His work, it must be said, had an advantage over the more recent art walls: his was specifically designed from the very start to blend perfectly

Architecture molle et poilue
1960
oil on plywood/ huile sur contreplaqué
38 × 56
Mme. Gérard O. Beaulieu, Montréal

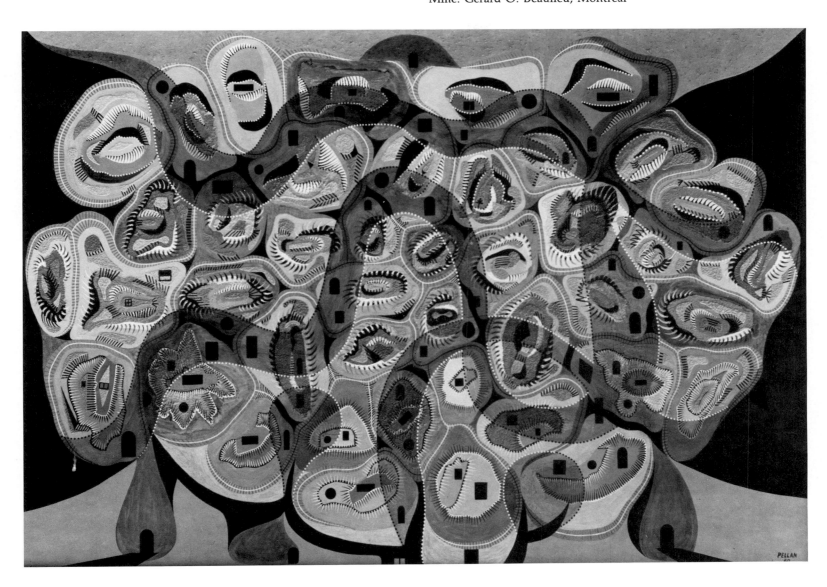

with the modular architecture of the pavilions designed by Vincent and embraces them in their totality. Everywhere, colour invades the smallest surface: drawing their dash from the inside walls, the geometric motifs spread outside through huge glass bays. The view is astonishing. It is like a village in wonderland, straight out of a fairy tale. Pellan, the enchanter, had waved his magic wand again.

Despite the considerable energy he expended preparing the models for his mural projects, the long hours of research, the discussions with the architects, the mosaic workers, ceramists or painters and, frequently, his active participation in the actual execution of the concept, Pellan still found time to work at his easel. True, he admits somewhat nostalgically, there was less than he would have wished. Still, there were enough paintings to present a series of highly consistent personal exhibitions in galleries in Montreal, Toronto, Ottawa, Kitchener, Sherbrooke, St. Catharines and Winnipeg.

The studio of the Auteuil house was a beehive of activity. The lights often burned until early in the morning.

It is hard to believe a single worker could maintain such a pace of production. At times, Madeleine assisted him in the preparation of models but essentially she was his administrative assistant, a function she carried out brilliantly while ensuring impeccable order in the house.

Pellan continued to astonish his public with his bold renewal. In April, 1958, at the Galerie Denyse Delrue, he presented a group of recent works dominated by his grandiose series of gardens – blue, yellow, red, green, orange and mauve. The search for plastic effect pushed to a new limit was expressed through plays of texture, once again revealing Pellan's great virtuosity. Somewhat jolted, the critics' opinions were divided: generally, there was praise – even enthusiastic praise – for Pellan's incredible pictorial invention. But serious reservations were expressed in regard to certain paintings, particularly *Jardin bleu.* They simply were not prepared to accept the artist's whimsy. He had incorporated in a cityscape, largely executed in heavy textures, two immaterial figurines in flight surrounded by jewels suspended in space, around a lunar sphere decorated

113

Chasse aux papillons
1961
oil on canvas/ huile sur toile
27 × 42
Private collection/
collection particulière

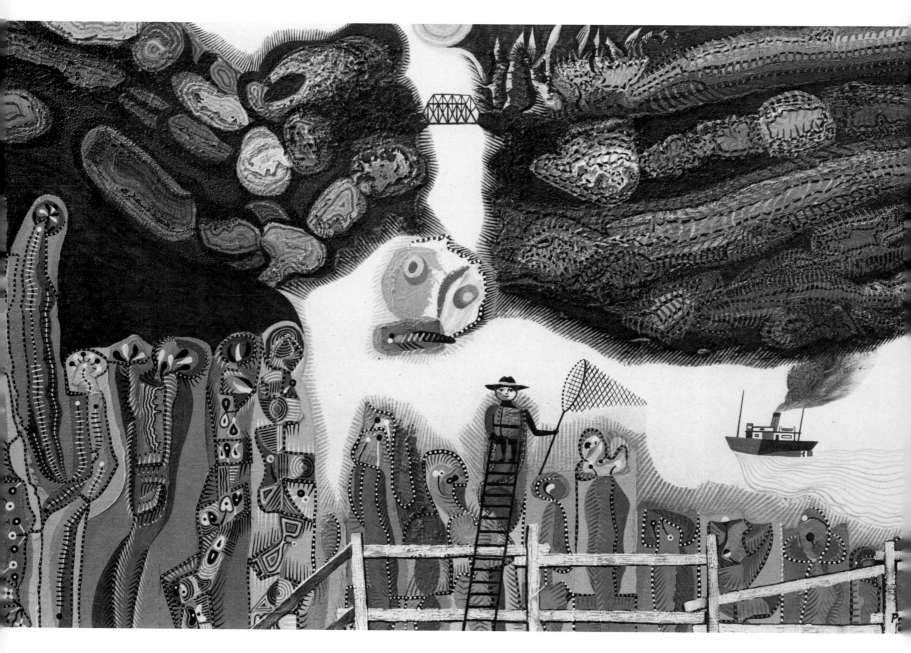

with a Christmas card candle. He was accused of bad taste and of lacking seriousness. Ironically, the painting was one of the highlights of the recent Pellan retrospective at The Montreal Museum of Fine Arts. An informal survey of visitors designated *Jardin bleu* as the work which, among all those exhibited, appealed to them most. There seemed to be great appreciation for the poetic change, the humorous commentary – in a word, the amusing spirit of the composition with its juxtaposed registers of interpretation. Someone even saw an early manifestation of the pop art trend in Pellan's use of popular imagery.

After about ten difficult years during which his star had been partially eclipsed because of the concerted obstruction of critics, the 1960's saw it shine increasingly among art lovers and even official agencies. Following a second exhibition at Galerie Denyse Delrue, appropriately titled

Hommage à Pellan, Canada, after France, finally decided in 1961 to recognize the importance of his work and its significance in the evolution of artistic values in the country. The National Gallery of Canada organized a retrospective of his work which also was shown later at The Montreal Museum of Fine Arts, the Musée du Québec and the Art Gallery of Toronto. The paintings were chosen judiciously and the impact of the exhibition was great on a vast public. Yet, one could not help but note that the number of works was barely a quarter of what Parisians could see in 1955. A handsome illustrated catalogue accompanied the retrospective and contained a study of Pellanian reality, signed by Donald W. Buchanan, as well as an assessment of the artist's creative process by Paul Gladu. " . . . There is no habitual process," wrote Gladu. " . . . His method of action is extremely flexible and does not easily lend itself

Rococomagie
1961
oil, silica on plywood/
huile, silice sur contreplaqué
36 × 36
Edmonton Art Gallery, Edmonton,
Alberta

Enracinement
1961
oil on plywood/
huile sur contreplaqué
24 × 32
Private collection/
collection particulière

to definition We are dealing with a complete artist. Vast experience and extraordinary gifts come into play. For Pellan, whatever is vague calls for vigour and the spirit of geometry makes him search within his heart. There is a need within him for balance between the abstract and the human. To arrive at it, all means are good. Pellan is the man of a thousand techniques.''

During this period, Pellan's name frequently appeared in the art columns of numerous publications, Montreal dailies forming only a small fraction of them. Robert Ayre, in *The Montreal Star*, Dorothy Pfeiffer, in *The Gazette*, Paul Gladu, in *Le Petit Journal*, and Jean Sarrasin, in *La Presse*, attentively reported on the events of a career which increasingly dominated public attention.

The second monograph devoted to Pellan and his work appeared in 1963. A significant distance had been covered since the book by Maurice Gagnon and the listing of the artist's achievements had grown considerably longer. His work, too, had attained a more imposing status. To give a better account of the complexity of the man himself and of his art, Guy Robert had been influenced in his text by the spellbinding wizardry which infiltrates the artist's universe. The "magic of metamorphoses", "the inexhaustible woman", the "gardens of the landscape", the "intimate liturgies" and the "global cosmology" of Pellan were evoked one after the other. The images proliferated in all directions, based on the same profound necessities which arise from the depths of Pellan's soul.

In 1969, new tribute was paid to the artist – a colour documentary produced by the National Film Board and an exhibition at the Musée d'Art contemporain of projects and completed work for the theatre, both called *Voir Pellan*.

The première of the film was held at the Musée as the show was officially inaugurated, and that night an unprecedented event occurred in the short history of the institution. The festivities unfolded in a carnival atmosphere. The large crowd of guests, a number of whom wore costumes – the invitation suggested fun clothes – danced late into the night to the music of the group *La Machine infernale*. A true spectacle-happening completely in the Pellanian spirit, it was as if the artist's paintings had suddenly come alive and the figures, released from their frames, had invaded the floor of the exhibition galleries. Pellan himself actively participated in the festivities program. He directed the projection of colour slides reproducing his paintings or fragments of his paintings on the bodies of dancers dressed in white bathing suits who performed against a black background. The bodies picked up the luminous projections and were covered with violently coloured motifs which continually changed, while the movement of their silhouettes further accented the decomposition and proliferation of visual suggestion. It manifested Pellan's irresistible need to dress up every surface, every object, with visions of dreams, with holiday colours; now, he had replaced the theatre wardrobe mistress and painted the bodies themselves with luminous rays. Some of the drawings exhibited – the *Polychromées* – involved a series of decorative variations on the female body.

Louis Portugais' film avoided the romantic plot too often associated with the screenplays of biographical documentaries on artists. It concentrated instead on the direct testimony of a meeting with the man, delivered to the pleasures of plastic creation, and on the inventive spirit shaping his entire work.

Pellan, Pellan, Pellan, Pellan, Pellan! That was the only copy in five vividly coloured strips on the cover of the catalogue for the retrospective exhibition jointly organized by the Musée du Québec and The Montreal Museum of Fine Arts, and later shown as well at the National Gallery of Canada. The cover design, created by Pellan at the request of the editors, expressed their reaction to the Pellan phenomenon. The same feeling guided the master planning of the exhibition: here was Pellan the conqueror, the omnipresent figure; here was Pellan, alive and well, and constantly in motion.

Pellan was open to everything. His eyes clearly saw everything visible. He wanted to touch everything, to invade chaos itself to restore his sense of order. He wanted to humanize. Striking down obstacles, he moved forward.

Pellan: 176 paintings on the walls of the exhibition galleries; Pellan: 16 costumes of characters from *Nuit des rois*, suspended from threads or shown on mannequins; Pellan: 75 polychromed masks, attached to the faces of the mannequins or lined up on dividers; Pellan: stones decorated with multi-coloured designs and displayed in the showcases; Pellan: the corporal fantasies of dancers dressed in paintings, projected on a screen. At the Musée du Québec, galleries usually reserved for the permanent collection had to be stripped to honour the giant. At The Montreal Museum of Fine Arts, all available space was turned over to the Pellan show. Even in Ottawa, fertile imagination was needed to show the brilliance of the Pellan galaxy.

Thousands and thousands of visitors invaded the enchanter's kingdom. Never before in Montreal had the work of a Canadian artist attracted such large crowds. The young came. So did the old. They returned with wives, children, friends; they came and marvelled; they were dazzled and their hearts were joyous. Children – the Museum provided them with drawing paper and coloured crayons – sat on the floor and, inspired by Pellan, drew the visions and dreams they spontaneously shared with him.

Pellan was moved. Yet it was nothing new for him to be honoured, he who recently had been accumulating tribute after tribute: he had received the Centenary medal, he had been named a Companion of the Order of Canada; the universities of Ottawa, Sir George Williams and Laval awarded him honorary degrees and, in 1972, the Société Saint-Jean-Baptiste named him winner of the Prix Philippe Hébert.

Certainly, all these honours were significant and Pellan was not unappreciative of the public recognition he received for his contribution to the evolution of contemporary art. But these were official tributes which took place at a somewhat disincarnated level, to be frank. In truth, Pellan is not in his element in this type of situation. He is somewhat embarrassed to dress up, to be swept up in the cloud of oratory and incense of official ceremonies.

For the first time, at least to such an extent, the retrospective brought about a very close relationship between Pellan and his public. In a sense, he was able to feel his public's pulse. In the comments of the many visitors and their obvious appreciation of his paintings, Pellan experienced an intimate and direct rapport; the rigid frontiers usually maintained by the intermediaries of analysis and classification had been torn away. Sweeping aside in a single stroke the last vestiges of the grey clouds formerly inflated by quarrels among schools, dialectical disputes and harassing justifications, a wind of madness purified the sky, liberating a dazzling light reflected in everyone's eyes.

Pellan was far from comfortable. On the night of the official opening, he was intimidated by the crowd of admirers who pressed around him, seeking autographs for their catalogues. It was the "big night" people dream about in their hours of solitude; but when the time suddenly comes, the person is surprised and disoriented.

Art columns in newspapers and magazines carried flattering reviews: *Pellan: a power! Pellan's tamed savagery, The long*

Joyaux perlés
1962
oil on canvas/ huile sur toile
23 × 27
M. Charles-Auguste Gascon, Montréal

maturing process of the eye and the hand, Pellan's living art, Pellan's magic hand, Pellan: creation and recreation of the world; Alfred Pellan's consecration. A note of intimate admiration also appeared: *Greetings, Alfred!*

In front of Pellan on the table are piles of letters of appreciation from enthusiastic art-lovers, letters of admiration from friends he has not seen for a long time and who want to restore relations with him. A boy of twelve writes that he had had a lot of fun at the exhibition and hopes to see other Pellan paintings and masks soon. Pellan gathers the precious messages and places them in a chest. The paintings and the masks of his personal collection have just been returned to him and he rehangs them in the playroom and in his studio. "It was very empty here. Everything was gone and I was anxious to decorate the walls again." Pellan had not had much time to paint in recent months. There had been constant interruptions and Pellan had been concerned with the preparation of the exhibition. He had been available at all hours: he would take out his files, his

photos, comment on the colouring of one of the paintings. "The colour in this one is very nice. I'd very much like to see it again." Suddenly, he would stop and apologize: "It must seem as if I'm promoting myself. You'll think I'm terribly pretentious." In fact, Pellan had been rediscovering the joys and enthusiasm he had experienced in the fascination of creation.

Madeleine is practising her last guitar lesson. The cat Grisette sneaks in through the basement door. With great precision, Pellan rolls a cigarette of light tobacco without any break in the spirited conversation. Though he dislikes to discourse, Pellan enjoys conversation and discussion about painting, music, the cinema, but not much, however, about politics. The house at Auteuil is not a retreat; good friends are readily welcomed. A good cup of coffee and a brandy often lead to a long and friendly evening.

The other day, Pellan invited a group of friends to celebrate the success of his retrospective and he saw to it that everyone had a good time. The wine was excellent and so were the *petits plats* prepared by Madeleine. Everyone stayed late, talking, dancing. No one wanted to go. Having crossed the threshold of the Pellan house, one hates to leave.

Upstairs in the studio, three or four large canvasses, freshly stretched and whitened and standing at attention, await his hand. They rest in racks alongside sumptuously clothed paintings.

Anonymous, without personality, not even embryos yet, they wait. Still, they have already begun to exist; they are getting ready; they are gently at work in the artist's mind. Intensely busy, concerned with a thousand and one things, Pellan gives them a moment of attention, a quick glance, a thought, and pursues his activities. Then later he comes back briefly; he thinks about them, calls them, without dwelling upon them, without bothering them. He lets them come to him, as he has always done, in fact, with all his other creations; at times, there were dozens and dozens of canvasses gestating at the same time, more or less developed, finding their way in infancy and maturity.

Pellan continues his search for images. He is preparing new festivities.

Part Two: His Work

The roads to the imaginary universe created by Pellan during the past fifty years are many and inviting. It is an open world, receptive on every side and offering thousands of pleasures to those who explore it. One meets joyous figures in fantasy costumes who inhabit strange and fabulous settings. A factory with the appearance of a fairy-tale palace stands at a detour; a little further are sumptuous and exotic gardens filled with unknown flowers and precious stones. Even the stones along the highway stand out because of their amusing decoration and gay colouring. In a land of festivities, charming aerial fairies ride high around a lunar crescent and bursts of fireworks illuminate the night. The whole is bathed in an atmosphere saturated with the most dazzling colours.

But if one can easily enter the heart of this land, it is not easy to sketch a precise route and even less to follow it. Each trip is full of unforeseen events. Pellan has never subjected himself to the dictates of a preconceived plan. He developed his art by pushing the sudden impulses of his consciousness to their limits. Everything is questioned anew. The structure, the drawing, the matter, the colour collide, reconcile and merge to give shape to the Pellanian reveries, themselves changing perpetually. The whole is baffling in its multiplicity, marked by unexpected upheavals, strange *rapprochements,* flashing shortcuts. Images emerge suddenly, take shape, develop and grow blurred. Then, they are born again, refreshed, in a new setting.

There is no fixed framework for the artist's plastic development, no preferred dimensions. Without transition, he moves from the smallest painting, meticulously executed, to vast mural compositions, with no break in the internal harmony of each.

With absolute freedom, the great work of the painter is carried out in all the complexity and unity of a living organism. The chains of cells regenerate continuously in the tissues by assimilating the essential nourishment into a vital fluid which ensures the growth and proper functioning of all the organs so as to sustain the extension and flowering of all the projections of the being. The organs, which here are called line, colour, matter, are fed abundantly by a bracing imagination. They function admirably in free association and develop the innumerable powers of being in constantly renewing visions.

And yet, despite the chronological springboard, the breaks in continuity and the spontaneous resurrection of the multiple components of the paintings, it remains possible, due to a certain insistence in the processes of composition and certain thematic emphasis, to sketch a path through the thick forest of works and to shed light on the obscure and sometimes mysterious reasons which give them life. Sometimes the thread leading from the first still lifes to the most recent metaphoric germinations is thin. At times, one must make a few detours in the labyrinth. But providential points of reference, placed here and there along the route, make it possible to avoid getting lost.

Happily, the access routes pose no problems. The paintings of the beginning of Pellan's career can be grouped within the framework of the major traditional genres. Pellan painted portraits, still lifes and a few landscapes. When he arrived in Paris, he already had a good knowledge of pictorial means. He had familiarized himself with the rules of composition, the subtleties of drawing and the riches of colour. He succeeded in personally gaining from his lessons at school by progressively moving away from the suggested models. Painting is not enslavement to reality and the artist's commitment is related to the transformations it must undergo in the quest for beauty.

The 1922 *Coin du vieux Québec* was seen from a window of the Ecole des Beaux-Arts. There is an escalation of snow-covered roofs oriented in different patterns which run into the façade of a window-covered building; above is a narrow strip of sky. The sixteen-year-old artist disregarded the rules of perspective, the correction of detail and the accuracy of the local colouring. All the elements of the setting are brought to the surface of the painting where they are organized into horizontal panels paced by the obliques. Colour, applied heavily and with broad strokes, accents the flatness of space. The general features of the landscape are preserved but relegated to the background because of needs of a plastic nature. The painting obeys these laws alone, imposing its own reality. A painting, according to Maurice Denis' famous definition, "before representing a battle horse or any other anecdote is a flat surface covered with colours in a certain assembled order."

The masterly revelation of contemporary art in the galleries of Paris was a powerful tonic for Pellan's art. His awakening to the specific powers of pictorial means deepened upon contact with the diversified aesthetic propositions which had revolutionized art at the turn of the century. Pellan was fascinated by the colourist experiments of Van Gogh, Bonnard, Matisse, Derain; the exaltation of pure colour, the rustling of juxtaposed manners, the collision of violent contrasts, neatness, the intensity of large surfaces saturated with flat tints. He was strongly impressed by the bold and knowledgeable organization of Léger, Juan Gris, Braque, by their solidity, their rigorous balance, while defying all symmetry. In the foreground of

L'échelle du souvenir
1962
oil, silica on canvas/
huile, silice sur toile
36 × 25
Private collection/
collection particulière, Toronto

this brilliant theatre were the genial inventions of Picasso, the incessant metamorphoses of his compositions, the great virtuosity of his drawing.

Pellan recorded all these data, studied them in all their facets, dissected them and assimilated the essential principles. Neither the Fauves, the Futurists, the Cubists nor the Surrealists alone succeeded in seducing him. Pellan espoused no theoretical concept. He nourished himself with a thousand and one marvels, whatever the sign under which they appeared. His own creative effort as a result was strongly enriched and broadened. He pressed his experiments in all directions, slowly but surely developing his own personal synthesis.

The numerous still lifes he executed at the time testify to the wide range of means at his disposal in his quest for a constantly changing art. The pretexts for his plastic development were as simple and banal as could be, taken directly from the drawers of painting classes; apples, pears, lemons, oranges, strawberries, knives, vases, pots, fruit bowls, flower baskets, an oil lamp, a coffee pot, a carafe. He

used these elements time and time again to create constantly different paintings, each one new because of the transfiguration of the drawing and colour. The green pears are placed in front of the crushed tablecloth and a small bowl, but they are lovingly caressed by the paint brush, giving them a second life. The lamp, the coffee pot, the casserole and its cover are vigorously encircled by a bold line which flattens them to the surface of the painting to create a distorted linear rhythm. Fruit fallen from the fruit bowl, deformed, cut up, hang in the cubist space.

Pellan's passionate, sensual temperament is freely imprinted in the rich unctuous matter, the heavy folds of the fabrics of *Panier bouclé.* Each flower, each object, all the modulations of the surface reveal the instinctive gesture of the hand which at times weighs, at times barely touches the canvas with a long stroke, or again moves rapidly on. The same inspiration is to be found in *Le panier de fraises:* the sinuosities of the flower pot, the basket with handles and the big-bellied bottle grouped in the centre of the painting produce an undulating movement which tightens in the upper part where flowers and leaves tend to envelop the elements of the composition. The very plane of the table on which various objects rest is animated by the play of curves, punctuated by the roundness of the fruit. The rich colouring of brassy browns, reds, yellows and greens, at times dark, at times light, couples with the moving vitality of the forms and establishes brilliant luminous contrasts in a warm tonality. Despite the pictorial schematization, there is a spontaneity, a freshness which expresses the direct emotions and sensations which provide the artist with the vision of these few components of a living reality.

To the ardent and sensual Pellan who allows himself to be carried away by the lyricism of colour and the subtleties of touch, corresponds a studious and cerebral Pellan who examines and develops his intuition, decomposes and analyzes it, organizes the elements, a Pellan who draws and builds. In the large painting entitled *Instruments de musique,* Pellan makes a step towards formal abstraction. He no longer looks at reality. He imagines another world based on autonomous figures, elements of memory stemming from the synthetical process of the second phase of Cubism. Though the objects he assembles in the right part of the painting are clearly identifiable – fruit, a fruit dish, an open book – the musical instruments are largely stylized. The guitar and the lute appear in detached and fragmented pieces which the artist superimposes to create a baffling system of lines and coloured planes.

No concession is made here to the sensibility and personality of the touch. The colours are applied on a uniform basis, following the geometric contours of motifs drawn with a firm hand. The process clearly recalls collages in which cuttings of coloured paper are applied to the surface of the painting to suggest a structure on which the painter

Fines tiges
1964
oil on plywood/
huile sur contreplaqué
11 7/8 × 22 7/8
Private collection/
collection particulière, Toronto

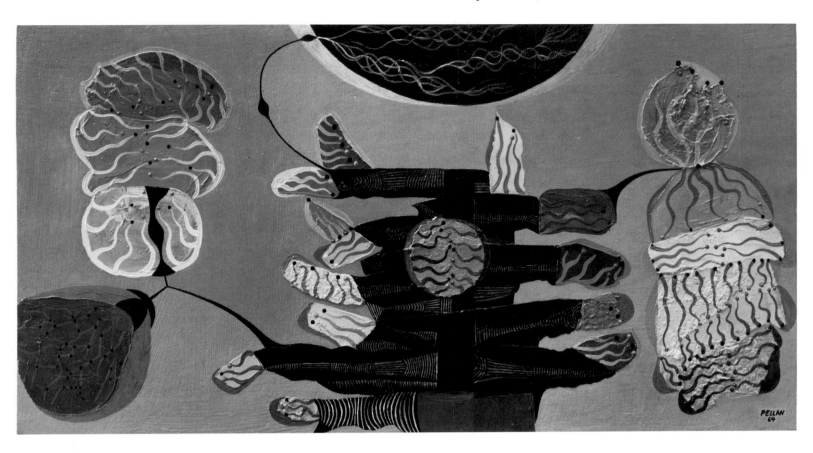

then adds the details of the figuration. The vigorous coordination of the curves and the long broken uprights determining the forms give off a force of impact amplified by the intense reds, underlined with black which dominate the composition. That is the painting Pellan presented in 1937 at the competition for the *Première grande exposition d'Art mural* in Paris and which earned him first prize.

Many other still lifes painted in the early 1940's indicate Pellan's growing interest for clear and simplified forms, precise contours, and surfaces of impeccably distributed colours. Pellan did not maintain in his paintings of objects the degree of abstraction he had introduced in *Instruments de musique*. He preferred to let himself be guided by the formal suggestions of knives, colour palettes, sliced fruit and cups that he placed on a corner of the table. From that, he elaborated an organization of lines and coloured planes in which he preserves the definition of objects but stylizes them, largely to integrate them within the plastic harmony of the whole. Often, purely decorative motifs add to the already intense vibration of strong tones, arbitrary stripes on tablecloths, alternating points and crosses. Such punctuation completely invades space in *Nature morte au gant.* Networks of fine lines intercrossed in red, green, blue and flecked with white, yellow or dark blue extend like a sparkling net over the surface of the painting. At times the outlines espouse the form of the objects, at times they conflict with them to breathe electrifying dynamism into the form/colour dialogue.

A series of portraits of young women brings a strange note into the concert of flamboyant colours with which Pellan covers the motifs of his still lifes. The *Femme au peignoir rose,* the image of *Geneviève Tirot,* the *Femme en gris,* the *Jeune fille au collier* appear in tonalities which are muffled if not extinct: greys, browns, wilted roses, insipid yellows, and black. Why this austerity, signalled by the very absence of all ornamentation and all embellishment? For the most part, the models are seen to the waist and are dressed either in a dark-coloured dress or a knit with broad neckline. All attention is focussed on the pale face – a pure oval – and especially on the look, lost in meditative, nostalgic reverie. Soon, one notices only the fixed, inanimate look. The severity of the representation, its nudity, produces an effect of grandeur which is difficult to explain. A grave vision of the human being seems to reign over the features of the mild faces with tight lips.

The *Jeune fille au col blanc* and the *Jeune fille aux anémones* painted in the same period do not smile more, despite the gaiety of their finery and the fantasy of the setting. A multicoloured scarf thrown over the shoulders, a bouquet of anemones set on her knees fail to cheer up the slim young blonde girl seated in front of a mural panel saturated with bursting blues and reds.

Looking at the portraits, one sometimes gets the impression that Pellan had attempted to combat a dark state of soul by giving it an aesthetic transformation. Or perhaps he wanted to intensify the expression by means of extreme

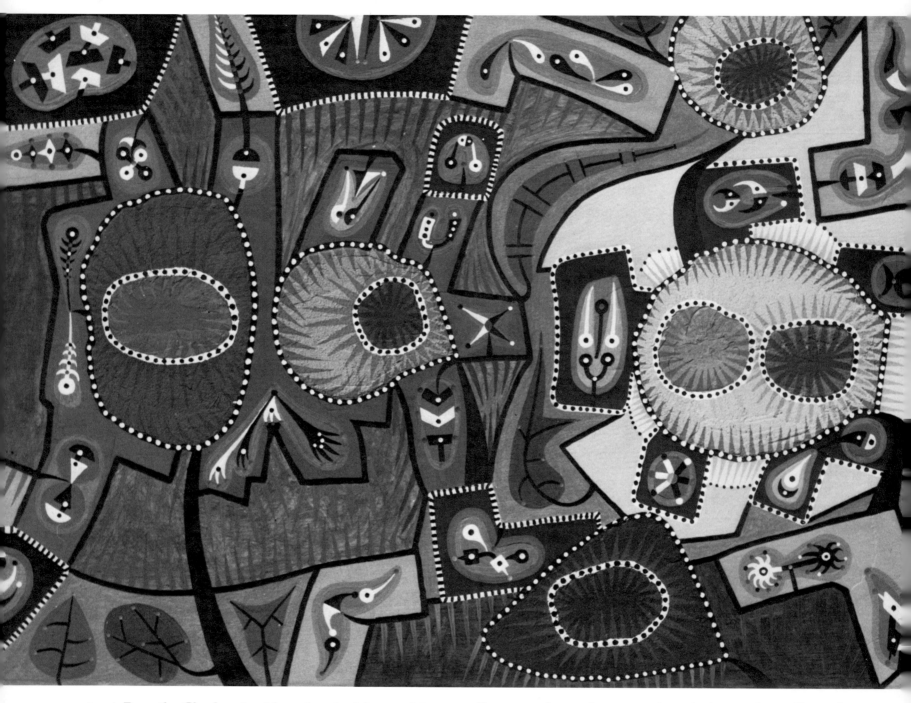

contrast. Even the Charlevoix girls, painted with surprising energy and with bold strokes in pure tones at times evoking Van Gogh, at times Matisse, do not escape the indefinable malaise which haunts all the portraits. In dealing with the human being, Pellan seems to seek to go beyond the strictly plastic needs of the painting. A moment of disquiet and of interrogation may be read in the eyes of his models. Pellan is involved in the world of the conscious. He soon will plunge into the mysterious regions of dreams, the bubbling of the subconscious, giving birth within him to troubling surrealist visions.

In Paris, Pellan was in contact with surrealist thinking. Its presence could not be ignored. It was manifested virtu-

ally everywhere – in poetry, in painting, and usually with éclat. Pellan read some of the poets. He obtained the *Dictionnaire abrégé du surréalisme* by André Breton and leafed through it with great interest. He was able to admire the works of Miro, Max Ernst, Chirico and Tanguy in the galleries of art dealers. He was far from indifferent to them. Until 1937, Pellan had painted only still lifes and portraits which kept him rivetted to reality, despite the great liberty he took with respect to appearances. Certainly, these paintings did not fail to reveal, through their plastic transpositions, Pellan's energetic, enthusiastic or methodical temperament. They testify to the concerns, the dreams, the projections of the man but within a strict framework. Like poetry, paint-

Le parc
1966
oil on plywood/
huile sur contreplaqué
10 × 28
Private collection/
collection particulière

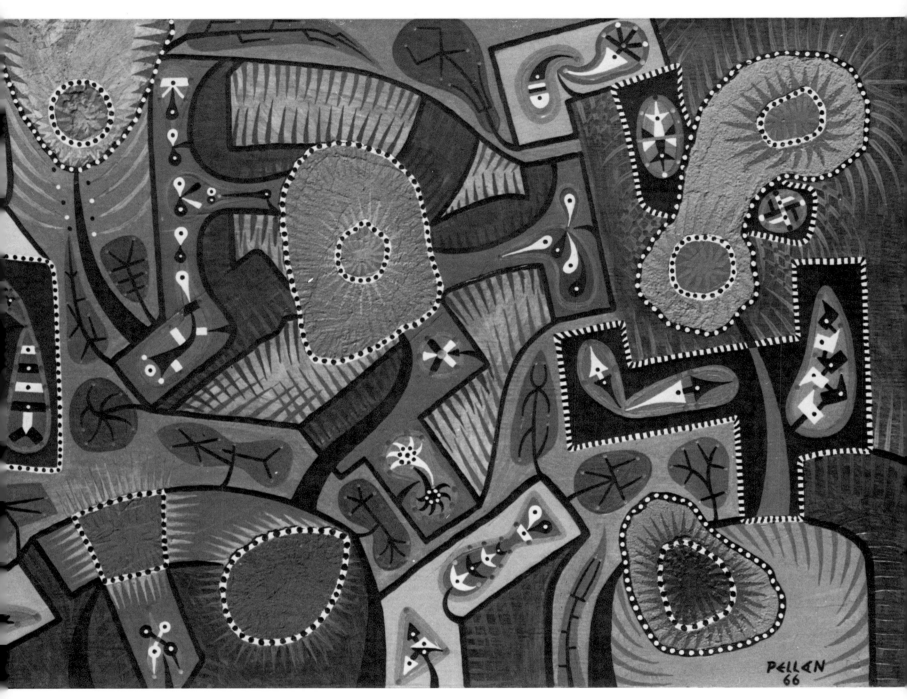

ing can reveal much more. It can recount, it can evoke the joys, the miseries of man far more directly, without the intermediary of pictorial genres. The canvas can become a screen on which are recorded symbols, images of reflection, a descent into hell, a propulsion into a kingdom of fantasy.

Pellan's initial concentration on an immediately perceptible or tangible foreign theme remained cautious and unpretentious. The subjects of his reverie were not terribly mysterious nor strange and were based on a familiar experience. The attempts were valid mainly because of the pictorial transposition to which they gave rise. A painting entitled *Hommes-rugby* evokes the movement of play, its unexpected rebounds and particularly the energy and ag-

gression animating the players. Only the ball is clearly identifiable in the composition. The rest is merely swirling curves braked by broken lines. Limbs appear and end with animal claws – the players' spiked shoes. The whole suggests a terrible struggle, a frantic engagement from which a combatant undoubtedly will emerge the winner, leaving an opponent torn and beaten.

Sous-terre, of 1938, is not a geological survey but rather a strange imaginary voyage under the earth's crust: unknown forces confront one another or join together. Nothing here can be identified. Strange beasts intermingled or roots of wild vegetation? Who knows? The painting is free, the colours broadly laid, the outlines drawn quickly, as

Sous cloche
circa/ vers 1956
oil, polyfilla on canvas/
huile, polyfilla sur toile
19 × 15
M. Gratien Gélinas, Oka, Québec

though by sudden compulsion. From this subterranean image emerges a somewhat heavy and dense sensation, which belongs to the earth, a poorly-defined, anarchical force which stirs in bitter, strident shades in the black.

The *Paysage à la femme-devinette,* on the contrary, stands out in full light. This does not mean it is free of enigma. Here, the problem is described with the clarity of a mathematical proposition and with completely mechanical precision. Serene areas of colour are knowingly established and clearly defined, light, tender, and happy: a well laid out spatial field without real depth in which there is a balance of coloured values – yellows, oranges, reds, greys, sober lights in geometrically cut panels – and in this field are motifs which are also flat with sinuous contours and turning, sliding circles. At times fixed, at times in motion because of a full and rigorous black stroke, these applications are organized, articulated like a complex clock movement. The eyes, the lips, the interchangeable faces, the limbs, the silhouette of the woman-riddle inhabits the indefinite space of the landscape.

The incoherent dialogue of the carnival heads of *Clair de lune* is not particularly disturbing. An immense human profile with mouth half-open seems to be saying things which upset the interlocutor, completely disarticulated. The lunar sphere flattened at the poles had come closer to enlightening the conversation while above, two pairs of decorated eyes roll with bewilderment. The atmosphere is one of gentle madness, sustained by the sober, strangely lit colouring. On a base on which the colours are cleanly laid over large surfaces, without smudges, the drawing imposes itself in thick contours without necessarily corresponding to the limits of the colour planes, conferring an immaterial appearance on the figures – illusion, inconsistency of the dream.

Pellan's most minor little picture is evidence of his profound attachment to painting; the generosity of a brush stroke, the splash of colour, the joyous arabesques of the line are some of the indications of the pleasure guiding the image's appearance. Pellan loves life. He bites into it hungrily. He loves the sun, the moon, the stars; he adores woman, flowers, the glow of matter. Pellan loves to live, to speak, to discuss with people, to stroll, to listen to music, to drink and eat well. And all of this is evident in his paintings; it is reflected in modulations, in symphonies of colour, in a dance of forms and features. Painting, however, is not only a game, not only a fantasy nor an escape from reality. The act of painting commits Pellan's entire being. The artist identifies himself with the act. He lives, breathes by and for the miracle which each time occurs in the communion of the eye and the hand and which establishes the link among the pulsations, the appetites of the soul and the rhythms, the necessities of the visible, the exterior reality. Pellan's breathing, his pulse, keep time with the vital

rhythm of everything which germinates and grows in him and around him and which he transcends in his paintings.

But life is not only love, life is not only caresses, warmth and light. Obscure, inescapable forces mark everyone's destiny, alter projects, sow concerns, reopen wounds, dig chasms in the unfolding of dreams. These also would become evident in Pellan's painting.

His existence has not been without difficulties and misfortunes. One need only recall his long hours of solitude as a child, the biting physical pain he endured. The bohemian years of his stay in Paris undoubtedly give the impression of a joyous, carefree existence but they ended abruptly. War! Pellan was thwarted, upset, torn by the unleashing of this world catastrophe. He had to leave Paris, the city of freedom, friendship, enthusiasm which stimulated him so much in his work. He had to abandon a career in full development. He watched the thinkers, the poets, the musicians leave, fleeing from aggression and dispersing everywhere. The war . . . destruction, a dispersal of values of the soul and the spirit, the abolition of art. Why?

Pellan was able to escape the physical miseries, the acute distress provoked by the guns. One cannot remain insensitive to so many horrors, echoed in pettiness and the most insignificant intolerance of daily life. Pellan is sensitive, vulnerable. He cannot tolerate injustice, smallness, narrow-mindedness gnawing at the freedom of human beings, braking the development of the lively forces of the thinking, living person.

The moving period in Pellan's art which often has been described as surrealist especially reflected his concerns in regard to the drama of humanity. Pellan is not a politically committed artist. He one day created a painting *Le Front catastrophe* to stigmatize the horror of destructive conflicts. Like Picasso, he was disturbed by the Spanish civil war. But these observations did not dominate his attention for long. He wanted to get to the source of the evil. He wondered about demoniacal forces, the occult powers which agitated within the very heart of life and endangered it.

His long self-interrogation began around 1940. The quest in the fathomless layers of reality led to a great harvest of strange and disconcerting images. The visions were blurred by the hazes of the subconscious, decomposed by the sudden changes, the metamorphoses of the dream. The obsessions most rooted in human consciousness, the most immediate pulsions of human flesh emerge in the paintings of the period: death, the passing time, natural cataclysms, predestination, eroticism come to the surface.

The paintings are called *L'heure inhumaine, L'amour fou, Les iles de la nuit, Vertige du temps, Le tout mobile, Le sixième sens* and *Ephémère.* A profusion of symbols associate, join together to recount these voyages to the heart of the magma of human matter: hands stretched out or clenched, eyes horrified or wide open, skulls, clocks, sand-glasses, meshing wheels,

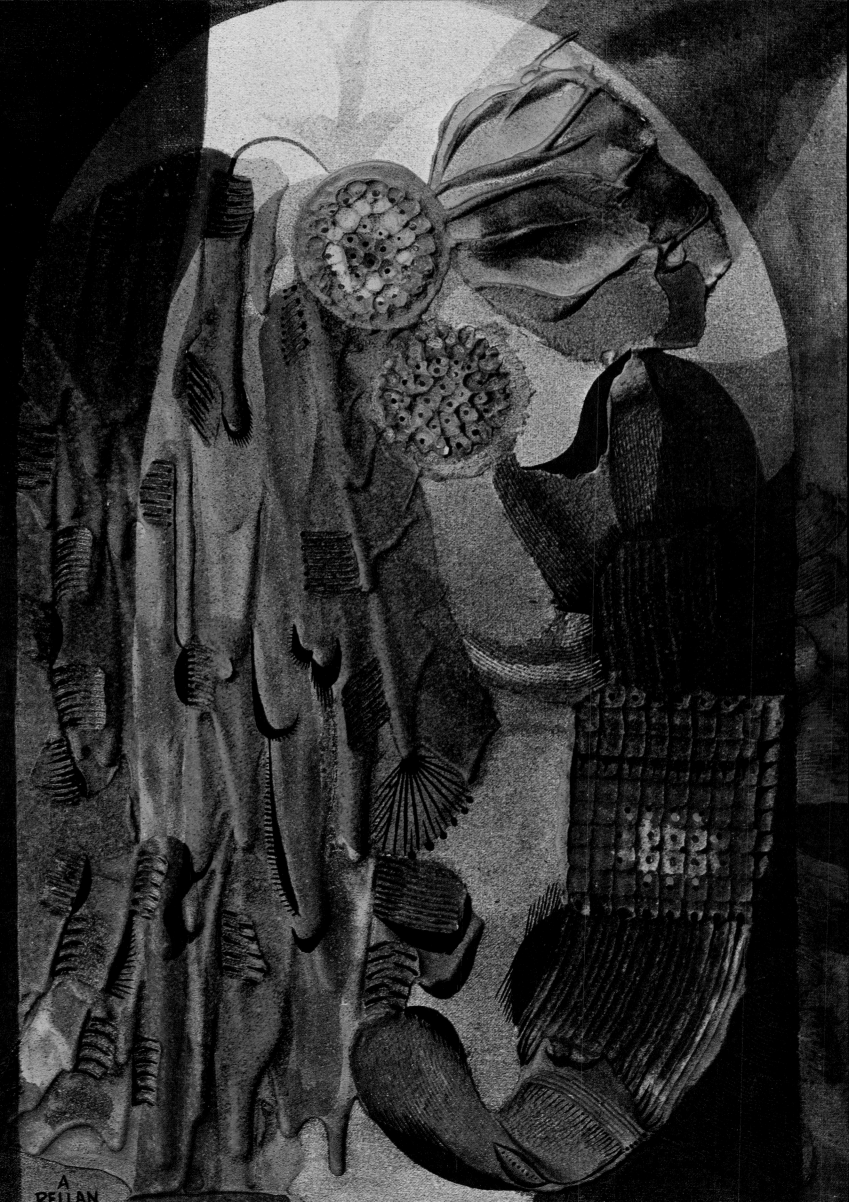

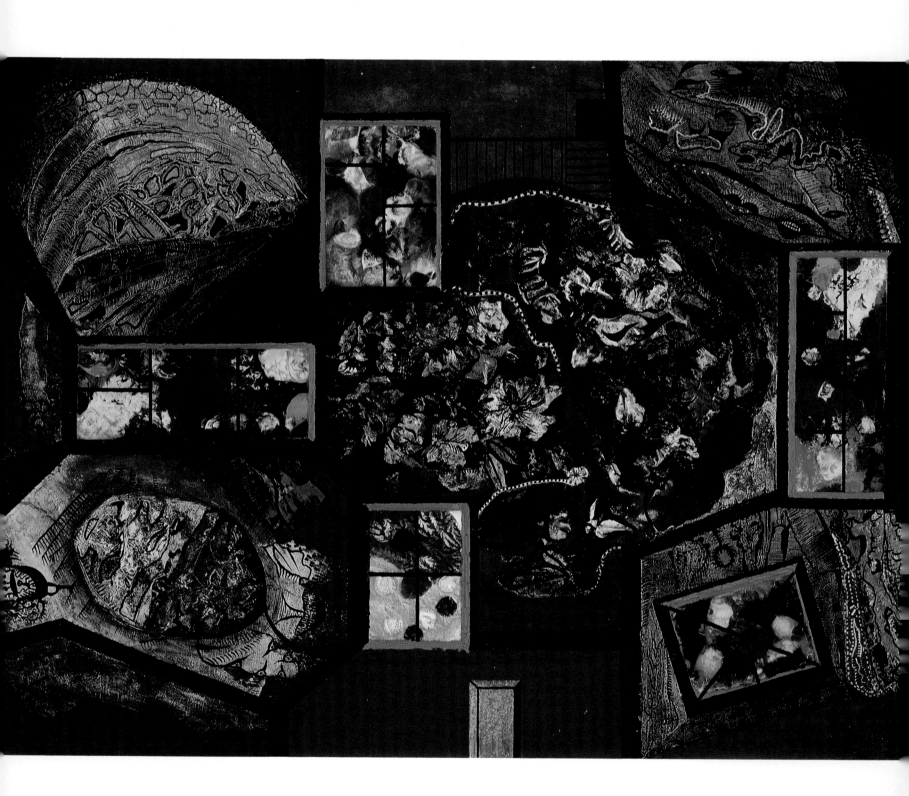

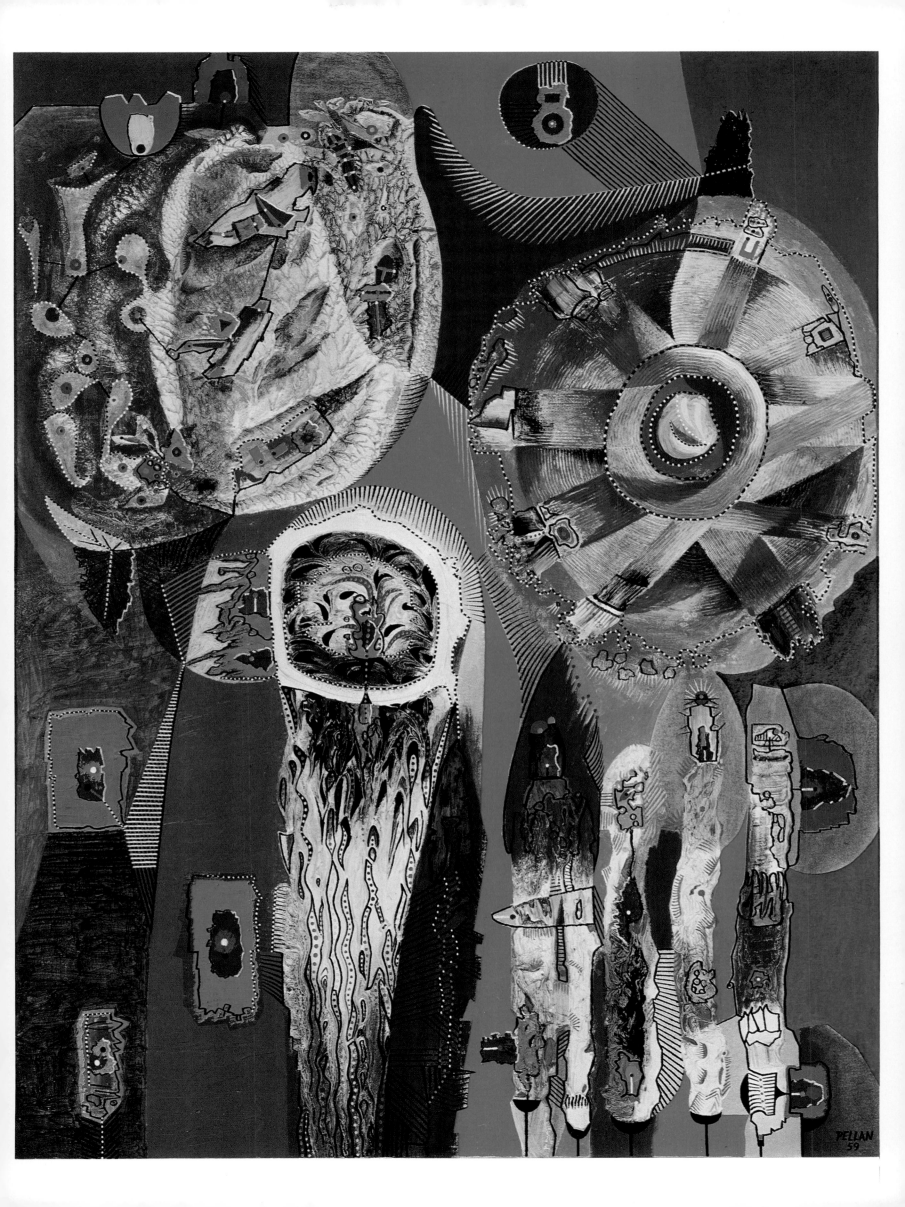

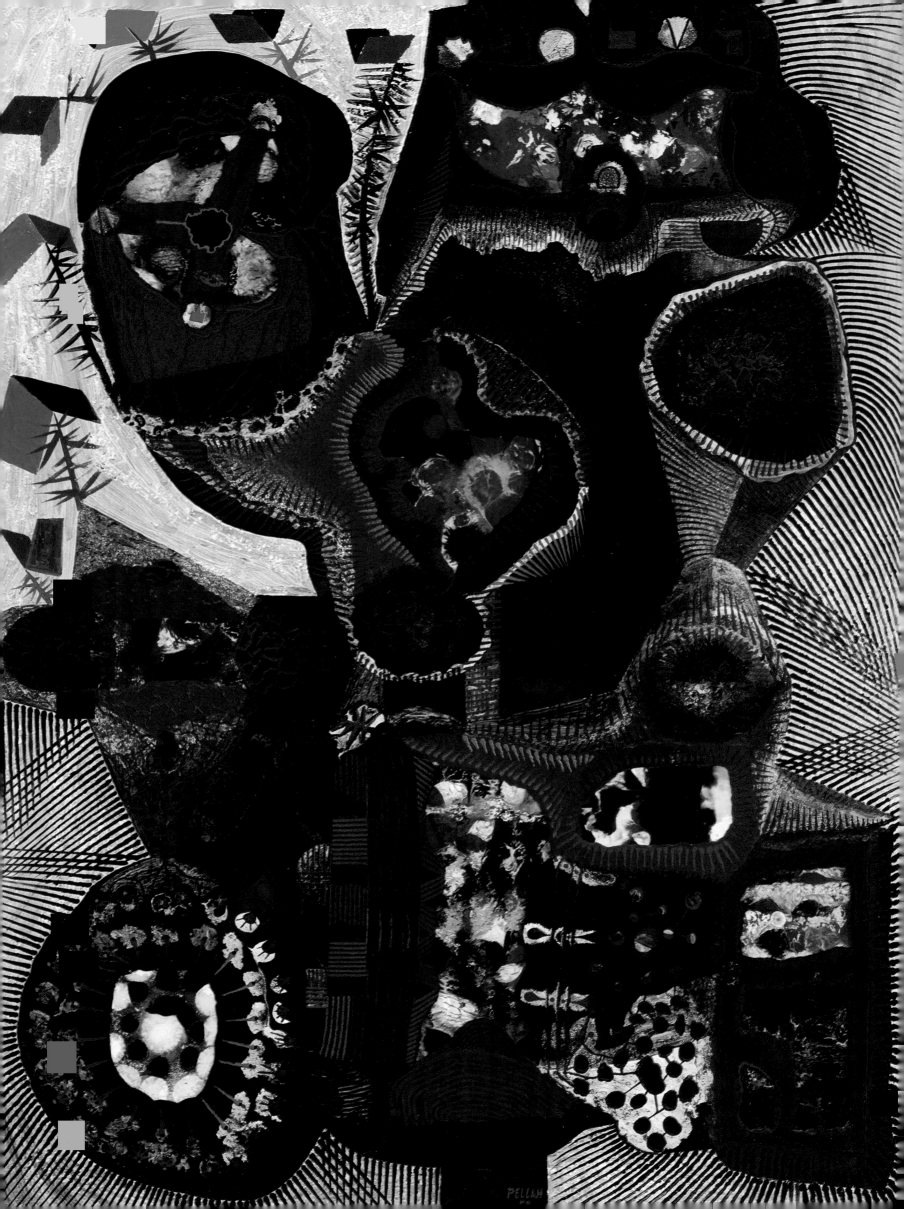

L'arbre-château
1959
oil, silica, glass on plywood/
huile, silice, verre sur contreplaqué
32 × 24
Mr. J.P. Erichsen-Brown, Toronto

Phosphorescence
1961
oil, silica on canvas/
huile, silice sur toile
45 5/8 × 50 5/8
Private collection/
collection particulière, Toronto

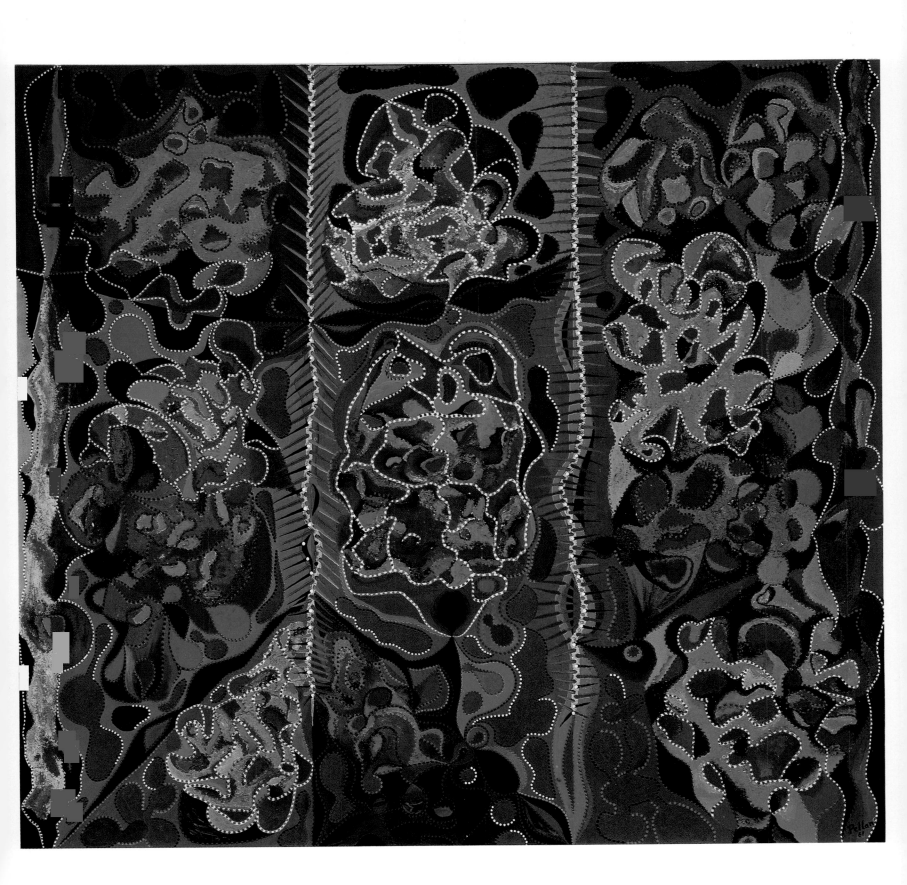

La mer rose
1964
oil, silica on plywood/
huile, silice sur contreplaqué
40 × 48
Mr. and Mrs. J. Wildridge, Toronto

Pyrotechnie
1961
oil, silica on plywood/
huile, silice sur contreplaqué
34 × 29
Private collection/
collection particulière, Toronto

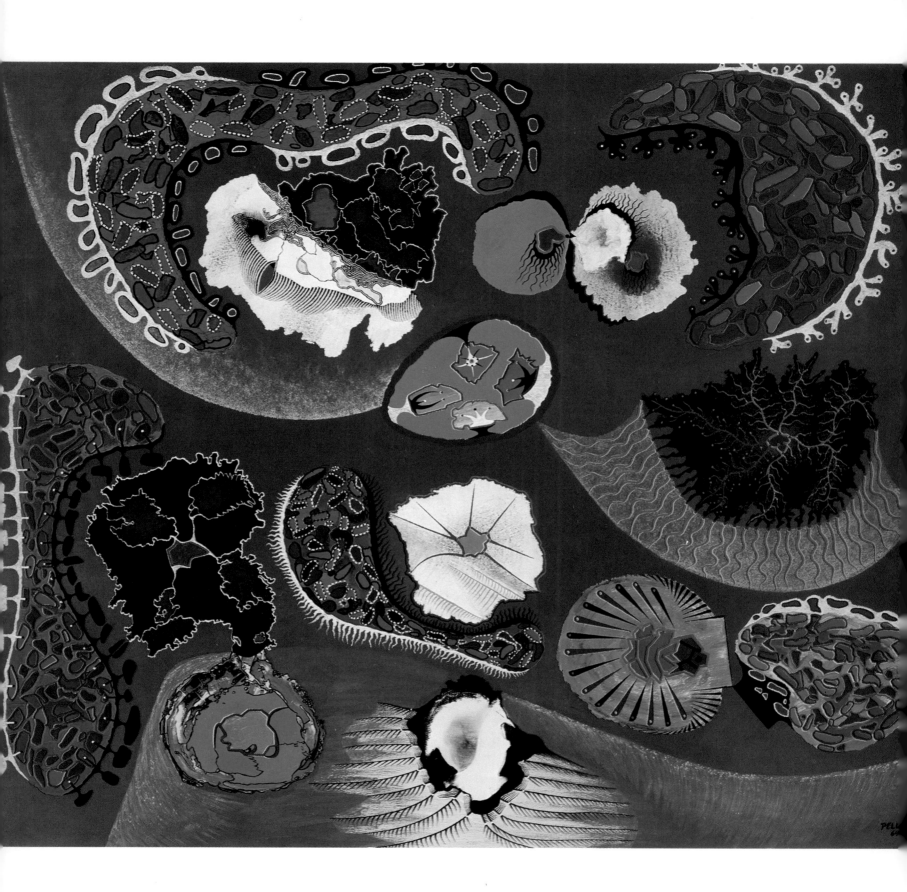

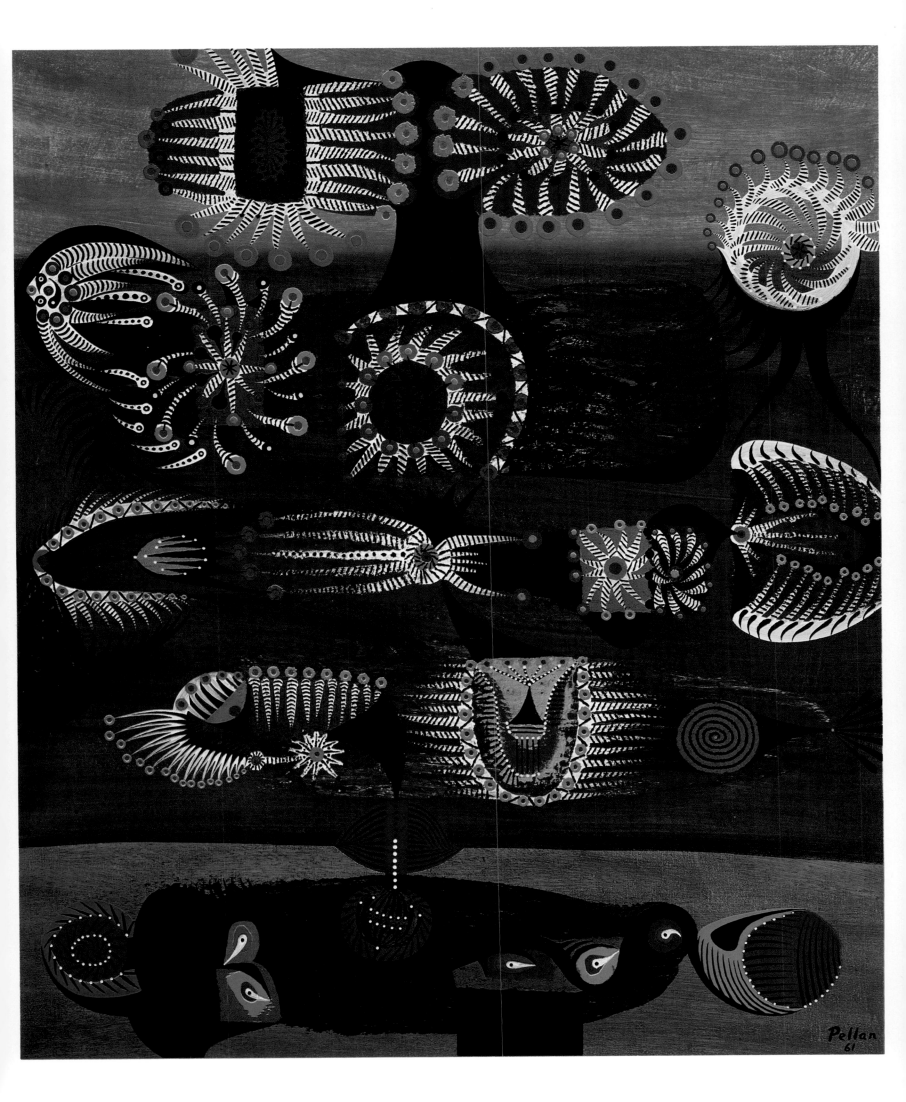

Mini-nature
1966
oil, silica on plywood/
huile, silice sur contreplaqué
11 7/8 × 36 1/4
Mr. R. Macdonald, Woodbridge, Ontario

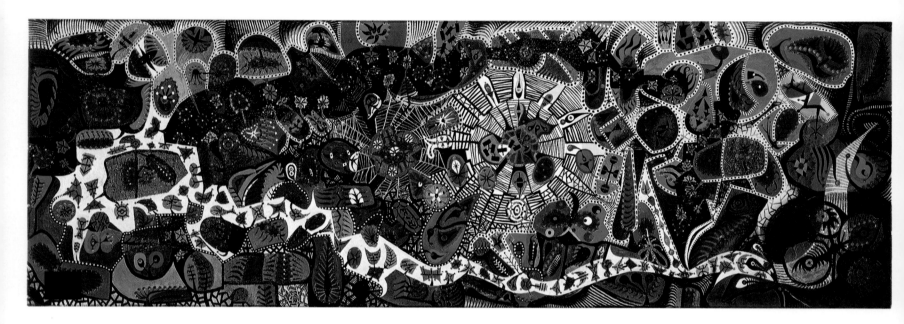

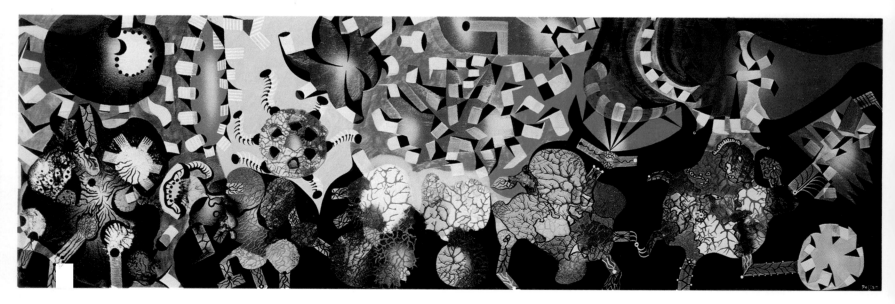

Ensemencement
1961
oil, silica on plywood/
huile, silice sur contreplaqué
12 × 36
Mr. and Mrs. J. Wildridge, Toronto

Végétaux marins
1964
oil, silica on plywood/
huile, silice sur contreplaqué
48 1/8 × 32 1/8
Art Collection Society of Kingston,
Ontario

132

Les ombelles
1966
oil, silica on canvas/
huile, silice sur toile
18 × 11 1/8
Private collection/
collection particulière, Montréal

Jardin mécanique
1965
oil, polyfilla on plywood/
huile, polyfilla sur contreplaqué
48 × 48
Mr. and Mrs. J.R. Longstaffe,
Vancouver

Le buisson ardent
1966
oil, silica on plywood/
huile, silice sur contreplaqué
12 7/8 × 21 5/8
Dr. and Mrs. O.J. Firestone, Ottawa

Les carnivores
1966
oil, silica on plywood/
huile, silice sur contreplaqué
26 × 18 5/16
Dalhousie Art Gallery, Halifax,
Nova Scotia

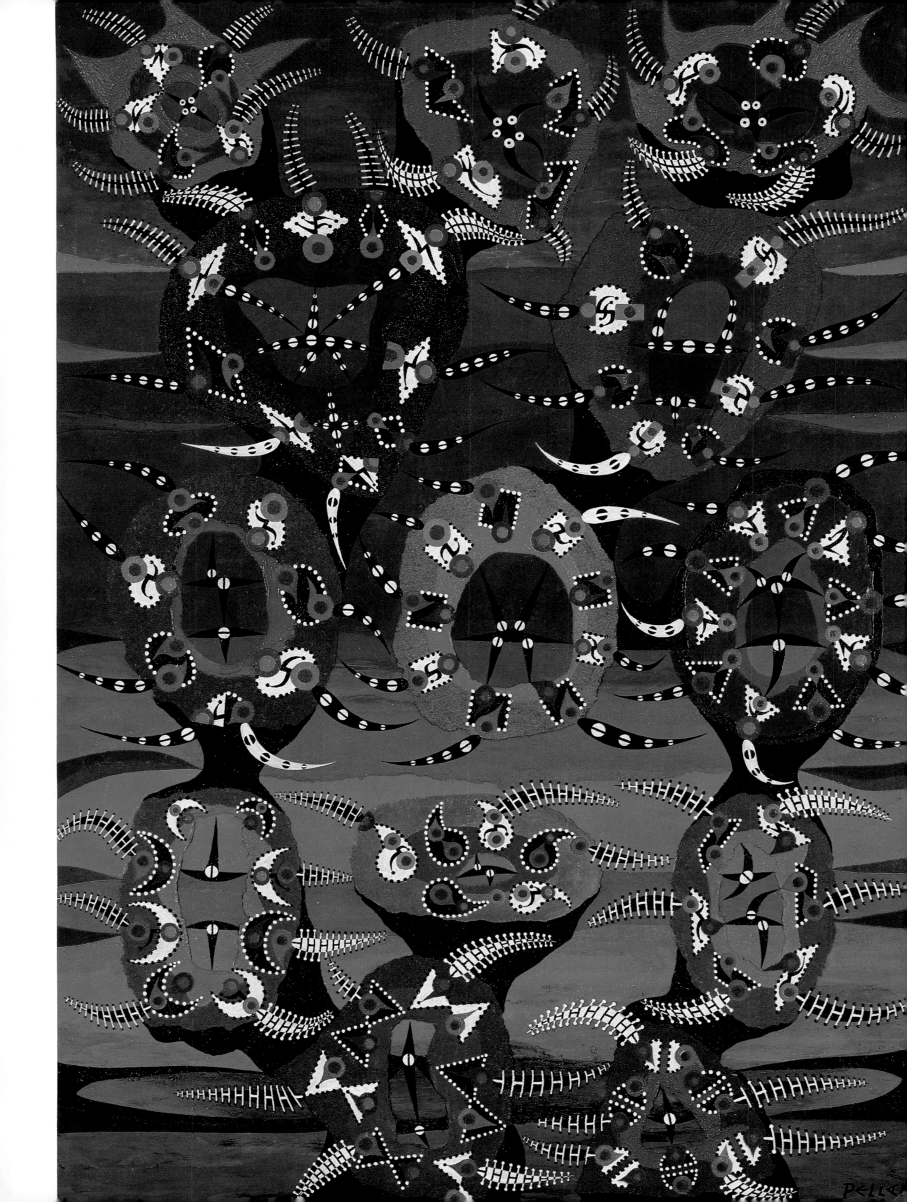

Jardin d'Olivia-A
1968
oil on cardboard/
huile sur carton
7 5/8 × 14 7/8
Private collection/
collection particulière, Montréal

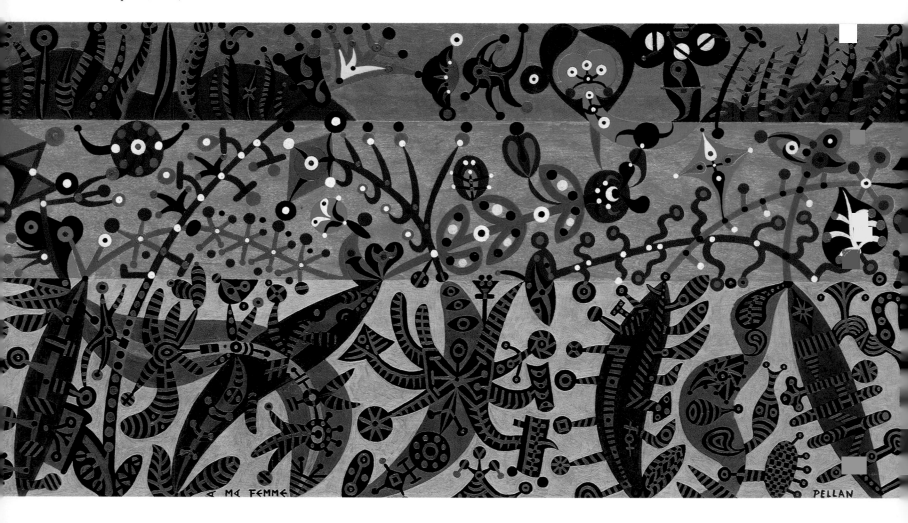

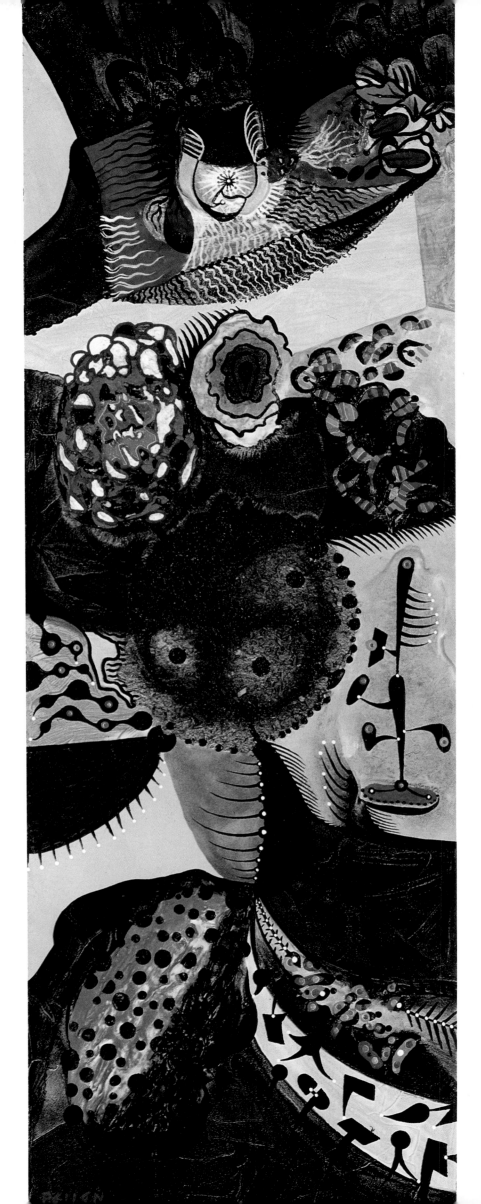

Oasis
1968
oil, silica on cardboard/
huile, silice sur carton
18 1/4 × 6 3/8
Private collection/
collection particulière, Montréal

Fond marin
1969
oil, silica, glass on plywood/
huile, silice, verre sur contreplaqué
12 1/4 × 14 7/8
Private collection/
collection particulière, Montréal

Sioux! Sioux!
1969
oil, polyfilla on plywood/
huile, polyfilla sur contreplaqué
13 3/8 × 14
M. Edouard A. Bourque, Lucerne, Québec

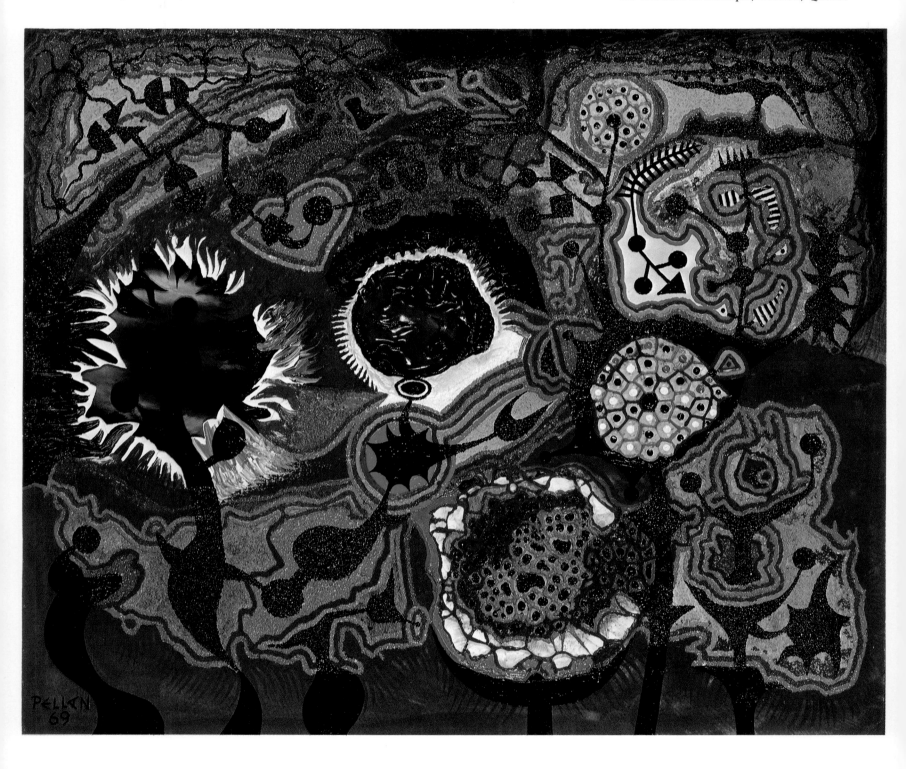

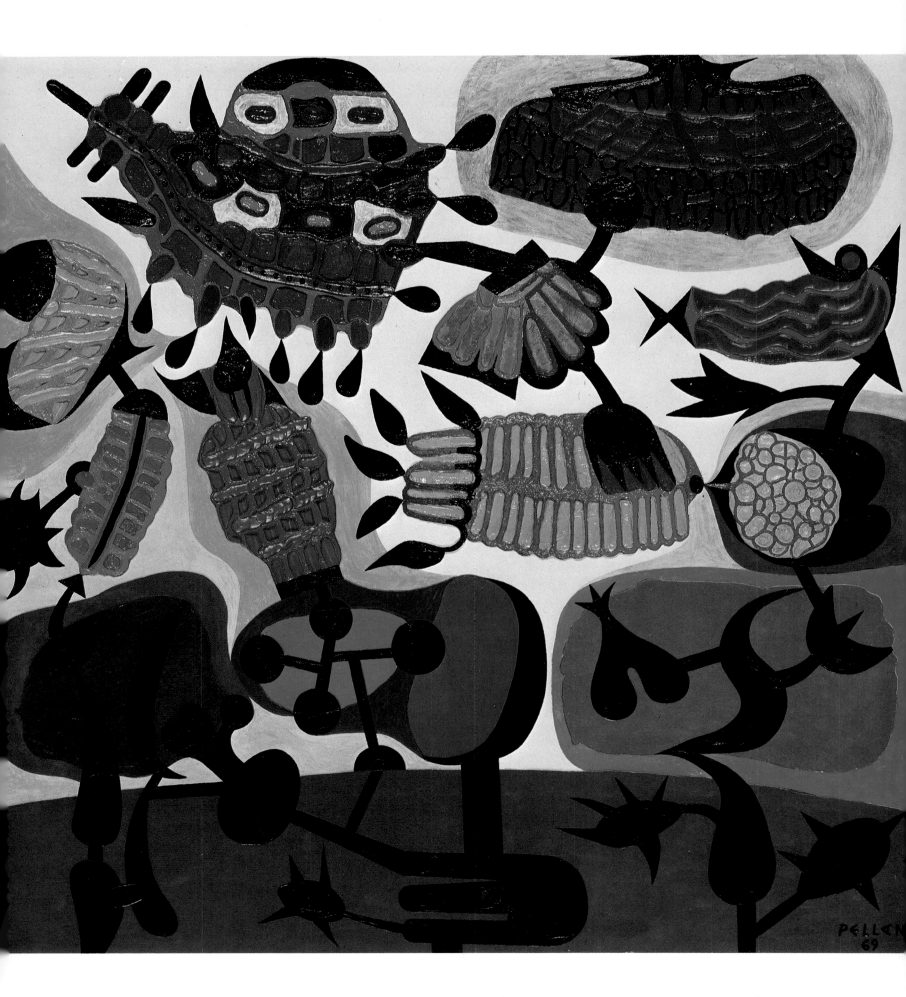

J'herborise
1969
oil, silica, glass on plywood/
huile, silice, verre sur contreplaqué
13 5/8 × 14 1/4

Fleurs-gadgets
1970
oil, silica on plywood/
huile, silice sur contreplaqué
10 3/4 × 21 7/16
M. Paul Laporte, Laval, Québec

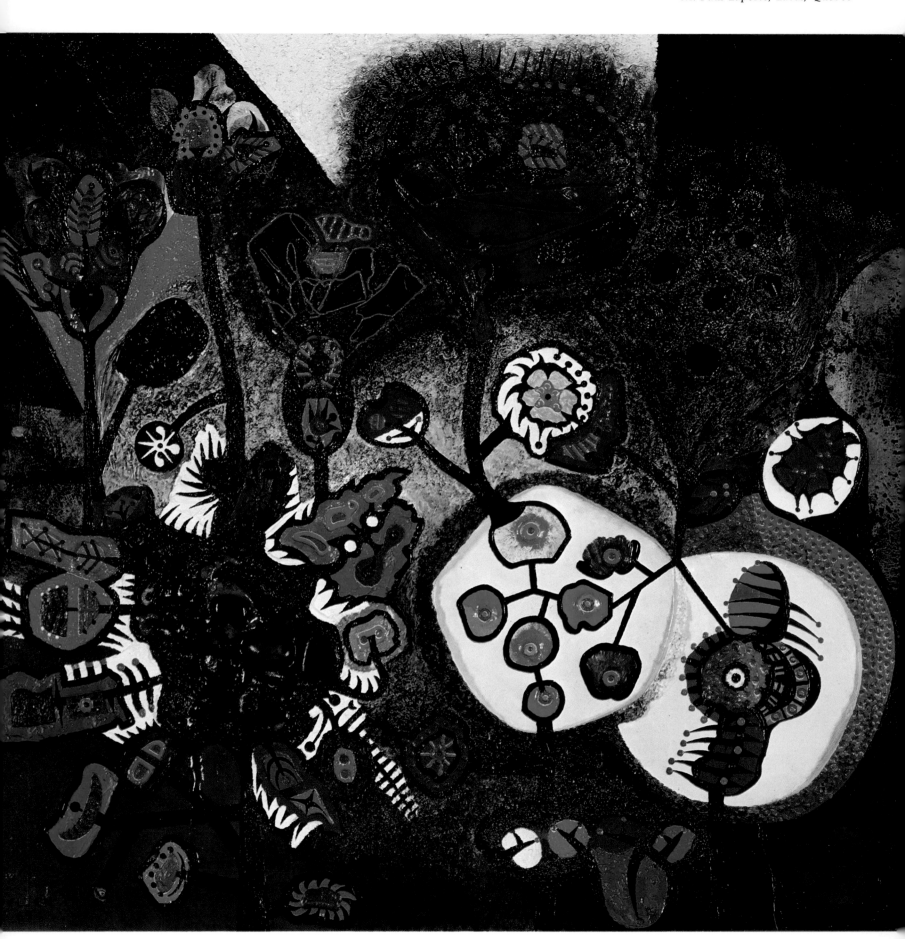

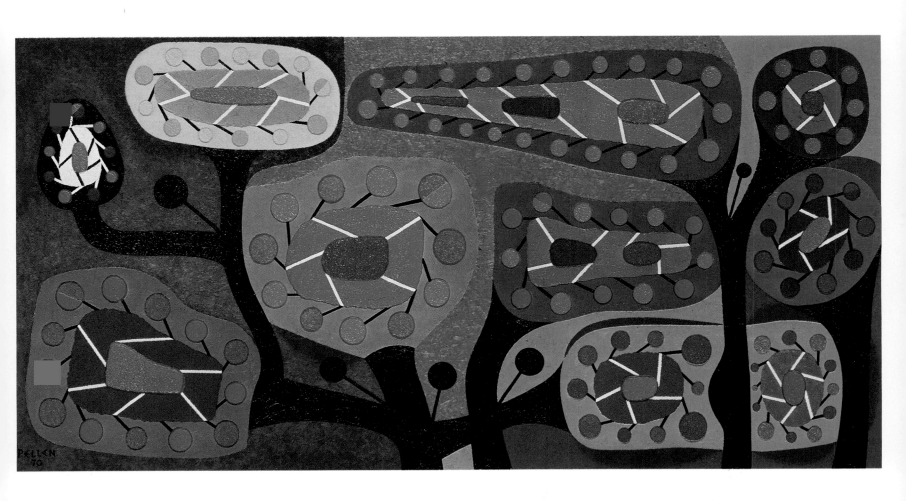

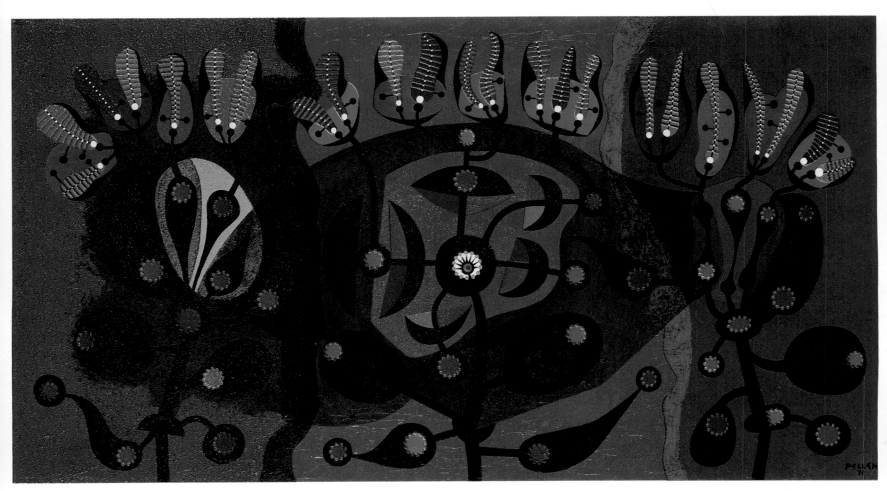

143

Série noire B
1970
oil on canvas/ huile sur toile
18 × 13
Mr. and Mrs. A Kilbertus, Montréal

Slurch
1970
oil, silica on canvas/
huile, silice sur toile
25 × 36
Société Perchol, Montréal

dead birds, bars, stairways. Pellan draws them, engraves them attentively. The drawing and the line control the development of the images. At times of self-interrogation and research, the most exact and precise description possible identify his reflection. The spirit seems to try to control the informal, the indefinite, by carving images which appear when one raises a corner of the veil of the unknown.

The line seems to lead the energetic current which develops visions, binds them, associates them with one another to complete the plan, the painting. A canvas entitled *L'homme A grave* evokes the situation of the human being, the distressed attitude of the artist. A large head dominates the centre of the composition; the open skull allows one to see the compartmentalized brain. Each area is insulated. Man can record all the data of the real, accept the various aspects of the world confronting him but because of incommunicability among the organs of his perception, he does not succeed in assembling the elements of information or in synthesizing them. He is furthermore heavily handicapped and if the senses of hearing and smell

can seize a mass of information, those of vision and of organized consciousness are paralysed. The eyes are sewn shut. Gropingly, the hand, helped by a stylet, engraves the acquisitions of thought.

The paintings become a witnessing screen on which images and symbols accumulate, combine or collide. One gets the impression, because of the rush of diverse elements, that all of this will spill over the framework of vision. Automatic writing inscribes in *Le sixième sens* the drawing of a hand which becomes a dove, of a face which is transformed into a profile, of a brain which opens and provides a glimpse of a clock. The figures develop, are transformed as in a dream, an uncontrollable delirium.

The disfigured faces which appear bathed in red, violet and blue in the nightmare atmosphere of the painting *Citron ultra-violets* express an unspeakable terror. A diabolical figure at the bottom of the painting seems to impose its powers on the chaos spreading in all directions in the form of fragmented networks of points and fine squares. In *Au soleil bleu,* the tension is borne to a great degree by the

Série noire A
1970
oil on canvas/ huile sur toile
9 1/2 × 19 3/4
Private collection/
collection particulière, Montréal

saturation of shades of red, yellow and orange, by the bold definition of zones of colour and motifs. The angles are acute and even the rounded forms are tense, ready to break. The atmosphere is truly that of a furnace where the suffocating human figure is dislocated, is twisted or flattens, cooked, under the eye of a monstrous infernal creature.

Other paintings propose a vast reflection on the relentless destiny of man. This is the case with *Femme d'une pomme* in which, beyond the frontiers of time and space, beyond consciousness itself, is written the myth of the condemnation of a fallen creature. It is the history of the world – should one say of the worlds? – and of metamorphosis, the history of a new order established at one point and which since then is constantly being questioned.

Eve picked up the apple, offered it to Adam who sealed the pact of violation by sharing it. The hand of God points reprovingly; with innocence lost, nudity is veiled but flesh perpetuates itself despite the change. The fallen man finds himself thrown behind bars. The couple is confronted in its enslavement to the vital circle marked with the brand of old age and of death, and is subjected to chemical laws and to cataclysms. Strangled in its heavy gangue like a wall of masonry, the eternal soul exhausts itself answering the desperately persistent call of its original desires.

On rolls the ball and the unending waltz of the infinitely small – atoms, molecules, cells, crystals – and the infinitely large – stars, planets, galaxies – under the impulse of forces unfolding to the infinite. Caught in full flight, the lively images and reflections become superimposed, decompose and regroup around a despairing vision.

Vertige du temps, Derrière le soleil and *Le sablier* – part of a series of sketches prepared in 1957 for the mural competition of the City Centre building – develop the theme of time, inevitably running out, on a freer, more decorative basis. With the symbols of the hand holding a clock, a sand-glass, whirlwinds carrying away the seconds, the hours add up insistently. In *Ephémère,* the image is terrifying: the pitiless machine of time swallows its human prey and pulverizes it. Above shines a flame which ultimately will extinguish itself; a butterfly flies about during the few hours of its existence; a sun clock, inflexible, rules the use of time and of life. An obsession regarding lost moments, growing old and death persists, even in recent paintings. The 1968 *Equateur magnétique* suggests the illusion of life through the fleeting reflection of a face in the mirror. Under the mirror is death: inert hands, a broken skull, birds which have been destroyed, wilted, lifeless flowers, and shattered pieces of stone.

146

Série noire D
1971
oil on canvas/ huile sur toile
30 × 43
Private collection/
collection particulière, Montréal

But confronted with death, the flesh revolts. The vital energies join together in an effort to escape usage, the heavy carcan of determinism, and the irritating oppression of obsessive chains. The body resists. In the series of large paintings executed during the years 1943 to 1947 and which scandalized some people during the City Hall exhibition, Pellan records the protest of the senses and the cry of the living. Exacerbated eroticism spreads throughout the deployment of forms, in the vibration of points and coloured bars. *Homme et femme, Trois personnes, Sur la plage, Le modèle* and *Quatre femmes* introduce impressive female figures in incredible poses; the head, breasts, hips, stomach, thighs, limbs, ample and heavy in form, swollen and fertile, turn and roll in the shadows and in the light, and contort. There is no relationship with love in the meadows, the suave and languorous idylls; it is rather the fire of passion, the ardour of desire whipped to a brutal paroxysm in *Homme et femme.*

Once again, a baffling mixture of the registers of sensa-tion and levels of expression appears in Pellan's art. The space in the painting *Quatre femmes* barely contains the monumental nude figure seated in the centre of the composition, crushing two other female forms, half stretched out, with her foot and elbow. The imposing woman is set in absolute immobility; she is pensive, serious, her look is fixed and frightful. The violence of the vision is underlined by the incisive black outline defining the volumes. At times the line swells, at times thins out, ready to burst under internal tension. To this formidable force whose explosion may be feared is opposed the free geometry of coloured zones of light hues and decorative motifs which adorn the limbs of the figures and the constellation of thousands of luminous points spread over the whole of the painting's surface. Confronted with the disturbing concentration of the theme, Pellan suddenly seems to pirouette, substituting plastic seduction, since painting has its own virtues to overcome overly insistent obsessions.

147

Pop Shop
1970
oil, silica on paper/
huile, silice sur papier
12 13/16 × 12
Private collection/
collection particulière, Montréal

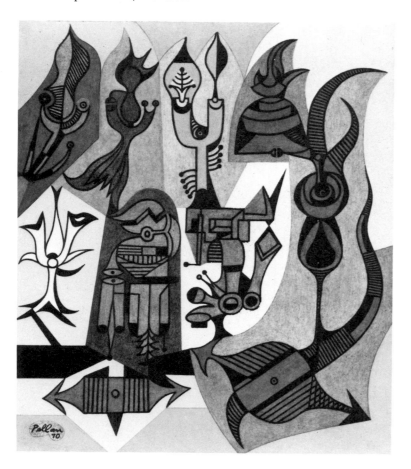

Pellan could not long continue in the dark spheres of great human drama, the lugubrious metaphysical mysteries, and the distressing anguish provoked by reflection on the relevance or irrelevance of existence. For a time, he was able to sustain the attempt to elucidate the I, the projection of deaf concerns which tormented him during difficult times, the unexplainable impulses which haunted his dreams or even his waking hours, but not for long. All of a sudden, he escaped. Something happened and he was led towards action, towards the known, joy, life, towards creation. Pellan had crossed the frontiers of the Freudian universe. Intuitively and by human necessity, he had brushed against the deep chasms of eternal myths. At times, he may have foundered but he ultimately leapt free.

Pellan does not belong to a grey and black world. He is a child of the sun, of light, and colour. He is a son of Dionysus and not of Saturn. A surrealist? Perhaps. He probed the enigmas of the subconscious and the visions of dreams. His images unfolded on the basis of irrational automatism, collided, depending on the whims of the line. Surrealist? Yes, perhaps in the manner of Miro, of Klee also, if the categories of art history can be broadened somewhat, but especially in the manner of Picasso, the magician, the conjurer of form. Most often, pictorial requirements and plastic necessities guided Pellan's imagination, eye and hand.

Even as he extended his reflections in regard to time, death, and unsatisfied desire, Pellan allowed himself to be carried away by the slightest call of fresh poetic humour and towards the fantasies of colour. In this festive spirit, he executed the costumes and stage settings for the play by André Audet in 1944 and the dazzling fantasy of *Soir des rois* in 1946. His taste for games, surprises, the ambiance of the spectacle and even of fairyland are rediscovered in many paintings, called *La magie de la chaussure, Luna Park, Discothèque, Fabrique de fleurs magiques, Fées d'eau,* or *Chasse aux papillons.* One sees shoes, boots, nailed heels, soles dancing a wild saraband in the middle of active hands and above the roofs of attractive factories; here are charming dancers, nude, decorated with multi-coloured balloons gambolling in a mechanized choreography. *Par le bleu de la fenêtre* provides a glimpse of a joking gymnast, children playing ball, wild trees, comic-strip birds.

Sometimes, it is solely the theatrical setting of certain landscapes which evokes the child's enchanted world. In *Santorin,* for example, Pellan on successive planes assembles small white houses covered with domes; in *Jardin bleu,* he builds a vaporous dream city, its lanes bordered with blinking street lamps.

Pellan recently pursued this whimsical vein by transforming a wall of masonry in his house into a joyous bestiary: a long stone became a centipede; a small rounded pebble, a clumsy chick. A contemplative cat, mischievous mice, an octopus, a bull, a stork, a pigeon, a whale, a seal and a ram also appear.

A new acquisition appeared in Pellan's pictorial development around 1944, establishing a certain analogy with music. Abandoning for a time the descriptive analysis of the line which dominates the dream-world compositions, Pellan concentrated on the plastic possibilities of the graphic sign. Large, lively, rhythmed features express in imagery the rapture of music in *Symphonie.* They reappear later in *Temps, Les Voltigeuses* and *Hommage à Ruggieri. Les Voltigeuses* is not content to produce the visual transcription, the spontaneous and automatic notation of a superpolyphonic musical improvisation: it is the entire multicoloured "underground" concert which vibrates and resounds outside the apparent limits of pictorial space. It no longer is a painting, not even a mural, but a total environment, a true sound-and-light spectacle in full anarchy. Beyond the graphic equivalents of rhythmed sounds incorporated within coloured amplitudes, visual and auditive sensations are confused in the imagination. A euphoric music whose writing allows neither rules nor arbitrary symbols springs forth everywhere at the same time without beginning or end. Melodic phrases slide into the corridors of the sinuous sound, extending, swelling, and breaking – oranges, reds, blues, pinks or mauves. At times pressed and booming, at times loose and running or again

Oniromancie
1970
oil, silica on paper/
huile, silice sur papier
13 3/4 × 12 1/16
Private collection/
collection particulière, Montréal

jerky and tart, strange airs are juxtaposed, or become isolated, bursting acutely, gravely, clearly, or somberly.

The theme of the woman reappeared around 1958 and developed into an abundant series. The spirit, however, was completely different from that in the large-scale paintings of 1943-47. Instead of the opulent and aggressive creatures of the time emerged the calm, serenity, and freshness of elegant figurines which move gracefully within an enchanting framework. After the still recent nightmare visions of *Maison hantée* and *Les tréteaux,* Pellan is visited by the fairies. The sky brightens, the gardens blossom again and female beauty develops. It is spring and all the charms of nature are rediscovered. The unpretentious images unfold in allegories which sing the joys of living, relaxation, the pleasures of the senses.

A small painting presents *Jeunesse* in the form of a young girl with only the traces of a bosom; she is timid, her eyelids are demurely lowered, and her arms are behind her back. A companion with a more mature figure gestures to draw attention to her pupil so people will admire her charm. The canon of this beauty underlines the attributes of the female sex – the full hips, the bountiful flesh evoking great fertility.

Equally ravishing creatures gambol with pleasure in *Piscine de Jouvence,* swimming, turning, dashing about in the precious fluid where they at times are confused with the marine plants which appear to have given birth to them. *Fées d'eau* again takes up this ballet, surrounded by strange aquatic vegetation, and evolving through the stratifications of coral or espousing the fine lacework of the shells; they subject the kingdom of the waters to the supreme authority of their beauty.

After the water, the fairies visit the earth and confront fire. *Les ondoyantes* quells the bursting of the earth's layers. The soil is red, green, blue, lilac; the craters, properly defined, are now only vestiges of old explosions. In *Mirage,* the volcanoes similarly have exhausted themselves. The forces still rumbling in the layers of the sub-soil do not give rise to any fear on the part of the carefree creatures. They stretch out voluptuously in the crevices or float in the inoffensive smoke of the cooled furnaces. In another sequence called *Les téméraires,* the figurines even defy the hungry flames in slow, gliding flights. Finally, the air and the sky are conquered. One witnesses aerial movements which scatter in the joyously decorated aerial fields of *Jeux dans l'espace* or the fields sprinkled with sparkling flowerings in *Au soleil noir.* At the end of their great peregrinations, the emissaries of Pellanian fantasy cross the borders of the atmosphere and spread out in an immaterial spray in *Fragment de lune.* Others, more dynamic, seek to resolve cosmic order in *Croissant de lune.*

Innocent reverie, frivolous escapes, dazzling apparitions . . . should one find a transcendental significance in all

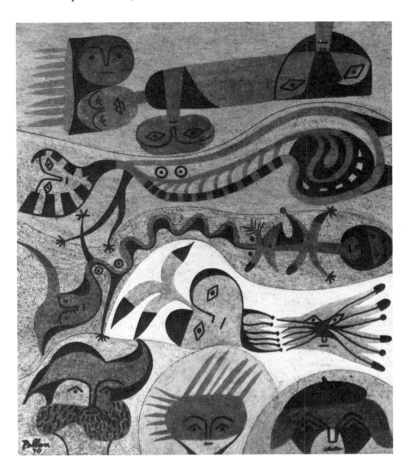

this? Pellan does not try to explain anything whatsoever. He allows himself to be guided by his insatiable appetite for rejoicing, surprises, his thirst for whimsy. He gives free rein to his imagination and to his powers of enchantment. He gives the floor within himself to the poet of unexpected joys, to the creator overflowing with humour and undoubtedly with love. Does one have to analyze everything, to label everything, to enjoy the thousand and one treasures of the real or the unreal? Must one untangle all the enigmas and solve all the mysteries? Does not the most essential food, both of the soul and of the spirit, offer a form of evidence which makes it immediately accessible to the senses? For the time being, Pellan seems to subscribe to this sybaritic hypothesis.

In the unfolding of imagery, the persistence of the many symbols of life and growth cannot but evoke the natural world; shells, plants, flowers, stars and especially fertile women are constantly brought together so as to give rhythm to an enthusiastic hymn to life. Pellan considerably enriched his pictorial vocabulary to materialize these animist visions. The drawing, colour, the subject matter, are developed with new boldness and subtle refinements.

Pellan freed his line to follow the undulating, sensual contours of the bountiful flesh of *Joyeuses joallières* and *Mécaniciennes;* the line slides, becoming more supple. It thins out and gains in refinement. It comes to the surface so as

Fleurs d'yeux
1972
oil, silica on canvas/
huile, silice sur toile
20 × 23 7/8
Dr. and Mrs. O.J. Firestone,
Ottawa

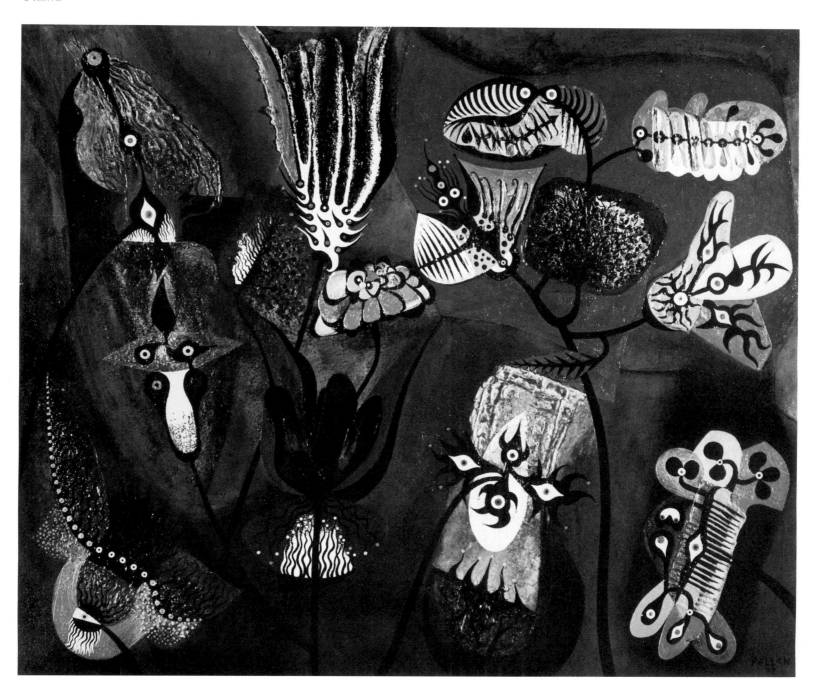

not to betray the rhythmic grace of the dancing figures. The matter swells, rounded shapes are in relief and seem to tremble and palpitate at the slightest caress of colour. Numerous images appear under the sign of the greatest plastic freedom. The landscape and figures are born through chance situations.

In his treasure drawer, where colour essays and experiments with matter accumulate, Pellan found the sources of a number of these compositions. Spurts of colour, assemblies of various elements, aggregations of thick paint and abstract images unleashed the process of creation. Pellan took up his rough sketches, discovered lines of force and

formal association in the tissues of chance. Little by little, the plans, motifs, lighting and the actors of the figuration took shape. The automatism of the starting point is controlled, assumed by a visual consciousness and alerted intuition, taking charge of the most astonishing pictorial digressions, purifying and completing the plastic potentialities while introducing figurative elements and poetic commentary.

The beginning of the cycle of flourishing young women roughly coincide with the execution of the celebrated series of gardens in 1958. The remarkable series – an important milestone in Pellan's work – gave rise to a vigorous renewal

of his pictorial language. It developed with the creation of the small paintings discussed earlier. In fact, the development of the gardens, in a sense, constituted the study of the setting of the aquatic gambols, the fire dances and spatial ballets of dozens of fairyland creatures whose charm already has been noted. On the other hand, concentration on the theme of the fertile soil in which resplendent flowers grow, and on nature itself, provider of a thousand splendours, presaged luxuriant vegetation and infinite organic variations which characterized production of the 1960's and which reappeared in more recent paintings.

There are six gardens, identified by the basic colours of the prism: *Jardin bleu, Jardin jaune, Jardin rouge, Jardin vert, Jardin orange,* and *Jardin mauve.* On these large surfaces, Pellan engaged in manipulations of matter and plays of texture to support the sparkling coloured modulations arising from changes in lighting. These were not his first experiments in the area. All his work manifests a constant search for the most spectacular colours and the most dizzying optical plays. Did he not say at one point that he dreamed about "an electric painting, a discordant painting which would burn the eyes, an almost insupportable painting"? For a long time, he had been using silica powder here and there to animate the coloured surfaces. In *Au soleil bleu,* he spread a layer of rice grains over certain motifs of the composition. Or again in *Calme obscur,* he gathered fragments of slag to create a relief in the female form stretched out at the bottom of the painting. Glass is superimposed on multicoloured spots in *La maison de verre.* Pellan also frequently incorporated tobacco, dried leaves and mineral debris in his colours.

The thick, dense paste is raised to produce the relief of the fantastic cities of the blue, red, and mauve gardens, defined on a background of sky which is free and smooth.

Pellan uses different forms of spatulas and even combs to grind the heavy substance, build small houses, outline lanes, lay out hills. He fashions paintings with a tactile joy which responds to man's profound need to leave his imprint on matter, to make it serve him, and to humanize it. The yellow, green and orange gardens eliminate any reference to landscape. The painter selects a portion of the soil and concentrates on the material. He examines it, turns it tenderly and it becomes unctuous, palpitating and fertile. Pellan used the icing tube to trace creamy, undulating pigmentation which spreads a vital influx through the furrows of the soil. The brilliant flowers grow, burst into bouquets like fireworks – pinks, reds, blues, mauves in *Jardin vert*; they acquire the precision and finesse of carefully cut precious stones in *Jardin orange*; they spread out and move to the surface of *Jardin jaune* like micro-organisms seen through a microscope.

This exaltation of colour or rather of coloured matter as the organizing principle of the painting expresses at the theme level a profundity which leads Pellan to the elementary sources of life. The painter turns towards the spectacle in constant effervescence and organic proliferation. The most arid fields can welcome the seeds of life, nourish them and promote their flowering. Pellan rekindles the cooled embers of *Jardin volcanique* to transform them into a garden of fire. He digs, scrapes and turns the earth. He frees large areas, cleans them, rubs the surface and polishes it hard. Elsewhere, rugged textures appear, such as the crevices of a dried earth and the chains of thousands of small craters developing like cankers. Through vigilant care, the matter little by little comes alive again, a miraculous fluid runs anew and circulates in the small canals, saturating the soil bloated with blues, greens, pinks, yellows and oranges. The flowers which soon germinate have a mineral aspect. They fill out, stretch and radiate with strident vividness.

This magic of flowering is renewed in *Jardin étang, Jardin mécanique, Jardin d'Olivia, Le champ, Oasis, Intérieur de serre. L'arbre persan, L'arbre château, Les ombelles, Le buisson ardent, Fleurs gadgets* appear. Everything is born, grows and spreads out. The aquatic environment is called upon to furnish its *Végétaux marins* and *Fleurs d'eau.* Plastic creation becomes a sign and poses as the equivalent of natural reproduction. It has vigour, energy, variety, multiplicity.

Certain paintings such as *Mini-nature, Rococomagie, Architecture molle et poilue* evoke vital energy itself, manifested in networks as complex as those of electronic circuits, in explosions of cells recalling atomic fission or cosmic phenomena. Life is present in all its forms, in all its ramifications and its virtualities which become visible.

Pellan again resorts to strong reliefs to mould his *Jardin mécanique* in which he imprints meshing elements. He integrates within *Fonds marins* and *J'herborise* fragments of glass but the play of materials never subordinates the passion for colour. The artist willingly limits himself in *Pop Shop, Oniromancie* and *Ripolinade* to spreading the fine layers of flat colour, with the greatest care, to diluting the lightest transparency so as to give new mobility to luminous space. Through the studied juxtaposition of transparent hues, Pellan often achieves an illusion of depth no less effective than the raising of matter for the exploration of coloured projections.

The artist's most recent works – *Sioux! Sioux!, Fleurs gadgets, Slurch* and *Série noire A-B-C-D* – tend towards greater simplification. The graphic concept and the colours, almost phosphorescent in intensity, are closely related and harmonize to create shock-images and symbols. Seeds, flowers, plants, stars or precious minerals constitute the words; blues, greens, yellows, mauves and oranges propose the rhythm and the melody of the resounding hymn which Pellan sings in tribute to the visible, to nature, and to life.

One-man exhibitions

Académie Ranson, Paris, January, 1935
Galerie Jeanne Bucher, Paris, 1939 (*peintre de la galerie*)
Musée de la Province de Québec, Quebec, June, 1940
The Montreal Museum of Fine Arts, October, 1940
Galerie Bignou, New York, April, 1942
Galerie Municipale, Quebec, April, 1942
Galerie l'Atelier, Ottawa, May, 1952
Coq Liban, Paris, January-April, 1954
Cercle Paul Valéry, Paris, June, 1954
Retrospective, Musée national d'Art moderne, Paris,
 February-March, 1955
Retrospective, Hall of Honor, City Hall, Montreal,
 November, 1956
Laing Galleries, Toronto, November, 1957
Galerie Denyse Delrue, Montreal, April, 1958
Hommage à Pellan, Galerie Denyse Delrue, Montreal,
 April-May, 1960
Robertson Galleries, Ottawa, October-November, 1960
Retrospective, National Gallery of Canada,
 The Montreal Museum of Fine Arts, Musée du Québec,
 Art Gallery of Toronto, 1960-61
Roberts Gallery, Toronto, April, 1961
Présence de Pellan, Galerie Libre, Montreal, October, 1963
The Kitchener-Waterloo Art Gallery, Kitchener, Ontario,
 February, 1964
Sherbrooke-Art, Howard Domain, Sherbrooke, Quebec,
 June 7th, 1964
Roberts Gallery, Toronto, November 10th-21st, 1964
Winnipeg Art Gallery, April 4th-28th, 1968
Voir Pellan, Musée d'Art Contemporain,
 April 29th-June 1st, 1969
Pellan, Musée du Québec, The Montreal Museum
 of Fine Arts, National Gallery of Canada,
 November-December-January, 1972-73
Pellan - Costumes et décors de théâtre, Ecole des Arts visuels,
 Université Laval, Quebec, September, 1972
Décors et costumes, gouaches d'Alfred Pellan, Galerie de Montréal,
 October, 1972

Principal group exhibitions

1933 Galerie Beaux-Arts, Paris
1934 *Salon d'Automne*, Paris
1935 *Salon des Tuileries*, Paris
 Galerie des Quatre-Chemins, Paris
1936 Galerie Bernheim, Paris
 Galerie de Paris, Paris
 Galerie de l'Equipe, Paris
 Galerie Joseph Barra, Paris
1937 *Exposition des Surindépendants*, Paris
 Galerie Carrefour, Paris
1938 Galerie Billiet Pierre Worms, Paris
 Exposition des Surindépendants, Paris
 Galerie SV, Prague
 Galerie Montaigne, Paris
 The Hague
 41 Grosvenor Square, London
 9, boul. Montparnasse, Paris
1939 Galerie no 14, rue des Beaux-Arts, Paris
 Exposition des *Surindépendants*, Paris
 Museum of Modern Art, Washington
1941 *Exposition des Indépendants*, Galerie Municipale,
 Quebec
 Exposition des Indépendants, Henry Morgan & Co.,
 Montreal
 Annual exhibition, Contemporary Art Society,
 Henry Morgan & Co., Montreal
1942 *Contemporary Painting in Canada*, Addison Gallery
 of American Art, Phillips Academy,
 Andover, Mass.
 Canadian Group of Painters, Art Gallery of Toronto
 Joliette, Quebec
1943 *Pan-American Exhibition*, Contemporary Art Society,
 Andover Museum, Boston, Mass.,
 Morse Gallery of Arts, Winter Park, Florida
1944 *Group of Canadian Painters*, Rio de Janeiro
 Yale University Art Gallery
1945 *Women's International Exhibition of Arts and Industries*,
 Pavilion of the Province of Quebec, New York
1946 *Premier Salon des Réalités nouvelles*, Palais de New York,
 Paris
 Unesco – *Exposition internationale d'Art moderne*,
 Musée d'Art moderne, Paris
1948 *Prisme d'Yeux*, first official exhibition, The Montreal
 Museum of Fine Arts
 Salon de Peinture, Ecole Technique, Trois-Rivières,
 Quebec
1949 *Canadian National Exhibition*, Toronto
 Fifty Years of Canadian Painting, Art Gallery of Toronto
 London Public Library and Art Museum, Ontario
 Art Gallery of Toronto

1950 National Gallery of Canada, Ottawa
1951 Musée d'Art, Granby, Quebec
1952 *XXVI Biennale,* Venice
 Festival de Montréal, The Montreal Museum
 of Fine Arts
 IIe Mostra Internazionale di Bianco ed Nero, Lugano,
 Switzerland
 Archambault and Pellan, Art Gallery of Toronto
 Canadian National Exhibition, Toronto
1953 National Gallery of Canada, Ottawa
 Festival de Montréal, The Montreal Museum
 of Fine Arts
 Canadian Art for Israel, Bezalel Museum, Jerusalem
1954 *Dixième Salon de mai,* Musée Municipal d'Art
 moderne, Paris
1956 *Candian Artists Abroad,* organized by the London
 Public Library and Art Museum, Ontario, and
 circulated under the auspices of the National
 Gallery of Canada
 Quelques peintres canadiens-français, travelling
 exhibition, National Gallery of Canada
1957 *Thirty-five contemporary painters,* The Montreal
 Museum of Fine Arts
 Second biennial of Canadian Art, travelling exhibition,
 National Gallery of Canada
 Contemporary Canadian Painters, travelling exhibition,
 Australia, National Gallery of Canada
1958 *Art contemporain au Canada,* Palais des Beaux-Arts,
 Brussels
 Primera Bienal Interamericana de Pintura Y Grabado,
 Instituto Nacional de Bellas Artes, Mexico
 Canadian Group of Painters, Vancouver Art Gallery
 A Canadian Portfolio, Dallas Museum for
 Contemporary Arts
 Moderne Canadese Schilderkunst,
 Utrecht Central Museum

1959 *Moderne Canadese Schilderkunst,* Groningen Groninger
 Museum, The Netherlands
 Art contemporain au Canada, Rath Museum, Geneva
 Third Biennial of Canadian Art, travelling exhibition,
 National Gallery of Canada
 The Art Students' Club, University of Manitoba
 The Fifth Winnipeg Show, Winnipeg Art Gallery
 Zeitgenossische Kunst, Wallraf-Richarts Museum,
 Cologne, Germany
1961 *Twenty-five Quebec Painters,* Stratford Festival, Ontario
1963 *Nowoczesne Malarstwo Kandysskie,* Muzeum Narodowe,
 Warsaw
 Festival des Deux Mondes, Spoleto, Italy
 Master Canadian Painters and Sculptors, London Public
 Library and Art Museum; Sarnia Public Library
 and Art Gallery, Ontario
 Fifteen Canadian Artists, travelling exhibition
 organized by the Canada Council and the
 Museum of Modern Art, New York
 Cinq peintres canadiens, Musée Galliera, Paris
1964 *Canadian Painting 1939-1963,* The Tate Gallery,
 London
1965 *Sixth biennial,* National Gallery of Canada
 Artistes de Montréal, Musée d'Art contemporain,
 Montreal
1966 *Montreal Collects 1960-65,* The Montreal Museum
 of Fine Arts
 Quebec Department of Cultural Affairs, travelling
 exhibition
1967 *Expo 67,* Quebec Pavilion, Pavilion of Canada
 Three hundred years of Canadian art, Centenary of
 Confederation, National Gallery of Canada
 Panorama 1, Modern painters of Quebec 1940-55, Musée
 d'Art contemporain, Montreal
 Canadian Art of Our Time, Winnipeg Art Gallery
 One hundred years of Canadian art, Rothmans Art
 Gallery, Stratford, Ontario
1968 *Canadian Painting 1850-1950,* London Public Library
 and Art Museum, National Gallery of Canada,
 Ottawa, Musée du Québec, Quebec
 Dix peintres du Québec, Musée d'Art contemporain,
 Montreal, Musée du Québec, Quebec
 Galerie Champagne, Quebec
1970 Quebec Pavilion, *Expo 70,* Osaka
 Pavillon Pollack, Université Laval, Quebec

Permanent collections

Musée national d'Art moderne, Paris
Musée de Grenoble, France
Musée du Québec
National Gallery of Canada, Ottawa
The Montreal Museum of Fine Arts
Art Gallery of Ontario, Toronto
Lord Beaverbrook Art Gallery, New Brunswick
Art Gallery of Hamilton, Ontario
Art Gallery of Edmonton, Alberta
Kitchener-Waterloo Art Gallery, Ontario
Musée d'Art contemporain, Montreal
Dalhousie Art Gallery, Nova Scotia
Willistead Art Gallery, Windsor, Ontario

Awards and distinctions

Bursary from the Province of Quebec, Paris, (1926-1930)
First prize for painting, Ecole des Beaux-Arts, Paris, (Atelier Simon), 1928
First prize, poster competition, *Kiwanis Frolics Program,* Quebec, 1926
First prize, *Première Grande Exposition d'Art mural de Paris*, 1935
Canada's official representative at the Art Institute of Chicago during an exhibition grouping artists from forty countries, 1945
First prize for painting, *65th Annual Spring Exhibition*, The Montreal Museum of Fine Arts, 1948
First prize, *Concours artistiques de la Province de Québec*, 1948
Bursary from the Royal Society of Canada, 1952-53, for research in France
First prize, mural competition, City Center Building, Montreal, 1957
Professor of painting, Canadian Art Centre, 1958
National prize for painting, University of Alberta, 1959
Medal, Canada Council, 1965
Member of the International Jury, *Quatrième Biennale de Paris*, 1965
Companion of the Order of Canada, 1967
Centenary Medal, Canadian Confederation
National Film Board, *Voir Pellan*, 1969
Doctorate *honoris causa*, philosophy (fine arts), University of Ottawa, 1969
Member of the Royal Canadian Academy of Arts, 1971
Doctorate *honoris causa*, arts, Université Laval, 1971
Doctorate *honoris causa*, law, Sir George Williams University, 1971
Prix Philippe Hébert, Société Saint-Jean Baptiste, 1972
Molson's Prize, 1973.

Theatre

1944-45 *Madeleine et Pierre*, by André Audet, costumes, sets and props by Pellan, Monument National, Montreal

1946 *La nuit des rois*, Shakespeare, costumes, sets, props and makeup by Pellan, Compagnons de Saint-Laurent, Gesù, Montreal

1957 Curtain maquette, Montreal Theatre Ballet

1968-69 *La nuit des rois*, Shakespeare, Théâtre du Nouveau Monde, Place des Arts

Murals

Canadian Embassy, Rio de Janeiro (painting)

Tétrault Shoe Ltd., Montreal (painting)

Jean Désy, Canada (fluorescent painting)

Musée national d'Art moderne, Paris (painting)

City Center Building, Montreal (mosaic), 1957

Ecole Secondaire Immaculée-Conception, Granby, Quebec, (ceramic), 1960

Three murals for the Miron brothers (ceramic and mosaic), 1962

Winnipeg Airport (painting), 1963

Place des Arts, Montreal (stained glass window), 1963

Eglise Saint-Théophile, Laval-West, Quebec (stained glass windows), 1964

National Library of Canada, Ottawa (painting), 1968

Vermont Construction Inc., Laval, Quebec, (architect: Jacques Vincent), 1969

Jardin d'Olivia, Atelier de Tapisserie Haute-Lisse, Musée du Québec

Summary bibliography

Monographs

Gagnon, Maurice, *Pellan*, Montreal, L'Arbre, 1943
Cinquante dessins d'Alfred Pellan, Montreal,
 Editions Lucien Parizeau, 1945
Buchanan, Donald W., *Alfred Pellan*, Toronto,
 McClelland & Stewart, 1962

Principal articles

De Tonnancour, Jacques, "Alfred Pellan, propos sur un
 sorcier", *Amérique Française*, Montreal, 1ère année, no 2,
 décembre 1941, *Quartier Latin*, Montreal, juillet-août-
 septembre 1943
Bon, Antoine "Alfred Pellan", *Amérique Française*,
 février 1944
Ayre, Robert, "Pellan versus the band", *Canadian Art*,
 Vol. 3, Summer 1946
Drayton, Geoffroy, "Canadian Rebel: Alfred Pellan",
 The Studio, London, August 1951
Arbour-Brackman, Renée, "Alfred Pellan et les clefs de
 l'enchantement", *La Revue Française*, no 59, août 1954;
 "Un peintre canadien au Musée d'Art moderne",
 Les Cahiers de l'Ouest, no 17, juillet 1955
Dorival, Bernard, "Alfred Pellan", *Le Jardin des Arts*, Paris,
 mars 1955
Plackett, Joe, "Paris Honours Alfred Pellan",
 Canadian Art, Vol. 12, No. 3, Spring 1955
Dorival, Bernard, "Trois peintres canadiens au Musée
 national d'Art moderne de Paris", *Vie des Arts*, no 10,
 printemps 1958
Toupin, Paul, "Pellan chez lui", *Vie des Arts*, no 17,
 Noël 1959
Buchanan, Donald W., "Pellan", *Canadian Art*, Vol. 17,
 No. 1, January 1960
Gladu, Paul, "Mes tableaux, ce sont mes inquiétudes",
 Alfred Pellan catalogue, National Gallery of Canada,
 Ottawa, 1960

Steinhouse, Herbert, "Pellan, painter, poet and dreamer",
 Star Weekly Magazine, August 1960
Trent, Bill, "Alfred Pellan: Lover of life and art",
 Weekend Magazine, Vol. 10, No. 42, 1960
Viau, Guy, "Pellan, peintre primitif", *Cité Libre*, XII année,
 no 34, février 1961
Robert, Guy, "Pellan, peintre magicien", *Magazine Maclean*,
 janvier 1963
Wyllie, John, "Alfred Pellan", *Canadian Art*, Vol. 21, No. 93,
 October 1964
Villeneuve, Paquerette, "Alfred Pellan", *Châtelaine*,
 avril 1970
Lefebvre, Germain, Pellan catalogue, The Montreal
 Museum of Fine Arts, 1972; "Saison Pellan", *Vie des Arts*,
 no 68, automne 1972
Bédard, Jean, "La sauvagerie apprivoisée de Pellan",
 Culture vivante, no 26, septembre 1972
Bates, Catherine, "Quebec's Alfred Pellan still leads the
 artistic pack", *The Montreal Star*, October, 1972
Dumas, Paul, "Consécration d'Alfred Pellan",
 L'Information médicale, décembre 1972
Gagnon, François, "Pellan, Borduas and the Automatists,
 Men and Ideas in Quebec", *Artscanda*, Vol. XXIX,
 No. 5, December, 1972/January 1973 issue nos. 174/175

Illustrations

First edition, 1973.

Photographs of the paintings
used in this volume were taken by
John Evans and Kilbertus.

The typeface used throughout
is Compano, set by Swift-o-type Ltd.

Colour separations were supplied by
Herzig-Somerville Ltd.

Printed and bound in Canada.